D1417822

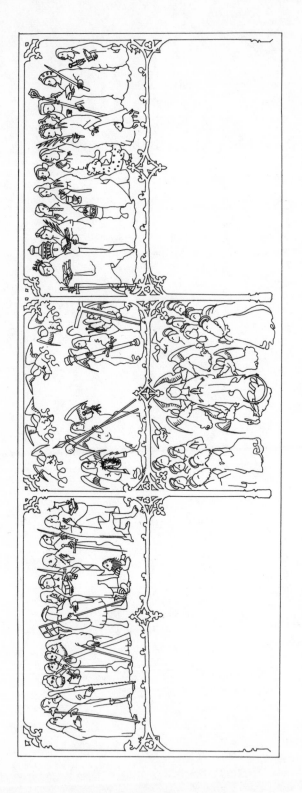

The Coventry Tapestry. St. Mary's Hall, Coventry. This illustration does not show the figure of Justice added when original figure of Trinity at top and center was removed, nor does it show the contemporary figures present in lower portion of the tapestry.

The Early Art of
COVENTRY, STRATFORD-UPON-AVON, WARWICK
and Lesser Sites in Warwickshire:

A Subject List of Extant and Lost Art
Including Items Relevant to Early Drama

by

Clifford Davidson and Jennifer Alexander

Early Drama, Art and Music
Reference Series, 4

MEDIEVAL INSTITUTE PUBLICATIONS
Western Michigan University
Kalamazoo, Michigan 49008
1985

Printed in the United States of America

ACKNOWLEDGEMENTS

Among the many individuals whose assistance in various ways helped to make these subject lists possible are Dr. Derek Hughes of the University of Warwick, Dr. Levi Fox of the Shakespeare Birthplace Trust, Gordon D. Balderston of the European Sculpture and Works of Art Department of Christie, Manson, and Wood, Ruth Taylor of the Birmingham and Warwickshire Archaeological Society, Francis Cheetham of the Norfolk Museums Service, Howard E. Brown, Peter Lockyer of the Henry VIII School in Coventry, the Marquess of Northampton who kindly arranged for us to examine the wood carvings in the chapel at Compton Wynyates, and Dr. Peter Newton, whose University of London dissertation on painted glass in the Midlands was crucial to our work.

We are further grateful to the directors and the staff of the following: The Medieval Institute of Western Michigan University; the Warburg Institute Library; the British Library; the Bodleian Library; the Local Studies Centre and Records Office at Coventry; the Conway Library of the Courtauld Institute; the Archives Department of the City of Birmingham Museum and Art Gallery; the Herbert Art Gallery and Museum, Coventry; the Warwickshire Museums Service; the Birmingham and Warwickshire Archaeological Society; the Birmingham Reference Library; the University Library, Cambridge; the Trinity College, Cambridge, Library; the Fitzwilliam Museum; the Society of Antiquaries; the Council for the Care of Churches; the National Monuments Record; the Public Records Office; the Records Office maintained by the Shakespeare Birthplace Trust, Stratford-upon-Avon; the Warwick Records Office; the University of Michigan libraries; the University of Chicago libraries; the University of Minnesota libraries; and the Western Michigan University libraries. Western Michigan University additionally provided a Faculty Research Fellowship for initial work in Warwickshire by Professor Davidson, and also gave subsequent support by means of smaller grants and other kinds of assistance through the completion of the project. Millward Brown of Leamington Spa awarded Jennifer Alexander a leave of absence and helped in other ways.

Permissions to use photographs which provide the basis for the illustrations in this book have kindly been granted by the Ackland Art Museum of the University of North Carolina, Chapel Hill; the Royal Commission on Historical Monuments (England); the Trustees of the British Museum; the Syndics of the Fitzwilliam Museum; the Warwickshire Museum; the Reference Library, Archives Department, Birmingham Public Libraries; the National Trust; Sir Robert Throckmorton; the City Council of Coventry; the Coventry Arts and Museums Division; the Stratford-upon-Avon Town Council; the Rev. Michael Freeman, Vicar, and the Churchwardens of the Collegiate Church of St. Mary the Virgin, Warwick; Coventry

v

Cathedral; Canon Antony S. B. Rowe, Rector, and the Churchwardens of All Saints, Ladbroke; the Rev. J. E. Bluck, Vicar of the Church of Our Blessed Lady, Halford; the Rev. A. L. Fermor, Vicar of All Saints, Burton Dassett; the Rev. J. Trevor Sammons, Rector, Newton Regis Church; the Rev. Roger Spiller, Vicar, Astley Parish; the Rev. E. F. Williams, Rector, and the Churchwardens of Wixford Church; the Rev. Gordon Elliott, Vicar, Withybrook Church; Mrs. I. D. M. Iles, Principal, Wroxall Abbey School; the Rev. Ivan Lilley, Vicar, Oxhill Church; the Rev. Edward Rainsberry, Rector, and the Churchwardens of Whichford Church; the Rev. F. A. Carroll, Vicar, and the Churchwardens of Coughton Parish Church; the Rev. Graham Dow, Vicar, Holy Trinity Church, Coventry; the Rev. George Baisley, Rector, Clifford Chambers Church; H. E. Brown; G. Dennis Spiller, Rector, Holy Trinity Church, Stratford-upon-Avon; the Rev. S. R. Marriott, Rector, and the Churchwardens of Merevale Church; the Rev. John Haynes, Vicar, Ufton Church; the Rev. A. Mairs, Vicar, St. Peter's Church, Mancetter; and Mrs. Marion Austin, Secretary of the Parish Church Council, and the Churchwardens of Wolverton Church. The drawing of the Coventry tapestry was provided by Nigel Alexander.

C. D.
J. A.

vi

CONTENTS

ILLUSTRATIONS

Frontispiece. The Coventry Tapestry.

Illustrations in the text:

1. God the Father, from St. Mary's Hall (originally from ?reredos). Herbert Gallery and Art Museum, Coventry.

2. Angel. Misericord, Holy Trinity Church, Coventry.

3. Jesse Tree. Misericord, St. Michael's Cathedral (destroyed).

4. Closed Door representing Immaculate Conception. Misericord, Holy Trinity Church, Coventry.

5. Annunciation. Corbel, gateway of St. Mary's Hall, Coventry, showing deteriorated condition.

6. Magi and Virgin Mary with Child. Seal of Shearmen and Taylors, Coventry. Aylesford Collection: Warwickshire Churches.

7. John the Baptist, from St. Mary's Hall (originally from ?reredos). Herbert Gallery and Art Museum, Coventry.

8. Betrayal. Painted glass from St. Michael's Cathedral, Coventry.

9. Five Wounds. Spandrel, roof of nave, Holy Trinity Church, Coventry.

10. Signs of the Passion: Hammer and Nails. Spandrel, roof of nave, Holy Trinity Church, Coventry.

11. Signs of the Passion: the Crown of Thorns. Spandrel, roof of nave, Holy Trinity Church, Coventry.

12. Last Judgment. Misericord, St. Michael's Cathedral (destroyed), Coventry.

13. Corporal Acts of Mercy: Visiting the Sick. Detail of misericord, St. Michael's Cathedral (destroyed), Coventry.

14. Corporal Acts of Mercy: Burying the Dead. Detail of misericord, St. Michael's Cathedral (destroyed), Coventry.

15. St. Michael, from St. Mary's Hall (originally from ?reredos), Coventry. Herbert Gallery and Art Museum.

16. St. Catherine, from St. Mary's Hall (originally from ?reredos), Coventry. Herbert Gallery and Art Museum.

17. St. George, formerly in Chapel of St. George, Gosford Gate, Coventry. Herbert Gallery and Art Museum.

18. King Henry VI, from Coventry Cross. Herbert Gallery and Art Museum.

19. Dance of Death. Details from misericords, St. Michael's Cathedral (destroyed), Coventry.

20. Picking Grapes. Detail from misericord, Hospital of St. John. Herbert Gallery and Art Museum.

21. Crushing Grapes. Detail from misericord, Hospital of St. John. Herbert Gallery and Art Museum.

22. Sol in Libra. Detail from misericord, Hospital of St. John. Herbert Gallery and Art Museum.

23. Green Man. Misericord, Holy Trinity Church, Coventry.

24. Wild Man. Misericord, Holy Trinity Church, Coventry.

25. Burial of Christ. Sculpture, very damaged, on Balsall Tomb, Holy Trinity Church, Stratford-upon-Avon.

26. Resurrection. Carved stop, hood mold over North Door of Chancel, Holy Trinity Church, Stratford-upon-Avon.

27. Angel and Holy Women at Tomb. Sculpture, very damaged, on Balsall Tomb, Holy Trinity Church, Stratford-upon-Avon.

28. The Last Judgment. Wall painting (present condition) over chancel arch, Gild Chapel, Stratford-upon-Avon.

29. Drawing illustrating wall painting of Last Judgment over chancel arch of Gild Chapel, Stratford-upon-Avon, in early nineteenth century. From Thomas Sharp, *A Dissertation on the Pageants or Dramatic Mysteries* (1825), Pl. 6.

30. Angels. Sculpture, Beauchamp Chapel, Warwick.

31. Angel Musician playing Clavichord. Painted glass, Beauchamp Chapel, Warwick.

32. Angel Musician playing Organ, while another works bellows. Painted Glass, Beauchamp Chapel, Warwick.

33. Mary as Queen of Heaven. Roof boss, Beauchamp Chapel, Warwick.

34. Trinity (head of the Father and the Dove are missing). Painted glass, Whichford.

35. Adam and Eve. Sculpture on font, Oxhill.

36. Sybil: Samia, with cradle. Painted glass, Coughton.

37. Prophets from Jesse Tree: Zephaniah and Malachi. Painted glass, Merevale.

38. David, from Jesse Tree. Painted glass, Mancetter.

39. Detail of Nativity. Alabaster at Coughton Court.

40. Presentation. Heavily restored painted glass, Wroxall.

41. St. John's Head, with St. Peter, St. Thomas Becket, and Christ of Pity. Alabaster, Ackland Art Museum, University of North Carolina, Chapel Hill.

42. Head of Jesus. Painted glass, Whichford.

43. Detail of Crucifixion. Ivory Carving, Alcester Cross. British Museum.

44. Chalice with Crucifixion on foot. Clifford Chambers.

45. Virgin Mary, from Crucifixion scene. Wall painting, Burton Dassett.

46. Extant head of Christ from Deposition (destroyed). Wall painting, Newnham Regis. Warwick Museum.

47. Figure of Christ from Image of Pity. Ivory, discovered at Astley.

48. Easter Sepulchre at Withybrook.

49. Soul of Departed, on half-effigy of priest. Newton Regis.

50. St. Michael. Fragmentary painted glass with made-up body of angel, Wolverton.

51. St. Thomas Apostle. Stall painting, Astley. Scrolls over-painted in 1624.

52. St. Peter and St. James the Less, from Creed Series. Painted Glass, Coughton.

53. St. Luke. Painted glass, Coughton.

54. St. Catherine. Restored (mostly modern but with some old glass) painted glass, Wroxall.

55. St. Chad. Painted glass, Ladbroke.

56. St. Cuthbert. Painted glass, Ladbroke.

57. St. Giles. Painted glass, Ladbroke.

58. Tumbling trick. Misericord, Halford.

Plates:

59. Churchyard Cross at Ufton showing deterioration of stone sculpture.

60. Angel musician with lute. Painted glass, Wixford.

61. Angel musician holding scroll with music. Painted glass, Wixford.

62. Angel musician playing lute. Roof of St. Mary's Hall, Coventry.

63. Angel musician playing rebec. Roof of St. Mary's Hall, Coventry.

64. Angel musician playing ?recorder. Roof of St. Mary's Hall, Coventry.

65. Angel musician playing bagpipes. Roof of St. Mary's Hall, Coventry.

66. Angel musician playing harpsichord. Painted glass, Beauchamp Chapel, Warwick.

67. Angel musician playing psaltery. Painted glass, Beauchamp Chapel, Warwick.

68. Angel musican playing tromba marine. Painted glass, Beauchamp Chapel, Warwick.

69. Angel musician playing bagpipes. Painted glass, Beauchamp Chapel, Warwick.

70. Fidel, played by man. Drawing in McClean MS. 123, fol. 78. Fitzwilliam Museum.

71. Apocalyptic angel blows trumpet. Drawing in McClean MS. 123, fol. 72. Fitzwilliam Museum.

Maps:

John Speed's Map of Coventry (1610). *Page xii*

John Speed's Map of the County of Warwick (1610). *Inside back cover*

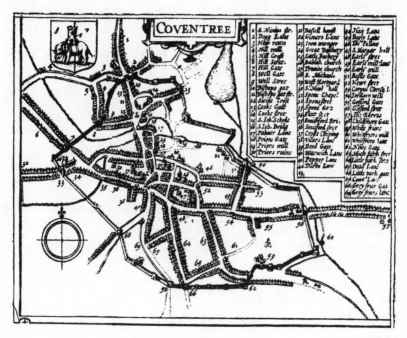

John Speed's Map of Coventry (1610).

INTRODUCTION

The City of Coventry, whose freedom was allegedly established through the offices of the legendary Lady Godiva and her husband in the dim past, was among the ten largest cities in the realm of England prior to its serious decline in the sixteenth century.[1] It was a city famous for its mystery plays[2] and also for the tradition of civic piety out of which the plays grew.[3] This same civic piety led to what were surely splendid collections of subjects in the visual arts in the churches and other buildings in the city. Unfortunately, most of this art has disappeared as the result of Reformation, neglect, war, and restoration. Hence the Church of St. John Bablake, which functioned as the gild chapel for the Holy Trinity Gild, is now in spite of its former richness entirely denuded of its medieval art. (An ivory panel that shows the Magi bringing gifts to the Christ Child, now in this church, is a recently acquired non-English item which hence cannot be included in the subject lists below.) The Church of the Holy Trinity, though it has fared less badly, nevertheless is miserably poor when compared to its former condition. Here there are only a few fragments of early glass in a single window (Win N11) with only a fragmentary figure of a knight on horseback recognizable,[4] while even the great Doom painting over the chancel arch has faded to a uniform blackness. True, on the roof of the nave there are splendid angels holding shields with the instruments of the Passion, and the chancel preserves a fine set of misericords, rescued from elsewhere in the city. St. Michael's Church (later, until its destruction, the cathedral) was bombed on the night of 14 November 1940, and only some panels of painted glass that had previously been removed were saved from the holocaust which left the walls and tower alone standing.

Also once glorious with decoration was St. Mary's Hall, which still preserves considerable vestiges of its former splendor and which continues as a functional building to serve the city of Coventry in various ways. The early sixteenth-century tapestry, the angel musicians on the roof and medieval glass in the oriel window in the great hall, and other extant items are witness to the elaborateness of the building's original ornaments. Though fragmentary, the extant art is indicative of its original function and its relation to the religious and dramatic activities of the city. The tapestry, for example, is arranged around the now lost figure of the Trinity with the Father holding the slain Son on a cross. This iconography is directly associated with the principal gild of the city, the Trinity Gild, which represented the highest aspirations of the citizenry.[5] In turn, the Trinity and the extant angels in attendance, adoring the deity and holding the instruments of the Passion, show the sig-

1

nificance of Passion devotion as a central fact of religious symbolism for the culture of the late Middle Ages. It is well known, of course, that the devotion to the Passion thus implied by this iconography was at the heart of civic piety in such cities as Coventry.[6] Additionally, this Passion theology (for thus we are able to label it) had its end in practical works which should widen and strengthen the life of faith. Drama of the kind encountered in the city of Coventry in the fifteenth and sixteenth centuries likewise may be regarded as an extension of this theology, which to be sure is of a popular rather than scholastic nature.

Not all examples of the visual arts in Coventry would have been thoroughly popular, however. St. Mary's Cathedral, now totally destroyed, was a Benedictine establishment where, presumably, Latin liturgical plays such as the *Visitatio Sepulchri* might have been presented, though records of such performances are not extant. We unfortunately know almost nothing about what must have been a major site;[7] even among the lost art the only item that has thus far been identified is an image of St. George that has appeared in an inventory of relics in British Library Egerton MS. 2603,[8] though we do have a seal of this monastic cathedral also recorded[9] and additionally an illuminated manuscript from the monastery's library. In the case of this site, our lack of knowledge is admittedly very unfortunate.

Art of a more or less "elitist" sort, however, does appear in a site only a short distance from Coventry in the Beauchamp Chapel at Warwick. Spared by the fire that devastated St. Mary's Collegiate Church in 1694, the Beauchamp Chapel represents the memorial of a nobleman, Richard Beauchamp, who died at Rouen in 1439. In his will he left money for the building and adornment of this chapel, which was erected between 1447 and 1464.[10] Painted glass for the windows was commissioned from John Prudde of Westminster, a man who was glazier to the king, while John Brentwood of London was given the task of painting the Doom on the west wall of the chapel. Careful attention was given to the creation of a tomb for the donor, an earl of Warwick, who would be buried in this chapel where priests would pray for his soul and for the souls of all Christian men and women. From above, the two roof bosses would look down—one of the Virgin as Queen of Heaven and the other of God the Father in the posture of blessing. In the glass tracery of the side windows is an angel orchestra unequalled in medieval art, while the angel singers elsewhere in the tracery also sing the Sarum antiphon *Gaudeamus* in honor of the Virgin, a composition to be sung on the Feast of the Assumption. Here, therefore, the iconography leads to an awareness of the role of the Virgin Mary, whose function at the Last Day of history will be to intercede for men at the Judgment Seat of God.

At Stratford-upon-Avon, a market town, we return to examples of the visual arts that are thoroughly popular. This is the town

which, as almost every school child (perhaps even in America) knows, produced the playwright Shakespeare (1564-1616). It would, of course, be tempting to try to make connections between his work and such spectacular examples of visual art in this locality as the wall paintings in the Gild Chapel if we did not know that in this case the playwright's own father had been instrumental in defacing them and covering them from the public view in January 1564 in accordance with the iconoclastic views of the relatively new Protestant government of Queen Elizabeth I.[11] On the other hand, not all the wall paintings were so covered, and as a boy Shakespeare must have seen the remarkable Dance of Death series that only later was covered over by paneling.[12] But further examples of subjects in art--e.g., the sculpture on the Balsall tomb (unfortunately mutilated) or other items in the chancel of Holy Trinity Church near the very spot where Shakespeare was eventually to be buried--were surely also presences in his childhood and youth.

The remaining examples of Warwickshire art, though not from such centers as Coventry, Warwick, and Stratford-upon-Avon, extend our knowledge of the visual arts in the region. The sites range from the impressive display of painted glass now at St. Mary's Church, Merevale, a church which was once the chapel outside the gates of the Cistercian monastery of Merevale dissolved by order of Henry VIII,[13] to such locations as Beaudesert, which has only an Easter Sepulchre, denoting the former quasi-dramatic Holy Week ceremonies of pre-Reformation times, or Wyken, which has only a fragmentary wall painting of St. Christopher located on the north wall where his image could be seen by persons, especially travellers, at the church door as they left the building.[14]

Warwickshire, the most central of the English counties, was well placed to receive a wide range of artistic influences in the medieval period. Its proximity to the Cotswold region with the major sites of Tewkesbury, Gloucester, and Hailes insured contact with new developments in architecture, and the noble patrons of the castles at Kenilworth and Warwick brought court styles and artists to the region. As noted above, the furnishings of the Beauchamp Chapel in St. Mary's, Warwick, are the work of London artists with both wall paintings and glass by metropolitan workshops. In country areas as well artists from major centers were employed, as at Coughton where the work of glass artists from Malvern has been identified.[15] In sculpture also we have evidence of important workshops producing material for the region, with the tympanum of the Harrowing of Hell from Billesley now thought to be Herefordshire School work.[16]

The effect that the introduction of mainstream work into the area must have had can unfortunately only be speculated on since the destruction by iconoclasm and neglect has been so thorough. Warwickshire's central position has also meant that those intending to destroy its works of art had easy access to its build-

ings. Examples of the minor arts--of ivory carving and metal-
work, for instance--have survived or have been discovered through
excavation. Thus the Astley figure and the Alcester tau cross
have come to light as illustrations of an art which suggests
wealthy patronage in the region. Evidence for monastic patronage
in Warwickshire is scarce, and the destruction of its few monas-
tic sites has been almost total. Apart from the Merevale Abbey
glass, now divided between the gate house chapel of St. Mary
(mentioned above) and Mancetter parish church, the main evidence
of monastic patronage can be found in the seals, which come from
Polesworth, Combe Abbey, Kenilworth, etc. The Charterhouse in
Coventry, however, does have the remains of a once magnificent
wall painting of the Crucifixion with the soldiers in plate
armor--a wall painting damaged by the insertion of a later ceil-
ing, but surviving because the building was put to secular use as
a domestic structure. Other wall paintings fared less well.
Newnham Regis' Deposition from the end of our period was des-
troyed with its church in the eighteenth century, but the three
fragments saved, now in the Warwick Museum, show it to have been
a quite exceptional painting and a major loss. Wall paintings
were, of course, never intended to last for more than a few
years, particularly in England's damp climate, and most survivals
have been recovered from the limewash of the sixteenth- and
seventeenth-century reformers; others have been lost in the nine-
teenth-century stripping of that protective layer by restorers
anxious to expose the stonework beneath. Where a record was kept
of the find before its destruction it has been entered in our
lists.

Admittedly, Warwickshire (and here it should be noted that
the area surveyed involves the county as it existed immediately
before the recent reorganization which changed its boundaries
considerably, though a few towns had been included in the county
then that had been part of other counties in the late Middle
Ages) is not a neatly coherent area. It is not assigned entirely
to a single diocese even today, and in fact it is offered here as
a region only for convenience in illustrating the survivals and
records of lost art from an area surrounding urbanized places of
crucial importance for both medieval and Renaissance drama. For
the student of iconography, the range of examples in the county
should, in spite of the losses lamented above, show at least
something of the scope of the art from an area representative of
the Midlands.

Most of the extant examples listed in these subject lists
are currently located in churches, civic buildings, and museums,
and the media represented include wall paintings, painted glass,
woodcarvings, stone sculpture, metalwork, etc., all of which are
identified below by the standard codes used in EDAM reference
volumes. Two illuminated manuscripts from Warwickshire also
demand notice. One, the *Nuneaton Book* from the abbey at Nun-
eaton, includes pencil sketches in a Bestiary as well as

Apocalypse illustrations. This manuscript, which may be dated thirteenth-century,[17] is now Fitzwilliam Museum, McClean MS. 123. Most of the bestiary illustrations are beyond the scope of the present subject list, though a few are noted (e.g., the figure of Christ with a book flanked by saints on fol. 59). A second manuscript, containing Bede's *Life of St. Cuthbert* and dating from the twelfth century, is identified with St. Mary's Cathedral in Coventry through an inscription on fol. 2. Now Cambridge, Trinity College MS. O.1.64, the manuscript contains two illuminations that illustrate the life of St. Cuthbert.[18]

The lost art of the county of Warwickshire is, of course, more extensive than can ever be recovered in such lists as the present ones. Nevertheless, information from records and antiquarian accounts should prove invaluable in visualizing the dimensions of the iconography of early art from the region. In the subject lists below, lost art has been indicated by means of an asterisk (*) following the medium code, and when it has not been possible or feasible to check the relevant documentary record, the source of information is indicated in brackets at the end of the entry. Descriptions derived from antiquarian sources (e.g., Thomas Fisher's early nineteenth-century drawings of the lost wall paintings at Stratford-upon-Avon) are also identified.

For extant art, iconographic descriptions are as full as possible within the scope of the subject lists, which by their nature require some condensation and selection of detail. Fortunately, it is possible to provide much more information than, for example, in *York Art*, which served as a pilot project for the series in which this volume appears. Nevertheless, donors are not listed here, though they are admittedly an excellent source of information about costume and armor, nor have the mayors of Coventry in the St. Mary's Hall glass been included. Some miscellaneous categories such as Animals involve a very selective listing.

Painted glass is located in windows according to the standard EDAM numbering system which designates the East Window as Win 1 and numbers consecutively thereafter on the north and south sides; hence the next window on the north side will be Win N2 while the corresponding window on the south will be Win S2. The lights in each window are numbered from left to right and are indicated after a decimal point; therefore, the third light in Window S2 would be numbered S2.3. The reference for the light may also be followed by the one of the following abbreviations: U=upper row; B=bottom row; M=middle row; T=top; Rfb=row from bottom (followed by number of panels from the bottom of the window); Rft=row from top; Tr=tracery.

The numbering system for misericords is consistent with the system for painted glass, and identifies each item according to north (N) or south (S) side. Thus the third misericord from the east on the north side would be N3. Similarly, the angels on the roof of Holy Trinity Church, Coventry, have been numbered from

east to west. However, no such numbering system has been deemed
practical in St. Mary's Hall, Coventry, since the great hall in
that building is not oriented from east to west as would be nor-
mal in the case of a church.

Other abbreviations, including identifications of medium,
are: al=alabaster carving; ba=banner; E=east; ESp=Easter Sepul-
cher; em=embroidery; fig=figure; il=illustrated in; im=image;
inv=inventory; iv=ivory carving; j=jewelry; msi=manuscript il-
lumination; N=north; ntd=noted in; pc=painted cloth; pclg=painted
ceiling; pg=painted glass; pl=plate; rb=roof boss; S=south;
sc=sculpture; st=saint; tp=tapestry; W=west; wdcarv=woodcarving;
wp=wall painting; win=window.

Locations are indicated by the following abbreviations:

Ansley	Ansley, Church of St. Lawrence
Arley	Arley, Church of St. Wilfrid (old church)
Arrow	Arrow, Church of St. James
Astley	Astley, Church of St. Mary the Virgin
Aston	Aston, Birmingham, Church of SS. Peter and Paul
AstonC	Aston Cantlow, Church of St. John the Baptist
Atherstone	Atherstone, Church of St. Mary
Austrey	Austrey, Church of St. Nicholas
BadClint	Baddesley Clinton, Church of St. Michael
Barton	Barton-on-Heath, Church of St. Lawrence
Beaudesert	Beaudesert, Church of St. Nicholas
Berkswell	Berkswell, Church of St. John the Baptist
Bickenhill	Bickenhill, Church of St. Peter
Billesley	Billesley, Church of All Saints
Bilton	Bilton, Church of St. Mark
Bir-Mus	City of Birmingham Museums and Art Gallery
Bir-StMn	Birmingham, Church of St. Martin, Bull Ring
BL	British Library
BM	British Museum
Bourton	Bourton-on-Dunsmore, Church of St. Peter
Brailes	Brailes, Church of St. George
Brinklow	Brinklow, Church of St. John the Baptist
Bulkington	Bulkington, Church of St. James
BurtonD	Burton Dassett, Church of All Saints
Caldecote	Caldecote, Church of SS. Theobald and Chad
C-FitzMus	Cambridge, Fitzwilliam Museum
Chadshunt	Chadshunt, Church of All Saints
Cherington	Cherington, Church of St. John the Baptist
Chesterton	Chesterton, Church of St. Giles
ChestH	Chesterton Hall (detroyed)
CliffChbrs	Clifford Chambers, Church of St. Helen (formerly in Gloucestershire)
Coleshill	Coleshill, Church of SS. Peter and Paul
CombeAb	Combe Abbey
ComptonV	Compton Verney, Church (demolished c.1850)
ComptonWy	Compton Wynyates

Corley	Corley, Church
Coughton	Coughton, Church of St. Peter
CoughtonCt	Coughton Court
C-Trinity	Cambridge, Trinity College
Cubbington	Cubbington, Church of St. Mary
Curdworth	Curdworth, Church of St. Nicholas
Cv	Coventry
Cv-Cath	Coventry, Cathedral of St. Michael (modern building)
Cv-Chrhs	Coventry, Charterhouse
Cv-CXiG	Coventry, Corpus Christi Gild
Cv-Ford	Coventry, Ford's Hospital
Cv-Herbert	Coventry, Herbert Art Gallery and Museum
Cv-GreyF	Coventry, Greyfriars
Cv-HspStJn	Coventry, Hospital of St. John the Baptist
Cv-HT	Coventry, Holy Trinity Church
Cv-HTG	Coventry, Holy Trinity Gild
Cv-KHVIII	Coventry, King Henry VIII School
Cv-Leofric	Coventry, Leofric Hotel
Cv-StJnB	Coventry, St. John Bablake Church
Cv-StMCath	Coventry, St. Mary's Cathedral (Priory Church of St. Mary) (destroyed)
Cv-STG	Coventry, Shearmen and Taylors Gild
Cv-StMH	Coventry, St. Mary's Hall
Cv-StNich	Coventry, Church of St. Nicholas
Cv-StMi	Coventry, Church (later Cathedral) of St. Michael
Cv-WhiteFr	Coventry, Whitefriars
GuyCliff	Guy's Cliffe, Church of St. Mary Magdalene (now Masonic Chapel)
Halford	Halford, Church of St. Mary
Haseley	Haseley, Church of St. Mary
Henley	Henley-in-Arden
Henley-GH	Henley-in-Arden, Gild Hall
Henley-StJ	Henley-in-Arden, Church of St. John the Baptist
HinewoodP	Hinewood Priory
Ilmington	Ilmington, Church of St. Mary
KenilP	Kenilworth Priory
Kingsbury	Kingsbury, Church of SS. Peter and Paul
Kinwarton	Kinwarton, Church of St. Mary the Virgin
Knowle	Knowle, Chapel of SS. John the Baptist, Lawrence, and Anne
Ladbroke	Ladbroke, Church of All Saints
LCompton	Long Compton, Church of SS. Peter and Paul
LItch	Long Itchington, Church of the Holy Trinity
L-RCF	London, Redundant Churches Fund
Mancetter	Mancetter, Church of St. Peter
Maxstoke	Maxstoke, Church of St. Michael
MaxstokeP	Maxstoke Priory
MervlAb	Merevale Abbey
Mervl-StM	Merevale, Church of St. Mary (formerly chapel-

8

	without-the-gates of Merevale Abbey)
Meriden	Meriden, Church of St. Lawrence
Middleton	Middleton, Church of St. John the Baptist
NewnhamR	Newnham Regis, Parish Church (destroyed)
NewtonR	Newton Regis, Church of St. Mary
Nun-StM	Nuneaton, Church of St. Mary (Priory Church)
Nun-StNich	Nuneaton, Church of St. Nicholas
NWhitacre	Nether Whitacre, Church of St. Giles
Oxhill	Oxhill, Church of St. Lawrence
Packwood	Packwood, Church of St. Giles
Polesworth	Polesworth, Church of St. Edith
Preston	Preston-on-Stour, Church of St. Mary (originally in Gloucestershire)
Radway	Radway, Church of St. Peter
Ratley	Ratley, Church of St. Peter *ad vincula*
Rowington	Rowington, Church of St. Lawrence
SalfordPr	Salford Priors, Church of St. Matthew
Seckington	Seckington, Church of All Saints
Sheldon	Sheldon, Church of St. Giles
Shotswl	Shotteswell, Church of St. Lawrence
Snitterfld	Snitterfield, Church of St. James
Solihull	Solihull, Church of St. Alphege
Stoneleigh	Stoneleigh, Church of St. Mary
Str	Stratford-upon-Avon
Str-BTMus	Stratford, Birthplace Trust Museum
Str-GCh	Stratford, Gild Chapel
Str-HCG	Stratford, Holy Cross Gild
Str-HT	Stratford, Holy Trinity Church
Str-NPMus	Stratford, New Place Museum
Str-WtSHl	Stratford, White Swan Hotel
Studley	Studley, Church of the Nativity of the Blessed Virgin
Tysoe	Tysoe, Church of the Assumption of the Blessed Virgin Mary
Ufton	Ufton, Church of St. Michael
Unknown	Present location unknown
US-UNC	United States, Ackland Art Museum, University of North Carolina
War	Warwick
War-BCh	Warwick, Beauchamp Chapel
WarCastle	Warwick Castle
War-HspS	Warwick, Hospital of St. Sepulchre
War-StM	Warwick, Collegiate Church of St. Mary
War-StNich	Warwick, Church of St. Nicholas
Weston	Weston-under-Wetherley, Church of St. Michael
Whichford	Whichford, Church of St. Michael
Whitchurch	Whitchurch, Church of St. Mary
Willoughby	Willoughby, Church of St. Nicholas
Wilmcote	Wilmcote, Church of St. Andrew
Withybrook	Withybrook, Church of All Saints

Wixford	Wixford, Church of St. Milburga
Wolston	Wolston, Church of St. Margaret
Wolverton	Wolverton, Church of St. Mary
WoottonW	Wootton Wawen, Church of St. Peter
Ws	Warwickshire
WsMus	Warwickshire Museum, Warwick
Wroxall	Wroxall, Church of St. Leonard
Wyken	Wyken, Church of St. Mary Magdalene

NOTES

[1]See Charles Phythian-Adams, *Desolation of a City: Coventry and the Urban Crisis of the Late Middle Ages* (Cambridge: Cambridge Univ. Press, 1979), pp. 7-30 and *passim*.

[2]Hardin Craig, ed., *Two Coventry Corpus Christi Plays*, 2nd ed., EETS, e.s. 87 (1957); R. W. Ingram, ed., *Coventry*, Records of Early English Drama, [4] (Toronto: Univ. of Toronto Press, 1981).

[3]Civic piety is explored in another civic context in Clifford Davidson, "Northern Spirituality and Late Medieval Drama," in *The Spirituality of Western Christendom*, ed. E. Rozanne Elder (Kalamazoo: Cistercian Publications, 1976), pp. 125-51, 205-08.

[4]It has been suggested that the figure, who holds a branch, may be from a representation of the season of May, but the evidence is not conclusive. See, however, Bernard Rackham, "The Glass Paintings of Coventry and Its Neighbourhood," *Walpole Society*, 19 (1931), 100.

[5]Phythian-Adams, p. 130.

[6]See Davidson, "Northern Spirituality," *passim*.

[7]For a report on excavations at this site, see Brian Hobley *et al.*, "Excavations at the Cathedral and Benedictine Priory of St. Mary, Coventry," *Birmingham Archaeological Society Transactions and Proceedings* (1971), 45-139.

[8]Ingram, p. 488.

[9]R. B. Wheler, *Collections for the History of Warwickshire*, British Library MS. Add. 28,564, fol. 36.

[10]William Dugdale, *The Antiquities of Warwickshire*, 2nd ed. (London, 1730), pp. 445-47.

[11]*Minutes and Accounts of the Corporation of Stratford-upon-Avon*, ed. Richard Savage, Dugdale Soc., 1 (Oxford, 1921), p. 128.

[12]See Wilfrid Puddephat, "The Mural Paintings of the Dance of Death in the Guild Chapel of Stratford-upon-Avon," *Birmingham Archaeological Society Transactions and Proceedings*, 76 (1960), 30.

[13]*The County of Warwick*, Victoria County History (London: Oxford Univ. Press, 1947), IV, 142-43.

[14]See E. Clive Rouse, "A Wall Painting of St. Christopher in

St. Mary's Church, Wyken, Coventry," *Birmingham Archaeological Society Transactions and Proceedings*, 75 (1959), 36-42.

[15]See Richard Marks, "The Glazing of the Collegiate Church of Holy Trinity, Tattershall (Lincs.): A Study of Late Fifteenth-Century Glass-Painting Workshops," *Archaeologia*, 106 (1979), 133-56, where the canopies and female heads in Windows S5, S6, and S7 are attributed to the Twygge-Wodshawe workshop which Marks has identified at Tattershall and which, he believes, comes from Malvern. Work from this workshop has also been found by Marks at Gloucester Cathedral and Westminster Abbey.

[16]See R. K. Morris, "The Herefordshire School: Recent Discoveries," in *Studies in Medieval Sculpture*, ed. F. H. Thompson, Soc. of Antiquaries Occasional Papers, n.s. 3 (London, 1983), pp. 198-201. Morris' thesis is supported by George Zarnecki in the Sculpture introduction to the catalogue to the exhibition *English Romanesque Art, 1066-1200* (London: Arts Council, 1984).

[17]N. R. Ker, *Medieval Libraries of Great Britain*, 2nd ed. (London: Royal Historical Soc., 1964), p. 140; M. R. James, *A Descriptive Catalogue of the McClean Collection of Manuscripts in the Fitzwilliam Museum* (Cambridge: Cambridge Univ. Press, 1912), pp. 267-69.

[18]Ker, p. 54; M. R. James, *The Western Manuscripts in the Library of Trinity College, Cambridge* (Cambridge: Cambridge Univ. Press, 1902), III, 66-67. For discussion of the miniatures, see Malcolm Baker, "Medieval Illustrations of Bede's *Life of St. Cuthbert*," *Journal of the Warburg and Courtauld Institutes*, 41 (1978), 16-49.

SUBJECT LISTS OF EARLY ART
IN COVENTRY, STRATFORD–UPON–AVON, WARWICK,
AND LESSER SITES IN WARWICKSHIRE

COVENTRY

I. REPRESENTATIONS OF GOD, ANGELS, & DEVILS

GOD THE FATHER

Cv-Herbert wdcarv from decorated ceiling of Council Chamber, Cv-StMH, but probably originally from reredos (?Cv-WhiteFr). c.1400-50. Bearded Father is blessing (hands raised; R hand has 2 fingers extended). He is crowned & seated; head was surrounded by nimbus of rays & stylized clouds with 4 angels in spandrels. Clad in long robe with girdle. FIG. 1.

TRINITY (THRONE OF GRACE)

Cv-StMi wdcarv*, misericord. c.1465. Fig destroyed in 16c or 17c. Harris plausibly suggests presence of this fig through association with Gild of H Trinity & SS Mary, Jn Baptist, & Cath ("Misericords of Cv," p. 262).

Cv-StMH tp*. c.1510. Scharf in 19c suggested that fig removed by Protestants in early 17c was Christ in Majesty "judging from what now remains of a handsome throne and part of a richly embroidered mantle" (p. 446). But certainly scene was Trinity with slain Son on cross. This suggestion, advanced by A. F. Kendrick ("The Cv Tapestry," pp. 84, 89), is given substance from gild associations, especially H Trinity Gild of Cv, as well as word "Jehovah" in Hebrew above lost segment of tp. 8 angels, 4 with instruments of Passion & 4 in postures of adoration, remain. Il ibid., Pls. I-II. Replaced in 17c by fig of Justice, probably added by Sheldon workshop in Ws.

Cv-HT al*? S aisle. In 1519, Nich Burwey asked to be buried before "table of the Trinitie," presumably Father with slain body of Son. [Sharp, *Illustrations of . . . H Trinity Church*]

im* "on the Topp of the . . . Orgayns," ntd indenture of 1526. New organ, to be built by Jn Howe & Jn Clymmowe of London, was to have "Image of the Trinite," presumably Father with body of slain Son, above. [Sharp, *Illustrations of . . . H Trinity Church*]

Cv-StMi im*, Ch of St Tho. Im of "Trinitie," presumably with

13

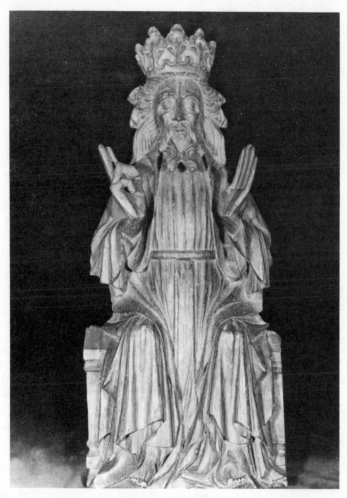

1. God the Father, from St. Mary's Hall (originally from ?reredos). Herbert Art Gallery and Museum, Coventry.

Father & body of slain Son, on S side of Ch; ntd indenture of Saddlers & Cardmakers, 8 Jan 1537. [Ingram]

Cv-HTG seal, Gild of H Trinity, SS Mary, Jn Baptist, & Cath. Above, Trinity. Father holds Christ on cross; dove is at side of Father. Below, BVM & Child, & St Jn Baptist. Il Aylesford Collection: Ws Country Seats, I, 262.

Cv-StMH pg*, formerly in "some Rooms beyond the Mayoresses Parlor." In 1719, Humphrey Wanley believed Trinity had formerly been placed next to BVM & Child; by then this panel, he reported, consisted "of other Glass ill patched together." [Transcription by M. D. Harris in Coventry Local Studies Centre]

SYMBOLS OF THE TRINITY

Cv-StMi pg. Early 15c. Shields held by angels have symbol of Trinity with text "pater est deus," "pater non est filius," etc. [Rackham]

Cv-HT painted spandrel, roof of nave (W1). 15c. 2 angels painted on spandrel support shield with symbol of Trinity.

ANGELS

Cv-StMH sc, corbel in kitchen. Late 14c. Angel bearing shield with initials JP (for ?John Percy, fl. 1392).

Cv-KHVIII wdcarv, misericord, from Henry VIII's Grammar School; formerly in Cv-HspStJn & possibly originally in Cv-WhiteFr. c.1400. Angels in albs peep around shield which has arms—within a bordure, 2 bendlets joined by saltire between 2 annulets—of John Onley, mayor of Cv in 1396 & 1418.

Cv-HT wdcarv, misericord N3; formerly in Cv-HspStJn but possibly in Cv-WhiteFr originally. c.1400. Bust of angel, center, dressed in garment of square cut with border of rosette. Hands clasped in front. Additionally, some elbow rests have angels, though most are modern replacements. FIG. 2.

Cv-Cath pg St Michael's Hall; formerly in Cv-StMi. Early 15c. 6 angels, in patterned garb & with 6 wings, standing on wheels & holding scrolls above heads with inscriptions. Each has cross diadem & amice at neck. 3 against blue ground & 3 against red. One fig il Rackham, Pl. XVI.

Cv-Herbert wdcarv from decorated ceiling of Council Chamber, Cv-StMH; probaby originally from reredos (?Cv-WhiteFr). c.1400-50. Seated fig in alb is holding scroll across lap. L wing is broken. Probably Evangelist symbol.

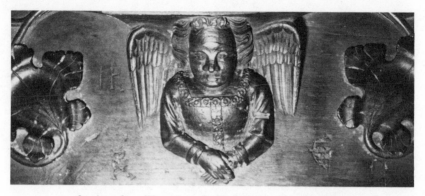

2. Angel. Misericord, Holy Trinity Church.

wdcarv from decorated ceiling of Council Chamber, Cv-StMH, but probably originally from reredos (?Cv-WhiteFr). c.1400-50. 4 angels in spandrels of nimbus surround head of God the Father (see GOD THE FATHER, above). They are clad in albs with cross diadems, & have hands raised. Some damage to wings & diadems. Il Lancaster, *St. Mary's Hall*, 2nd ed., p. 18.

Cv-StMi wdcarv*, misericord, destroyed 1940. c.1465. Feathered angel holds shield with cross of St Geo. Il Harris, "Misericords of Cv," Pl. XXXII. Also, angel elbow rest on one seat.

Cv-StMH pg, Gt Hall, oriel win, moved to this location in 1893 from anr location in bldg. 14-15c. Several fragments.

Cv-StMi pg, formerly in apse & S nave clerestory windows; now in Bp Haigh Ch. Several fragments of angels with wings & feathers; also some complete examples. Il Chatwin, "Medieval Stained Glass" (1950), Pl. IV.

Cv-HT painted spandrels, roof of nave. 15c. Kneeling angels hold glass vessel (W3), reed plant (W7), & trinitarian emblem (W1) as well as Christ's wounds & emblems of Passion on shields. See also FIVE WOUNDS & SIGNS OF PASSION, below, & SYMBOLS OF TRINITY, above.

 sc, tomb, N aisle. Late 15c. Demi fig of angel bearing 2 souls (see SOULS OF DEPARTED, below). Angel's head is missing.

Cv-StMH tp. c.1510. 4 demi angels in clouds in top of panel adoring central fig (replaced by fig of Justice). 4

angels also hold Instruments of Passion. See INSTRU-
MENTS OF PASSION, below. Il Kendrick, "The Cv Tapes-
try," Pls. I-II.

Cv-StMi sc*, alabaster tomb of Julian & Johanna Nethermyl;
formerly in Drapers' Ch. 1539. Destroyed 1940. 2
kneeling angels in albs as supporters of shield with
arms on end of tomb. Il Chatwin, "Monumental Ef-
figies," III (1925), Pl. XXII.

Cv-StMi wdcarv*, destroyed 1940. 16 angels on roof.

ANGEL MUSICIANS

Cv-StMH wdcarv, roof of Gt Hall. c.1390-9. Angel musicians,
some in albs & all with cross diadems, playing rebec
with curved bow, lute, harp, trumpet (fragmentary),
bagpipe (mouthpiece missing), pipe (possibly re-
corder). Anr has lost instrument. 2 further are
without instruments & have hands raised & wings re-
stored. Only harp player has intact wings. Removed
during WWII & restored to different sites on roof from
those recorded by Harris in 1898. Repainted. FIGS.
62-65; see also Crossley, *English Church Craftsman-
ship,* Pl. 156.

pg, Gt Hall, oriel win, Light 5T; moved to this lo-
cation in bldg. 15c? Hands, probably from angel
musician, playing psaltery. L hand is fairly com-
plete; portion of R hand only.

DEVILS

Cv-StJnB pg*. Early 16c. Fragments noticed in 1930 contained
devil with large head, long nose, short legs; Harris
reported that he had "star-shaped addition to cap"
(*Some Manors*, p. 232). Above it was dog scratching
self. Win also contained head of angel. [Harris,
Romance of Two Hundred Years & *Some Manors*]

18

II. OLD TESTAMENT

CONCLUSION OF FLOOD

Cv-StMCath seal. On reverse side, ark on water; Noah looks forth
& is taking hold of olive branch brought by dove, a-
bove. Inscription: "SIGNUM CLEMENTIE DEI." Other side
of seal has BVM suckling Child at breast. Il Wheler,
Collections, fol. 36.

MOSES AND TEN COMMANDMENTS

Cv-StMi al*? Ch of St Tho, ntd indenture of Cardmakers & Sad-
dlers, 8 Jan 1537: "Item a table of the Mounte of Sy-
nay." Possibly Moses receiving 10 Commandments. [In-
gram]

PROPHETS

Cv-StMH pg, Gt Hall, oriel win; moved to this location in 1893
from elsewhere in bldg. 14-15c. 2 unidentified pro-
phets. Head of one only (wearing cap); for second,
torso, wearing white cloak with yellow hem, only is
extant.

DAVID AS MUSICIAN

*An actor playing the role of K David helped to welcome Q
Margaret in 1456.*

Cv-KHVIII wdcarv, misericord, formerly in Cv-HspStJn & possibly
originally in Cv-WhiteFr. c.1400. On L of miseri-
cord, seated fig of David as crowned king is playing
harp; he wears long robe & mantle. Center fig is goat
with sun (Sol in Capricorn); fig on R is man before
trestle table with dishes spread; he is feasting, with
R hand raised & L hand holding food. Harris, "Miseri-
cords of Cv," speculates that "this fig evidently in-
dicates the feasting proper to Christmas."

JESSE TREE

Cv-StMi wdcarv*, misericord, destroyed 1940. c.1465. Figs
covered entire surface of misericord. BVM, center,
with Child. At R of BVM, David held harp. Tree
emerged from large fig of Jesse, lying at bottom, &
extended upward to 5 figs in center & 4 on each side.

Some heads were missing. For Jesse tableau over
Bablake Gate in 1456 for Margaret of Anjou, see *Cv
Leet Book*, p. 287. FIG. 3.

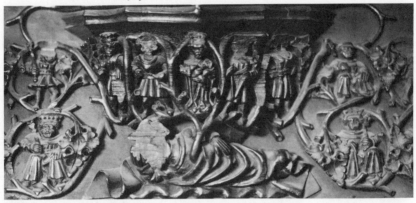

3. Jesse Tree (detail). Misericord, St. Michael's Cathedral
(destroyed). Courtesy of Royal Commission on Historical Monu-
ments (England).

III. PARENTS OF VIRGIN & HER LIFE (TO NATIVITY)

IMMACULATE CONCEPTION

Cv-HT wdcarv, misericord S3; formerly in Cv-HspStJn, but possibly in Cv-WhiteFr originally. c.1400? Closed door with tracery panels, under vault of battlemented canopy; on each side, a rose. Probably symbolizes Immaculate Conception. Harris, "Misericords of Cv," pp. 252-3, cites Ezekiel 44.2: "Then said the Lord unto me: This gate shall be shut, it shall not be opened, and no man shall enter in by it; because the Lord . . . hath entered in by it, therefore it shall be shut" (AV). FIG. 4.

4. Closed door representing Immaculate Conception. Misericord, Holy Trinity Church, Coventry.

ST ANNE

Cv-Chrhs seal, Carthusian Priory of St Anne. 1436. R, St Anne holding book in R hand & pointing to it with L hand. On L is BVM with Christ Child. *Catalogue of Seals*, No. 3009.

Cv-StMH tp. c.1510. St Anne, wearing red gown & blue mantle & head covering, holds staff in L hand & open book in R. No nimbus.

ST ANNE TEACHING BVM TO READ

Cv-StMi sc*, formerly on tower (replaced 19c). 14c. Standing

fig (L) of St Anne (with veil over long hair) holds
book; young BVM on R. St Anne teaching Virgin to
read, presumably.

Cv-Chrhs wp. c.1415? Large-scale fig destroyed above waist by
 insertion of later ceiling. Seated fig of St Anne,
 clad in fur-edged robe, holds book, which she is show-
 ing to (obliterated) Child at her side. She is point-
 ing out characters with R hand; on book are words
 "Domino labia [mea aperies]." Il Turpin, "Ancient
 Wall-Paintings," p. 250.

BLESSED VIRGIN MARY

*In addition to her appearance in pageants of Shearmen & Tay-
lors, Cappers, & Weavers, BVM was also represented in Corpus
Christi procession, 1539-46.*

Cv-HTG im* on mazer belonging to H Trinity Gild. Inv of 1441
 records "maser with an ymage of owre lady in the
 prynte" (printe=small disc, probably of silver, in
 bottom of bowl of mazer). [Templeman]

Cv-StJnB al*, St Mary's Altar. Ntd, churchwardens' accounts,
 1462. Alabaster statue of BVM bought from sculptor
 from Burton-on-Trent at 40s and additionally 7s for
 base, for Lady Ch altar. [Fretton, "The Collegiate
 Church of St. John the Baptist"]

Cv-WhiteFr im*, exterior of Lady's Tower, "richly paynted." Anr
 im* of BVM & altar dedicated to her inside, "whereat
 most travellers wh'ch passed by did offer more or
 lesse, out of confidence that their journey would be
 the better blest" (Dugdale, as quoted by Fretton, "Me-
 morials of the Whitefriars," p. 72). For examples of
 offerings to "Owre Lady of the Towre," see Stevenson,
 Report on the Manuscripts of Lord Middleton, pp. 334,
 354, 357.

ANNUNCIATION

See Shearmen & Taylors' Play, ll. 47-99.

Cv-StMH sc, exterior, gateway inner arch, W corbel. c.1390.
 Poor condition. Standing fig of Virgin in simple
 waisted gown & with hands joined over lap. Lily pot
 is still visible though very worn. Angel also very
 worn. 2 further badly worn figs to R of BVM. As
 early as 1789 this example was already said to be
 "mouldering away." FIG. 5.

22

5. Annunciation. Corbel, gateway of St. Mary's Hall, Coventry,
showing deteriorated condition. By permission of the Coventry
City Council.

IV. THE INFANCY OF CHRIST

BVM & CHILD

Cv-Herbert wdcarv from decorated ceiling of Council Chamber,
Cv-StMH, possibly from reredos (?Cv-WhiteFr). c.1400-
50. Seated fig of BVM on bench. She is crowned, clad
in kirtle & mantle with belt, & holding staff (broken)
in L hand. Child, seated on her R hand, is dressed in
simple drapery; he proffers vessel (broken) with both
hands. Il Lancaster, *St. Mary's Hall*, 2nd ed., p. 63.

Cv-Chrhs seal of Carthusian Priory of St Anne. 1436. L,
standing BVM (crowned), with Child on R arm & with
scepter in L hand. *Catalogue of Seals*, No. 3009.

Cv-StMH wdcarv, relief on side of Gild Chair. c.1450. BVM &
Child, who is held on her L arm. Above, fig of demi
angel. Il Pevsner, *Ws*, Pl. 16.

 pg*, formerly in "Some Rooms beyond the Mayoresses
Parlor." In 1719, Humphrey Wanley saw fragmentary
"B.V.M. & the little Jesus." [Transcription by M. D.
Harris in Cv Local Studies Centre]

Cv-StMi wp*, discovered following 14 Nov 1940 bombing.
Crowned BVM (with nimbus) held Child (with nimbus) on
L arm. Il Borenius, fig. 2.

Cv-StMCath seal. Seated BVM & Child suckling at her breast. In-
scription: "SIGILLUM SANCTA MARIE DE COVENTRIA." Il
Wheler, *Collections*, f. 36; cf. Aylesford Collection:
Ws Country Seats, I, 262.

Cv-HTG seal, Gild of H Trinity, St Mary, St Jn Baptist, & St
Cath. BVM is standing & holding Child on R arm (L);
above, Trinity; at R, Jn Baptist. Il Aylesford Col-
lection: Ws Country Seats, I, 262.

ADORATION OF MAGI

 *Magi's adoration of Child is dramatized in Shearmen & Tay-
lors' pageant, ll. 699-767. Magi also appeared at Cross
Cheaping as part of royal entry for Edw IV in 1474. Relic
of "thre kynges of Colleyne" in Cv-StMCath.*

Cv-STG seal of Gild of Shearmen & Taylors. Magi on L: 2
kings crowned & holding gifts; anr with crown removed

& kneeling before Christ Child who is reaching out
toward gift with R hand. Star above. Child is seated
(nude) on lap of seated & crowned BVM. FIG. 6.

6. Magi and Virgin Mary with Child. Seal of Shearmen and Tay-
lors, Coventry. Aylesford Collection. Reproduced by permission
of the Reference Library, Archives Department, Birmingham Public
Library.

V. CHRIST'S MINISTRY

JOHN THE BAPTIST

One of patrons of combined Gild of H Trinity, St Mary, St Jn Baptist, & St Cath.

Cv-HspStJn seal, from Hosp of St Jn Baptist. 14c. St Jn Baptist holds plaque with Agnus Dei in L hand, & is pointing to it with R hand. *Catalogue of Seals*, No. 3010.

Cv-Herbert wdcarv from decorated ceiling of Council Chamber, Cv-StMH; probably originally from reredos (?Cv-WhiteFr). c.1400-50. Bearded St Jn wears belted tunic with cloak over it & legs bare. He holds book with lamb in L hand; R hand is held to his chest. FIG. 7.

Cv-StJnB pc*, St Jn's Ch, painted by Tho Garden[er]. 1474. Included im of Jn Baptist. [Sharp, *Bablake Church*]

Cv-StMH tp, L panel. c.1510. Jn, with nimbus, wears red mantle over camel skin, head visible. He holds book with lamb with cross & pennon in L hand. Il Pevsner, *Ws*, Pl. 18.

pg, reported in 1719 by Humphrey Wanley in "Some Rooms beyond the Mayoresses Parlor." Early 15c? Fig of Jn Baptist. Wanley described this glass as "Painted very finely; but now all almost gone, excepting some few saints wanting half their Bodies, &c." [Transcription by M. D. Harris in Cv Local Studies Centre] Possibly fragment of this fig--hand holding Agnus Dei on book, & also portion of camel skin--was inserted in oriel win in Gt Hall, & was hence all that remained after 1893.

BEHEADING OF JOHN THE BAPTIST

Cv-StMi wdcarv*, misericord, destroyed 1940. c.1465. Probably beheading of Jn Baptist on supporter, R. Executioner, behind st, was removing sword from scabbard; he wore laced coat & scalloped work on shoulders. Martyr, kneeling, prepared for blow. [Harris, "Misericords of Cv"]

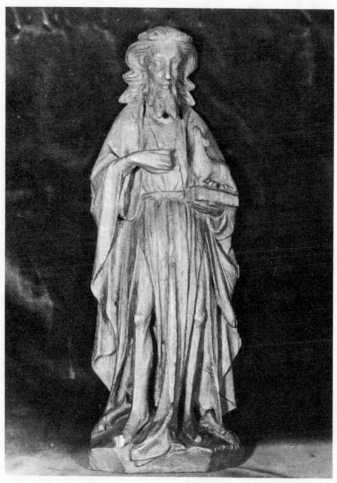

7. John the Baptist, from St. Mary's Hall (originally from ?reredos). Herbert Art Gallery and Museum, Coventry.

AGNUS DEI

Cv-StMi pg, Bp Haigh Ch; formerly in Win S3. 15c. Agnus Dei ntd by Sharp in 1818; kneeling Lamb (facing R) has cross nimbus. Il Rackham, Pl. XVI.

VI. THE PASSION

Passion pageant presented by Smiths, whose documents from 15c record following characters: Jesus, Annas, Caiaphas, Herod, Judas, Malchus, Pilate, Procula, Pilate's son, Peter, a porter (also identified in 1489 as "Dycar, the bedyll"), a devil, & soldier tormentors.

BETRAYAL

Cv-StMi pg, fragmentary. c.1350-99. Scene was ntd in fragmentary condition by Sharp in 1818; extant fragments show turbaned man in beard (representation of Jewish priest, presumably) grasping Christ's L shoulder & his arm while Judas, at L, kisses him. Anr fig also depicted. FIG. 8.

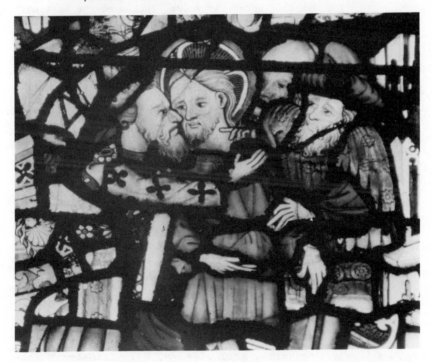

8. Betrayal. Painted glass from St. Michael's Cathedral, Coventry. Courtesy of Royal Commission on Historical Monuments (England).

SCOURGING

Cv-StMi pg, Bp Haigh Ch; formerly in S clerestory win.
 c.1350-99. Current scene is made up from fragments:
 torso of Christ with cross nimbus & clad in loincloth
 with hands bound behind back; 4 other figs, one with
 ?scourge arranged around Christ. Torturers were re-
 ported in Win S3 in 1913, when they were described as
 having "red faces." Faces are colored (one is blue).

VERNICLE

Cv-HTG im* on mazer belonging to H Trinity Gild. Inv of 1441
 records "maser with a vernycle." [Templeman]

PASSION

Cv-StMi pc*? Ch of St Tho. Cardmakers & Saddlers' indenture
 of 8 Jan 1537 notes "ij Auter Clothes of the passion."
 Also listed in this document are "ij pagiont Clothes
 of the passion." [Ingram]

FIVE WOUNDS

Cv-HT painted spandrel, roof of nave (E2). 15c. Kneeling
 angels painted on spandrel hold shield with 5 wounds
 (heart in center, feet below, hands above). FIG. 9.

9. Five Wounds. Spandrel, roof of nave, Holy Trinity Church,
Coventry.

Cv-StMi pg, formerly in Win S3. 15c? Shield with 5 wounds,

with middle wound in heart, held by feathered angel. [Rackham]

sc*, on alabaster tomb of Eliz Swillington (d. 1546) & 2 husbands. c.1540. 5 wounds on square shield held by feathered angels, each with 2 pairs of wings. Beneath wounded heart (mutilated) was kneeling angel with chalice, into which blood dropped. Also, angels stood at each side of panel. Il Chatwin, "Monumental Effigies," III (1925), Pl. XXIV.

SIGNS OF PASSION

Cv-HT painted spandrels, roof of nave. 15c. Kneeling angels painted on spandrels support shields, which contain instruments of Passion: robe & 3 dice (W2); cross (W4); ladder (W5); 2 scourges (W6); staff with sponge & lance (E3); hammer & 3 nails (E4); cross raguly (E5); pincers (E6); crown of thorns (E8). Additionally, E1 & E7 have inscription "ihs" on shield, while W8 has "XPi." See also FIVE WOUNDS and ANGELS. FIGS. 10-11.

10. Signs of the Passion. Hammer and Nails. Spandrel, roof of nave, Holy Trinity Church, Coventry.

Cv-StMH tp. c.1510. Instruments of Passion are held by 4 angels in central panel, above. Beneath is fig of Justice, a replacement for original fig (Trinity) & dating from Protestant period. Instruments of Passion held by angels are (L to R): (1) cloth & crown of thorns; (2) spear & sponge (in R hand), pincers & hammer (in L); (3) pillar (in R arm) & scourge (in R

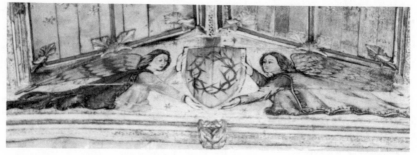

11. Signs of the Passion. Crown of Thorns. Spandrel, roof of nave, Holy Trinity Church, Coventry.

hand), 2 batons or sticks (in L hand); (4) cross (in L arm) & 3 nails (in R hand). Il Kendrick, "The Cv Tapestry," Pls. I-II.

Cv-StMi sc*, on alabaster tomb of Eliz Swillington (d. 1546) & 2 husbands. c.1540. Side panels had shields held by feathered angels with signs of Passion: IHC emblem, sponge, crown of thorns, scroll (inscription lost), scourge, anr scourge (of reeds), possibly palm of hand, 3 dice, cross, 3 nails, hammer, & mutilated spears. Il Chatwin, "Monumental Effigies," III (1925), Pl. XXIV; Aylesford Collection: Ws Churches, I, 86.

JESUS

Cv-StMi wp*, uncovered in bombing of 14 Nov 1940. 13c. Head of Christ only. Il Borenius, "Wall Paintings," fig. 1.

pg, formerly in Win N3; undergoing restoration prior to redisplay in CvCath. 15c. 2 heads, each with cross nimbus & crown of thorns.

CRUCIFIXION

Cv-StMi pg, formerly in Win S3. 15c. Fragments extant: head of Christ crowned with thorns, legs, wounded side, R hand.

sc*, alabaster tomb of Julian & Johanna Nethermyl. Formerly in Drapers' Ch. 1539. Defaced crucifix, destroyed in bombing in 1940. The Crucifixion was depicted on scroll, center, above shield with Nethermyl arms. On each side were parents & children, all

kneeling in adoration. Il Chatwin, "Monumental Effigies," III (1925), Pl. XXI.

Cv-HT im*, Mercers' Ch, removed 1645. Ntd churchwardens' accounts. Crucifix "on the Topp" of ch. [Sharp, *Illustrations of . . . H Trinity Church*]

CRUCIFIXION WITH MARY & JOHN

Cv-Chrhs wp, painted room. c.1415. Fragments only remain, with Crucifixion; St Jn (beardless & holding book) & BVM (now lost) were figs at foot of cross. St Jn has nimbus & brooch on garment at neck. Angel collects blood from L foot in chalice; anr (mostly lost) is collecting from R foot. Single nail through R foot (on top) & L foot (underneath). Soldiers are in plate armor, one with overgarment & other with short mantle at Christ's L. One soldier, who also has helmet & holds battle axe, points toward Crucified Christ with one finger. Inscription above soldier reads: "Ecce filius dei erat. . . ." A soldier also holds pennon. Is it Longinus, & also perhaps anr soldier who helped to guide spear? Il Turpin, "Ancient Wall Paintings," Pl. facing p. 252.

Cv-StNich sc*, metalwork. Ntd inv of Corpus Christi Gild, 1502. Crucifix with Mary & Jn "of Syluer & parte gyld lakyng a deadym." [Ingram]

Cv-StJnB sc*, metalwork. In 1519, Gild records note that goldsmith was paid "for mendyng the crosse, for mary and John were losse & the deodem was off, and setyng it on again." Perhaps this cross was the one used in processions, ntd Gild accounts for 1518, on St Geo's day, Ascension, Pentecost, & Corpus Christi. [Sharp, *Bablake Church*]

Cv-StMi pax*, Ch of St Tho. Ntd Cardmakers & Saddlers' indenture of 8 Jan 1537. Pax with Crucifixion & Mary & Jn. Anr pax* also had "a Crosse of Iverey." [Ingram]

Cv-HT wdcarv*, taken down in 1559. Ntd Churchwardens' Accounts, 1559: "payd for takyng downe þe rode & marie & Ihon iiij s iiij d." WRO DR 581/45.

Cv-Herbert pg, from Cv-Ford. Early 16c. Only BVM & St Jn remain. BVM, facing R, holds up R hand, palm out, & with L wipes tears from L eye. St Jn, facing L, seems to hold up hands (joined) before his face in prayer; he is bareheaded, wearing mantle with embroidered

edging over tunic. Il Rackham, Pl. XVI.

OUR LADY OF PITY

Cv-StMi im*, Ch of St Tho. Cardmakers & Saddlers' indenture
of 8 Jan 1537 notes "pax of Ihesus of Marie of petie."
[Ingram]

IMAGE OF PITY

BM j, ring (gold), found in 1802 & in possession of Tho
Sharp in 1816. (Copy of ring is currently in Cv-
Herbert.) Late 15c. Savior rising from sepulchre,
with emblems of Passion. Also shows wounds, with
wound in side identified as "the well of ewerlasting
lyffe," 2 other wounds as "the well of confort" & "the
well of gracy," & also 2 as "the well of pitty--the
well of merci." Inscription inside ring: "Wulnera
quinq dei sunt medicina michi, pia crux et passio x̃pi
sunt medicina michi, Jaspar, Melchior, Baltasar,
ananyzapta tetragrammaton."

Cv-GreyFr im* of Our Lord, ntd will of Rich Verney, who ordered
that "his Executor should cause to be made five
lights" which should be placed "before the Picture of
our Lord, in the *Grey Friers* Church" in honor of the 5
wounds. Possibly this im was Image of Pity. He also
provided "100 marks to enlarge the Rood Chapel there,
that people might have more room to see the devotion
there." [Sharp]

HARROWING

*Harrowing was included in Cappers' pageant; dramatic records
from this gild include costumes for & payments to "the
sprett of god," presumably Anima Christi, from 1534 to
1579.*

Cv-StMi pg, formerly in Win S3 & now in Bp Haigh Ch. 15c.
Fragmentary. Christ is missing, but portion of hell
mouth is extant, as are Adam & Eve with other nude
figs. Il Rackham, Pl. XVI; Chatwin, "Medieval Stained
Glass" (1950), Pl. VI.

EASTER SEPULCHRE

Cv-StJnB ESp*, ntd in accounts for 1469, when Jn Kerver was
paid 26s 9d for making it. The ESp was sold in 1551
to Henry Moore for 13s 4d. [Sharp, *Bablake Church*]

Cv-HT ESp*, ntd inv of 21 Jan 1559: "It' ii peyntted clothes ffor ye seypoulkur." Constitutions of 1452 indicate that first deacon's office was to watch "sepulcur, on Astur evyn, tyll ye resurrec'ion be don, then he and hys ffelow schall take downe ye lenttyn clothys abowte ye Awter, and a ffor ye rode." [Sharp, *Illustrations of . . . H Trinity Church*]

VII. THE RISEN CHRIST

RESURRECTION

Cv-Cath pg, St Michael's Hall; formerly in Cv-StMi, win in S clerestory. 15c. Restored. Christ, with cross-nimbus, crown of thorns, & bleeding wounds, holds cross-staff with banner as he steps out of coffer tomb; 4 sleeping soldiers in contemporary plate armor. He steps onto body of one soldier. Il Chatwin, "Medieval Stained Glass" (1950), Pl. V.

ASCENSION

Cv-StMi pg, formerly in win in S clerestory. 15c. Possibly Ascension. Fragment shows 4 (or 5) heads of Apostles with haloes closely grouped together. [Rackham]

DOVE OF HOLY SPIRIT

Cv-StMi pg, undergoing restoration prior to redisplay in CvCath. 15c. Dove of H Spirit.

VIII. CONCLUSION OF THE LIFE OF THE VIRGIN

ASSUMPTION OF BVM

Cv-StMi wdcarv*, misericord. Destroyed 1940. c.1465. BVM in
 aureole with 4-winged feathered angel at her L. Long
 robe & mantle clothed her, & she wore 2 brooches.
 Supporters also had 4-winged feathered angels. Il
 Harris, "Misericords of Cv," Pl. XXXI.

Cv-StMH tp. c.1510. Assumption, with group of 12 Apostles.
 BVM, supported by 4 angels, is encircled by clouds;
 she has long hair & wears patterned garment under blue
 mantle. Her hands are joined as in prayer. There are
 2 further angels beyond clouds, & she stands on
 shoulders of anr angel holding crescent moon beneath
 her feet. King Henry VII & his queen, Eliz, with two
 groups of attendant figs. Il Pevsner, *Ws*, Pl. 18.

CORONATION OF BVM

Cv-StMH rb*, Gate House, exterior, center boss. c.1390.
 Bas-relief; present rb is modern replacement of post-
 1878-9. BVM (with long hair) on L had hands joined in
 position of prayer; deity on R (bearded) was placing
 crown on her head with R hand (he held orb with L
 hand). Both were seated on bench. Il Carter, *Ancient
 Sculpture*, I, Pl. following p. 15.

Unknown wdcarv, on front of chest formerly in Cv-StMi.
 c.1500. God, seated on R (crowned), is placing
 crown on BVM seated at L. Il Hart, p. 81, where figs
 are (wrongly) identified as Henry VIII & Q Eliz.

IX. THE LAST JUDGMENT

SOULS OF THE DEPARTED

Cv-HT sc, tomb, N aisle. Late 15c. Demi fig of angel bearing 2 souls (heads missing) in folds of cloth.

LAST JUDGMENT (MATTHEW 25 ACCOUNT)

> *Drapers' pageant of Last Judgment in 16c included following characters: God, angels, patriarchs, pharisee, worms of conscience, devils, & good & evil souls.*

Cv-StMi wdcarv*, misericord. Destroyed 1940. c.1465. Central scene showed Christ, seated on rainbow which was given support by clouds. Feet were placed on world. 2 angels blew trumpets. On each side on supporters, figs rose from graves, emerging from coffins. Mutilated. Harris, "Misericords of Cv," p. 264, notes connection of scene with Corporal Acts of Mercy & Dance of Death illustrations in misericords at Cv-StMi. FIG. 12.

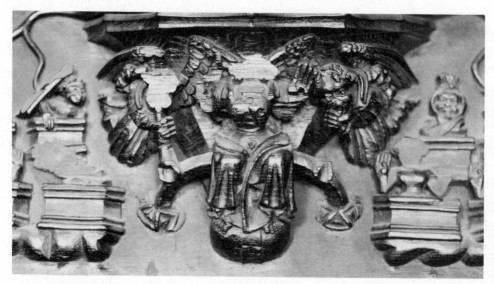

12. Last Judgment. Misericord, St. Michael's Cathedral (destroyed), Coventry. Courtesy of Royal Commission on Historical Monuments (England).

Cv-HT wp*, over W crossing arch, head of Christ still vi-
sible but otherwise entirely black. Discovered 1831,
wp is described by Poole: "In the centre is our Sa-
viour clothed in a crimson robe, seated, as would
appear, on a rainbow, with the earth as his footstool.
Below are the Virgin Mary and St John the Baptist, and
the twelve Apostles, arranged six on each side. Two
angels are sounding the summons to judgment, and the
tombs are giving up their dead. On the right side of
our Saviour is shown a flight of steps leading down to
a portico, over which angels are looking down on the
dread scene; while others are engaged in giving wel-
come reception to the figure of a man wearing a tiara,
and evidently intended to represent a Pope, who, hav-
ing passed St. Peter, may be supposed the first per-
mitted to enter heaven. On the left hand of the Judge
are the unhappy spirits [sic] condemned to exclusion
from the abodes of bliss, and who, in the most unac-
countable attitudes, are being removed by devils to
the place of torment" (pp. 76-77). Carved demon in
lower R remains as part of latter scene. Il Scharf,
"Observations," Pl. XXXVI, fig. 1 (drawing).

Cv-StMi pg, formerly in Win S3 & now in Bp Haigh Ch. Frag-
ments extant include nude figs with hands raised or
joined in prayer, or with arms crossed over breasts.
One is shouting & rising from tomb. Il Chatwin,
"Medieval Stained Glass" (1950), Pls. VI-VII (de-
tails).

CORPORAL ACTS OF MERCY

Cv-StMi wdcarv*, misericords. Destroyed 1940. c.1465. 3
scenes only were extant: (1) Burying dead. 2 men
lowered body of dead man in shroud into grave while 2
mourners looked on, behind; anr fig behind at R was
priest, who held book & aspergillum, with which he
sprinkled dead man with holy water. Digging tools
(spade & pick) at edge of grave. Shroud had cross on
it. (2) Clothing naked. Man in turban & long gown
assisted kneeling fig to put on garment. Behind,
cripple with crutch; il Harris, "Misericords of Cv,"
Pl. XXXI. (3) Visiting sick. Man, with head bound,
on bed. Visitor gave gift. Anr visitor also present,
R. Woman in attendance, L. FIGS. 13-14.

Unknown pg, roundel, formerly from Cv. 15c. Wealthy citizen
(larger in size) gives food & drink to (smaller scale)
poor & handicapped, a scene which is apparently illus-
tration from Corporal Acts of Mercy series. One fig

has crutch (injured hand & leg), one crawls on knees, which are padded, with hand supports (he is also blind, & appears with dog), & anr (with one foot only) wears pilgrim's hat; fourth fig is mentally infirm, & fifth is poor friar. All carry wallets; 3 of them

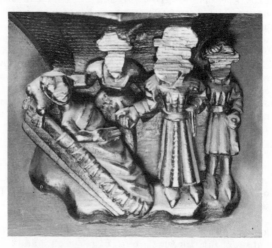

13. Corporal Acts of Mercy. Visiting the Sick. Detail of misericord, St. Michael's Cathedral (destroyed), Coventry. Courtesy of Royal Commission on Historical Monuments (England).

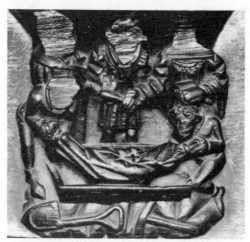

14. Corporal Acts of Mercy. Burying the Dead. Detail of misericord, St. Michael's Cathedral (destroyed). Courtesy of Royal Commission on Historical Monuments (England).

have staffs. Noticed by T[homas] S[harp] in 1793. Il
Read, *English Stained Glass*, Pl. 42.

ST MICHAEL

Cv-StMi sc*, exterior statuary, preserved *in situ* until bomb-
 ing in 1940. 14c. St. Michael. [Bird]

Cv-Herbert wdcarv from decorated ceiling of Council Chamber,
 Cv-StMH; probably originally from reredos (?Cv-
 WhiteFr). c.1400-50. Standing fig of St Michael in
 short tunic & kerchief at neck thrusts spear into
 dragon's mouth, its tail wrapped around his R leg.
 His L hand is resting on shield. R arm is broken off
 at elbow & part of spear is missing. FIG. 15.

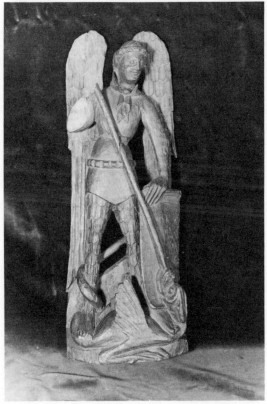

15. St. Michael, from St. Mary's Hall (originally from ?reredos),
Coventry. Herbert Art Gallery and Museum.

40

Cv-StMi wp*, formerly on cove between nave & chancel. St
 Michael, defeating Satanic beast. [Harris, *Story of
 Cv*]

CHAINING OF SATAN

Cv-StMi wdcarv*, misericord. Destroyed 1940. c.1465. Satan,
 whose head was horned & whose wings were batlike, had
 hairy body & claw feet. Scene was Chaining of Satan--
 a scene linked with Dance of Death & Doom series. An-
 gels in albs on supporters (mutilated) held chain. Il
 Harris, "Misericords of Cv," Pl. XXXII.

X. APOSTLES

See also Appendix I, below.

APOSTLES AS A GROUP

> *12 Apostles appeared in Corpus Christi procession 1539-46.*
> *"A smale shryne of the Appostells" in Cv-StMCath.*

Cv-StMH tp. c.1510. Apostles in 2 groups beside Assumption of BVM. See listings under APOSTLES (INDIVIDUAL FIGURES), below.

APOSTLES (INDIVIDUAL FIGURES)

St Andrew

Cv-StMH tp. c.1510. St Andrew appears with his saltire cross, which he holds in his L hand. Facing L & with nimbus, he wears patterned red garment under blue mantle.

St Bartholomew

Cv-StMH tp. c. 1510. St Bartholmew holding knife in R hand. Bust only visible, standing behind SS Simon & Andrew.

St James the Great

Cv-StMi sc*, formerly on tower (replaced in 1880's). 14c. St Js, standing & holding pilgrim staff in R hand. Purse was attached by strap over shoulder. Scallop shell emblem was present on hat.

St John the Evangelist

> *Actor representing St Jn Evangelist appeared inside the gate at the east end of Bablake Church as part of royal entry for Q Margaret in 1456.*

Cv-StMi im*, Ch of St Cath, ntd will of Wm Pysford the Elder, 1518, who wanted to be buried "before the ymage of sanct John the Evangelist." PRO: PROB 11/19, f. 67.

St Jude

Cv-StMH tp. c.1510. St Jude, in red gown under blue mantle, holds halbert in L hand & gestures toward it with R.

42

St has nimbus.

St Paul

Cv–StMH tp. c.1510. St Paul with sword held in L hand (point downward). Nimbed st wears blue robe. He gestures with R hand.

St Peter

Cv–StMH tp. c.1510. St Peter holding key in L hand. Bust only (behind SS Geo & Adrian). He has nimbus & wears red garment.

St Simon

Cv–StMH tp. c.1510. St with saw in R hand & open book in L. He wears blue garment under red mantle. Nimbus.

St Thomas

Cv–StMH tp. c.1510. Apostle, holding spear in L hand. Possibly St Tho. Bust only (behind SS Jn Baptist & Paul). He has beard & nimbus.

Cv–StMi pc*, Ch of St Tho, altarcloth "steyned *with* an Image of seynt Thomas," possibly apostle Tho. Ntd in Cardmakers & Saddlers' indenture of 8 Jan 1537. [Ingram]

pc*, Ch of St Tho. Ntd in Cardmakers & Saddlers' indenture of 8 Jan 1537, which lists "Cloithe of the liff of seynt Thomas," possibly apostle Tho. [Ingram]

FOUR EVANGELISTS (SYMBOLS OF)

Cv–Herbert wdcarv from decorated ceiling of Council Chamber, Cv–StMH; probably originally from reredos (?Cv–WhiteFr). c.1400–50. Fig of eagle holding one end of scroll in beak & standing on middle of it with both feet. Scroll (broken) curves around to cover tail. Il Lancaster, *St. Mary's Hall*, 2nd ed., p. 33. Also, angel, seated & holding scroll (see ANGELS, above).

XI. SAINTS

*Each saint in the list below is briefly described in order to
provide more positive identification. Reference is also made
whenever possible to the Herder* Lexikon der christlichen Ikon-
ographie *and to the* Sarum Breviary *(*Breviarium seu horarium
domesticum ad usum insignis ecclesie Sarum, Paris, 1531 *[STC
15830], referred to in the text below under the abbreviation*
SBr*). Dates for feast days in the Sarum calendar are also sup-
plied.*

St Adrian

> *Young soldier martyred in early 4c by having limbs crushed
> with anvil & then cut off.* Lexikon V.36-8.

Cv-StMH tp. c.1510. St, with anvil in R hand & sword in L,
 stands on lion. He wears armor with cloak over it.
 Nimbus.

St Agnes

> *Roman virgin martyred c.305 at 13 years when she refused
> marriage.* Lexikon V.58-63. SBr, II, ff. xv-xvii. *(Jan
> 21)*

Cv-StMH tp. c.1510. St, wearing brocade garment, holds palm
 in R hand & has leash held in L hand attached to lamb.
 Nimbus.

St Apollonia

> *Martyred at Alexandria, 249; her teeth were broken out prior
> to death by fire.* Lexikon V.231-6.

Cv-StMH tp. c.1510. St holds tooth in pincers in R hand &
 holds book in L. She has blue gown & long unbraided
 hair.

St Barbara

> *Syrian virgin placed by her father in tower as protection
> against suitors, but ultimately executed by him for refusing
> to marry.* Lexikon V.304-11.

Cv-StMH tp. c.1510. Barbara holds open book in R hand & palm
 branch in L. St has nimbus & wears blue garment under
 red mantle. Tower (her emblem) behind fig.

St Catherine of Alexandria

> *Virgin who withstood advances & tortures of tyrant Maxi-*
> *minus. Relic at Cv-StMCath. A patroness of combined Gild*
> *of H Trinity, St Mary, St Jn Baptist, & St Cath. In 1491 at*
> *Cv, there was "A Play of St Katherine in the Little Parke."*
> *Additionally, St Cath appeared along with St Margaret in*
> *Corpus Christi processions at Cv in 1539-42 & 1544-6. Lexi-*
> *kon VII.289-97. SBr, III, ff. clxxxvii-clxxxix. (Nov 25)*

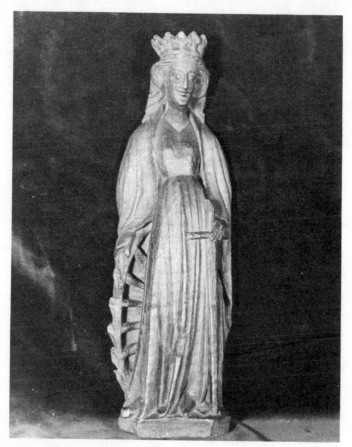

16. St. Catherine, from St. Mary's hall (originally from
?reredos). Herbert Art Gallery and Museum, Coventry.

Cv-Herbert wdcarv from decorated ceiling of Council Chamber, Cv-

StMH; probably originally from reredos (?Cv-WhiteFr).
c.1400-50. Standing fig of crowned st is clad in long
fitted gown with mantle over it. Her L hand rests on
sword hilt (sword is point down, resting on ground) &
R hand is on wheel. FIG. 16.

Cv-StMi im*, Ch of St Cath. Ntd in accounts of Gild of H
Trinity, St Mary, St Jn Baptist, & St Cath in 1457.
Candle was kept during feast of this st before im.
[Templeman]

wdcarv*, misericord. c.1465. Harris, "Misericords of
Cv," p. 262, suggests that fig of St Cath was present
prior to 16c or 17c. Her evidence is in series of
seats apparently devoted to sts & Trinity for whom
Gild of H Trinity & SS Mary, Jn Baptist, & Cath was
named.

Cv-StMH tp. c.1510. St, dressed in blue brocade garment
under red mantle, is crowned & has nimbus. She holds
open book in L hand, sword (point down) in R. Wheel
is behind st.

pg*, reported in 1719 by Humphrey Wanley in "some
Rooms beyond the Mayoresses Parlor." Early 15c. Fig
of St Cath was then extant with the following inscrip-
tion below it: "Orate pro an . . . Henrico Peyto
&" [Transcription by M. D. Harris in Cv Local
Studies Centre] Possibly this fig eventually strayed
into pg in oriel win in Gt Hall.

St Cuthbert

*According to tradition, St Cuthbert was originally a
shepherd converted by a vision of St Aidan's death in which
he saw that st borne to heaven by angels. He was designated
prior of Lindisfarne in 664; later, he retired to hermitage
on Farne Islands but was recalled to be Bishop first of
Hexam & then of Lindisfarne in 685. Shrine at Durham also
included head of St Oswald.* Lexikon VI.8-10. SBr, III, ff.
xxxvii-xxxix. (Mar 20)

C-Trinity msi, MS. 1088 O.1.64 [1088], ff. 9V-10. Late 12c.
Pencil underdrawing to 2 full page illustrations,
which show: (1) angel on horseback approaching young
Cuthbert (with nimbus), who is sitting at R in chair;
he is holding swollen knee in both hands. Anr nimbed
fig, behind. (2) Cuthbert & other fig in similar
posture; angel, now on foot, is touching Cuthbert's
knee. Il Baker, "Medieval Illustrations of Bede's

Life of St. Cuthbert," Pl. 3a.

St Dorothy

Virgin martyred during persecution of Diocletian. Following her beheading, she is said to have sent basket of flowers from paradise to Theophilus, who was then converted. Lexikon VI.90-2.

Cv-StMH tp. c.1510. St holds basket with roses in L hand. Wearing brown robe, she has nimbus & long hair in plaits. Facing L.

St Edmund, King of East Anglia

Martyred by Vikings, c.870, in Suffolk. Shot with arrows & decapitated; head thrown into bush, where guarded by wolf until found. His shrine was at Bury St Edmunds. Lexikon VI.107-8. SBr, II, ff. clxxxi-clxxxii. (Nov 20)

Cv-StMH pg*, Gt Hall, formerly in N win. 15c. Fragmentary inscription now in oriel window—"EDMUND DXIT"—possibly indicates original presence of fig of St Edmund.

St George

Patron st of England from time of Edw III. Golden Legend gives story of his encounter with dragon in defense of princess. For birth of St Geo in Cv, see [Robert Johnson,] The most Famous History of the seuen Champions of Christendome (London, 1608), p. 2: "for the famous Cittie of Couentrie was the place wherein the first Christian Champion of England was borne. . . ." Relic at Cv-StMCath. St Geo was included in royal entry in 1474 at conduit at Cross Cheaping: "seint George Armed and a Kynges doughter knelyng a fore hym with a lambe and the fader & the moder beyng in a toure a boven beholdyng seint George savyng their doughter from the dragon." This st also was represented at same location in 1498. St Geo's Day Procession was held annually. Lexikon VI.365-90. SBr, III, f. xlv. (Ap 23)

Cv-StMi sc*, formerly on tower (replaced in 1880's). 14c. St Geo, standing in helmet & armor, held spear in R hand (thrust into mouth of dragon, below) & shield with (?red) cross emblem on L arm.

Cv-HTG im* on cup. Ntd in inv of H Trinity Gild, 1441; im of St Geo is recorded on "gret stondyng Cuppe of Syluer . . . ouergilt." [Templeman]

Cv—StMCath im* of St Geo, with relic (bone), ntd list of relics at StMCath in BL Egerton MS. 2603, f. 26.

17. St. George, formerly in Chapel of St. George, Gosford Gate, Coventry. Herbert Art Gallery and Museum.

Cv-Herbert wdcarv, formerly in Ch of St Geo, Gosford Gate. c.1470-90. St Geo, on horseback (in full armor with visor open), holds reins in L hand & sword in raised R hand. Dragon trampled by horse clasps spear in claw & has tail wrapped around horse's back leg. Horse with trappings. Spear is missing. FIG. 17.

Cv-StMH tp. c.1510. St in armor with jupon & fashionable hat. He has nimbus, & holds staff with banner containing red cross emblem in R hand while he gestures toward it with his L.

St Gertrude of Nivelles

7th-century saint who refused marriage & retired to monastery at Nivelles, Brabant, where she became abbess. She was commonly invoked to guard against rats & mice. Lexikon VI.406-8.

Cv-StMH tp. c.1510. St, in brown habit & white robe, holds crozier & appears with emblem of 3 white mice. She has nimbus. This fig has also been identified as St Modwenna, for whom a monastery was built by royal command at Polesworth, Ws, where she was teacher of Princess Edith.

Henry VI (Unofficial Saint)

Noted for his piety & works of charity, K Henry (d. 1461) was widely venerated.

Cv-StMH pg, N Win, Light 5 (central position in win). c.1490. Crowned, with orb & cross in L hand, & sword in R hand. He is wearing surcoat with arms of France (modern) quartering England. Inscription: "Henricus." Fig is very restored with mostly modern glass from restoration in 1893 by Burlison & Grylls. Sharp's drawing of this glass was made prior to 1793 restoration when it was in better condition than at present (il Rackham, Pl. XVIII).

Cv-Herbert sc, from Cv Cross. Added to Cross in restoration of 1541-4, but certainly older & perhaps among statues brought from Cv-WhiteFr to fill niches. Standing fig is holding orb in L hand & staff or scepter (broken off) in R hand. Crowned & bearded fig wears tunic looped under belt to reveal undertunic reaching to knees. He also has cloak & ermine tippet. He has sandals on feet. FIG. 18.

18. King Henry VI, from Coventry Cross. Herbert Art Gallery and Museum.

St Margaret

> *Virgin martyr imprisoned for her faith; her legend tells how she was attacked by dragon in prison but was protected by sign of cross. This st appeared at conduit at Cross Cheaping for royal entry of Q Margaret in 1456: "there was made a grete dragon & seynt Marget Sleyng hym be myracull"; her speech on this occasion invited onlookers to call on her "power." She also appeared as a character along with St Cath in Corpus Christi processions at Cv in 1539-42 &*

1544-6. Lexikon *VII.494-500.* SBr, *III, ff. lxxxv-lxxxvi.*
(Jul 20)

Cv-StMH tp. c.1510. St stands on spotted dragon, which is
biting her blue mantle (over red gown).

St Mary Magdalene

*Exemplar of penitence & contemplation. Composite fig
combining 3 biblical characters in addition to legendary
material. She appeared in Cv Cappers' pageant along with 2
other Marys from 1534 to 1574.* Lexikon *VII.516-41.* SBr,
III, ff. lxxvii-lxxxix. (Jul 22)

Cv-StMH tp. c.1510. No nimbus; identified by her jar of
ointment, which she holds in her R hand (she lifts lid
with her L hand). She wears red garment under blue
mantle.

' St. Osburga

*Abbess of nunnery at Cv (d. 1018). Her feast was celebrated
on Mar 30 in Cv Archdeanery from 1410. Shrine in
Cv-StMCath.* Oxford Dictionary of Saints, *p. 302.*

Cv-Cath sc, from Cv-StMi; now in Cathedral Treasury. 14c?
Head, said to be of St Osburga, Abbess of Cv.

Richard Scrope (Unofficial Saint)

*Archbishop of York (executed 1405) & leader of popular
rebellion against abuses of reign of Henry IV.* Lexikon
VIII.267.

Cv-StMH pg*, Gt Hall, E side, 3rd Win (upper row, at R).
c.1405-10. Win is said to have contained fig of
Richard Scrope, Bp of Lichfield & Cv, 1396, & later of
York. He held closed book, & appeared immediately
above unidentified mayor & Robt Schypley, mayor in
1402 & 1415. [Reader]

St Sebastian

*Roman martyr who was shot with arrows in Diocletian's
persecution. Thereafter, he was brought back to life, again
arrested, & stoned.* Lexikon *VIII.318-24.* SBr, *III, ff.
xiii-xv. (Jan 20, with Fabian)*

Cv-StMi im*, Ch of St Tho. Im of "seynt Sebastiane" ntd (on S
side of Ch) in indenture of Saddlers & Cardmakers, 8

Jan 1537. [Ingram]

St Stephen

Protomartyr, whose stoning is recorded in Acts 7. *Normally depicted as deacon.* Lexikon *VIII.395-403.* SBr, *I, ff. xxxii-xxxiv. (Dec 26)*

Cv-StMi sc*, formerly in tower (replaced in 1880's). Standing fig of St Stephen as deacon holding stone in R hand. He was wearing dalmatic & stole.

St Thomas of Canterbury

Tho Becket, Archbishop of Canterbury; martyred in his cathedral, 1170, by knights loyal to Henry II. Lexikon *VIII.484-9. (Dec 29; Jul 7)*

Cv-StMH pg*, formerly in "some Rooms beyond the Mayoresses Parlor"; ntd by Humphrey Wanley in 1719: "Here seems to remain part of the Figure of Thomas à Becket etc." [Transcription by M. D. Harris in Cv Local Studies Centre]

XII. SEVEN SACRAMENTS

THE MASS

Cv-CXiG seal of Corpus Christi Gild. Hand of God issuing from cloud, above; priest in vestments at altar, below, with hands joined in prayer. On altar, chalice with large Host over it. Il Aylesford Collection: Ws Country Seats, I, 262.

XIII. MISCELLANEOUS

ANIMALS

Cv-HT wdcarv, misericords; possibly originally in Cv-WhiteFr. c.1400. S4: lion masks on center & 2 supporters (latter have tongues extended). S8: stag attacked by dog which is biting its muzzle; hare seated on back of dog. At L behind stag, man with sword at belt & hands raised. L side of stag's antler broken. S9: pair of eagles back to back. 4 further eagles stand on foliage as supporters. S10: pair of cockatrices back to back. 2 female masks with ornamented headdresses & collars as supporters. N2: lion mask on center with foliage on supporters. N8: griffin seated facing R. 2 lion masks as supporters (tongues extended).

DANCE OF DEATH

Cv-StMi wdcarv*, misericords. Destroyed 1940. c.1465. On 3 misericords, flanking Corporal Acts of Mercy, are: (1) Death with ?Emperor & with Pope; (2) Death with lay person in cloak & with staff, & also with bishop in mitre & chasuble (cf. pg in St Andrew's, Norwich); (3) Death with 2 unidentifiable persons (mutilated). FIG. 19; see also Harris, "Misericords of Cv," Pl. XXXI.

HISTORICAL & LEGENDARY

Cv-HT pg*, formerly in HT & lost in fire after removal; see Rackham, p. 100. Late 14c? Only naked head & shoulders of Godiva seem original, rest patch. Il Aylesford Collection: Ws Country Seats, I, 168; cf. Harris, *Life in an Old English Town*, p. 9. Fig in Cv-HT pg Win 11.2 sometimes now identified as Godiva is man in armor on horse.

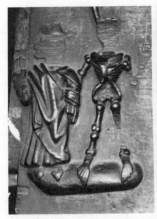 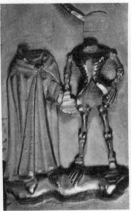 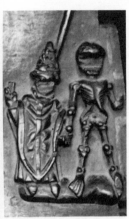

19. Dance of Death. Details from misericords, St. Michael's Cathedral (destroyed) Coventry. Courtesy of Royal Commission on Historical Monuments (England).

Cv-StMH pg, Gt Hall, N Win, Light 9. c.1490. Standing fig of Constantine (proclaimed Emperor at York) holding sword in R hand & true cross (flowery mound at base is modern) in L. Surcoat with arms quarterly 1+4 a spreadeagle 2+3 a cross between 4 staples. Very restored. Sharp's drawing illustrating pre-1793 condition of this win is il Rackham, Pl. XVII.

pg, Gt Hall, N Win, Light 1. c.1490. Standing fig of K Arthur holding sword in R hand & early crown in L. He wears surcoat (with arms 3 coronets) & richly bordered cloak fastened with annulet at neck. Fig is in good condition in spite of disastrous restoration of win in 1793 & over-restoration by Burlison & Grylls in 1893. Sharp's drawing illustrating pre-1793 condition of this win is il Rackham, Pl. XVII. K Arthur appeared in royal entries of 1456 & 1498.

pg, Gt Hall, N Win. c.1490. English kings appear in lights along with CONSTANTINE (see above) & beginning with K ARTHUR (see above). Light 2: K Wm I: standing fig holding sword in R hand & orb in L. Surcoat with 2 lions passant gardant (England pre-1195). Very restored. Light 3: standing fig of K Richard I holding sword in R hand & orb in L. Surcoat with arms 3 lions passant gardant (England c.1195-1340). Restored but good condition. Il Rackham, Pl. XVII. Light 4: standing fig of K Henry III holding sword in R hand & orb in L. Arms on surcoat 3 lions passant gardant.

Restored but good condition. Light 5: K Henry VI (see
SAINTS, above) in central position in win. Light 6:
standing fig of K Edw III holding sword in R hand &
orb in L. Arms on surcoat France (ancient) quartering
England (from 1340-c.1405). Restored but good. Il
Rackham, Pl. XVII. Light 7: standing fig of K Henry
IV holding sword in R hand & orb in L. He wears er-
mine cloak. Arms on surcoat France (ancient) quar-
tering England (arms of 1340-c.1405). Very restored
with much modern glass. Light 8: standing fig of K
Henry V holding sword with R & orb with L hand. Arms
on surcoat France (modern) quartering England (arms of
1405-1603). Mostly modern (face, portions of sword &
orb, one lion on surcoat, R knee, portion of mantle
betw legs, & inscription are reported by Rackham, p.
106, to be original). This win received disastrous
restoration in 1793 (see Sharp's drawing of win as il
Rackham, Pl. XVII, which shows it prior to this res-
toration) and was over-restored by Burlison & Grylls
in 1893.

SEASONS & ZODIAC

Cv-Herbert wdcarv, misericord, from Cv-KHVIII; formerly in Cv-
HspStJn but probably originally in Cv-WhiteFr. c.1400.
Sol in Libra, illustrating picking & crushing of
grapes on L & R. FIGS. 20-22. Anr misericord in
series remains at Cv-KHVIII & a third is lost.

Cv-KHVIII wdcarv, misericord; formerly in Cv-HspStJn & possibly
originally in Cv-WhiteFr. c.1400. Sol in Capricorn.
Man is seated at table with food (loaf of bread) in L
hand. Feasting scene. Also included on misericord is
fig of K David harping; see DAVID, above. Il Harris,
"Misericords of Cv," Pl. XXVI. This item is part of
series which also included Sol in Libra, now at Cv-
Herbert (see above), & Taurus, now lost but reported
in Lansd. MS. 209, ff. 204ff. Latter scene illus-
trated plowman, representing month of April.

Cv-StMH pg, Gt Hall, oriel win; moved to this location in 1893
from anr location in bldg. 15c. Roundel in Light 4B
(not complete) shows man, in tunic & with flail,
threshing wheat. Identified by inscription as Sep-
tember. Further subjects in series reported by Reader
included plowing, mowing, cutting down tree (all of
these were lost by 1810). Anr roundel, in Light 5B,
from same series shows incomplete August: reaping,
with sheaves of wheat & man, facing R; woman, holding
pot, behind. Yet anr scene, in Light 4B (incomplete),

shows cooking pot with fragment of hand; this may be
December.

20. Picking Grapes. Detail from misericord, Hospital of St.
John. Herbert Art Gallery and Museum.

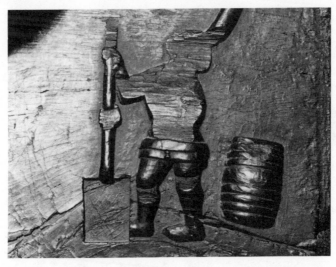

21. Crushing Grapes. Detail from misericord, Hospital of St.
John. Herbert Art Gallery and Museum.

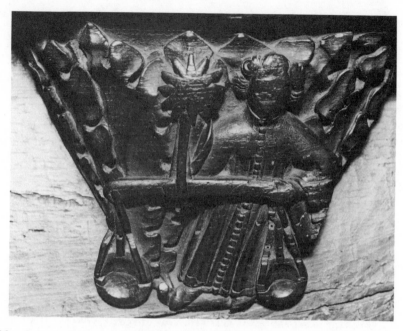

22. Sol in Libra. Detail from misericord, Hospital of St. John. Herbert Art Gallery and Museum, Coventry.

Cv-StMi pg. 15c. Roundel showing pig slaughtered. Representation of December. [Rackham]

Unknown tile, with inscription *Sol in Ariete*, formerly in Cv-StMH. Contains fig of ram. [Harris, "Misericords of Cv"]

OCCUPATIONS

Cv-StMi wdcarv*, misericords. Destroyed 1940. c.1465. Shepherd, amidst sheep, is piping on pipe. Scene was in grove of trees; rabbits & their holes were visible. R & L, man in long tunic (holding staff) with dog, & anr (in fashionably short tunic & hat) with ?hawk. Harris, "Misericords of Cv," p. 261, suggests association with seasons. Il ibid., Pl. XXXI. Anr misericord illustrated (L supporter) bat fowler wearing short tunic & girdle; he held net. There was fire near his feet. Bird passed toward net. On R supporter was thresher with sheaf of wheat. Il ibid., Pl. XXXI.

pg, now in Bp Haigh Ch. Workman with square. Il

Chatwin, "Medieval Stained Glass" (1950), Pl. VIII, fig. 2. Anr fig shows man with pack horse (incomplete); il ibid., Pl. VIII, fig. 2.

MINSTRELS & ENTERTAINERS

Cv-StMi wdcarv*, elbow rests, stalls. Destroyed 1940. c.1465. Carvings included sliding clown figs & double man. [Harris, "Misericords of Cv"]

HUMAN & SEMI-HUMAN TYPES

Cv-HT wdcarv, misericord S5; probably originally in Cv-WhiteFr. c.1400. Bearded male in profile with band around head (knotted at back of head). Foliage supporters.

Cv-StMi wdcarv*, misericords. Destroyed 1940. c.1465. 2 mermen have flippers, & wear ?breastplate as well as cap with jewel, on supporters. Il Harris, "Misericords of Cv," Pl. XXXII.

Cv-Leofric wdcarv. Late 15c. Standing male fig in plate armor; arms bent at elbow & broken off at that point. Used in Godiva processions from 17c. Several bust copies exist. Now thought to have been wdcarv of currently unidentified warrior saint.

23. Green Man. Misericord, Holy Trinity Church, Coventry.

Green Man

Cv-StMH rb*, exterior, gatehouse. c.1390; present fig is late 19c replacement. Mask of green man with foliage intertwined about head.

Cv-HT wdcarv, misericord S6, formerly in Cv-HspStJn; probably from Cv-WhiteFr originally. c.1400. Mask of green man. Foliage intertwined with hair on forehead. FIG. 23.

Wild Man

Cv-HT wdcarv, misericords S2 & S7; possibly in Cv-WhiteFr originally. c.1400. In S2, wild man (bearded & clad in fur), seated with L leg crossed under R, holds chain attached to collar around lion's neck with his L hand; in R hand, he holds club which rests over shoulder. FIG. 24. In S7, bearded wild man is clothed in fur & appears standing before lion with arms upraised (broken); il Harris, "Misericords of Cv," Pl. XXI.

24. Wild Man. Misericord, Holy Trinity Church, Coventry. Courtesy of Royal Commission on Historical Monuments (England).

I. REPRESENTATIONS OF GOD, ANGELS, & DEVILS

TRINITY, WITH CHRIST ON CROSS (THRONE OF GRACE)

Str-HT seal, College of Stratford-upon Avon (founded 1352-3). Late 14c. Trinity with Son on cross before Father. Tonnochy, No. 859; il ibid., Pl. XXV. Cf. *Catalogue of Seals*, No. 4111.

v*. 2 images for vestments purchased by Gild of H Cross, Blessed Mary, & St Jn Baptist, 1469-70. Stratford, Proctors' Accounts, No. 82.

banner* with im of Trinity, ntd in accounts of Gild of H Cross, Blessed Mary, & St Jn Baptist, 1469-70. Stratford, Proctors' Accounts, No. 82.

pc*, at Altar of H Cross. Inv of Gild of H Cross, Blessed Mary, & St Jn Baptist, 1475, lists "clothe steyned wt the Trinite & a crucifyx." Also, altar frontal "of the Trinite" in Gild's Ch. Stratford, Misc. Doc., III, No. 9.

brass*, formerly on top slab of tomb of Dean Tho Balsall. c.1491. Matrix of brass, removed prior to Dugdale's time and very damaged, has been said to indicate original presence of Trinity. [VCH]

rb, center of N porch. 15c. Mutilated Trinity with Christ on cross.

ANGELS

Str-HT wdcarv, on arms of stalls. c.1430-40; restored 1890. Angels. Possibly 5 are original.

Str-GCh sc, carved stop, hood mold over N door of nave. c.1495. Angel, in alb, holds shield.

Str-HT wdcarv*, on roof; ceiling plastered, 1790, & replaced by present roof, 1835. 15c. In 18c, Jordan described roof as "of oak timber consisting of beams and joists, profusely ornamented with uncouth images of angels and cherubims."

Str-NPMus wdcarv, formerly in Str-GCh. 15c? 6 angels, in-

59

cluding (wingless) set of 3 feathered angels standing & holding shields & wearing cross diadems; anr angel with fragmentary wings wears alb & holds shield; one angel is complete, with feathered body & cross diadem on head (he is holding hands up with thumbs toward breast). 2 further fragmentary angels.

Str-HT pg Win N11.2T. 14-15c. Fragments, incl parts of angels.

sc, under sedilia & on piscina drain, S side of chancel. Late 15c. Angels (busts, with wings outspread) hold shields.

Str-GCh wp*, chancel, S wall. Early 16c. Angel, wearing alb, held shield with Chalice & Host. Il Nichols/Fisher, Pl. XX.

Str-NPMus sc, 2 corbels, one with angel in alb holding shield, & anr with feathered angel, removed 1804 from Str-GCh.

DEVIL

Str-HT wdcarv, misericord S9. 1430-40. Devil mask, with large ears, 4 horns. Il White, *Fifteenth Century Misericords*, fig. 18.

II. OLD TESTAMENT

SOLOMON & QUEEN OF SHEBA

Str-GCh wp*, N side (W end) of chancel. Early 16c. Solomon (crowned), at R, held scepter with L hand; R hand was open, palm toward L side of his chest. He wore gown ornamented with letter S within flower design & with his name on bottom border, & wore red shoes. At his R was cock (symbolic fig). He was looking across at Q of Sheba (also crowned, & with veil over her hair), who stood with her hands touching together at L. At king's R was fig in red tunic & ermine-lined coat; he was looking at king & pointing at queen with his index finger. Betw them was timber, cut down for building of Temple in Jerusalem but rejected, later to be used for cross. See related scenes in this series of wall paintings listed in LEGEND OF CROSS & EXALTATION OF CROSS. 3 additional attendants were behind Solomon (2 men, 1 woman) & 3 behind queen (1 woman, 1 man, 1 indistinct in Fisher's drawing). Background included Jerusalem city gate & building probably intended to be Temple itself. Inscription: "Regina saba fama salamoni . . . a venit . . . soliman ubi lignum in . . . abatica. . . ." Il Nichols/Fisher, Pl. IV.

TOBIT

Str-WtSH1 wp. c.1570-80 (restored); discovered, 1927. 3 scenes: (1) Tobit & wife wearing hats & mantles (black--his has high collar, while she wears ruff); letter being handed to Tobias, who is dressed in doublet & hose; behind him is archangel Raphael, partly hidden by drapery. (2) City with turrets, etc., & Tobias & Raphael (with ?dog). Scene partly lost. (3) Tobias & Raphael on Tigris, the former with great fish. City is background to scene. Identified by inscription: "leap . . . a fysshe that lookid grave. But raphel bade tobias. . . ." Il Johnston, Pls. XX-XXII.

III. BLESSED VIRGIN MARY

See also CRUCIFIXION WITH BVM & JN BAPTIST, below.

BVM

St-HCG im* in mazer. Ntd inv of Gild of H Cross, Blessed
 Mary, & St Jn Baptist, 1475. Mazer had "nowche in the
 botom, of our lady." Stratford, Misc. Doc., III, No.
 9.

Str-HT im* at Altar of BVM, ntd accounts of Gild of H Cross,
 Blessed Mary, & St Jn Baptist, 1410-1, & in inv of
 1475, where "clothe to hong afore or lady in lente" is
 mentioned. Stratford, Proctors' Accounts, No. 25;
 Misc. Doc., III, No. 9.

IV. CHRIST'S MINISTRY

JOHN THE BAPTIST

*One of the patrons of Gild of H Cross, Blessed Mary, & St Jn
Baptist of Stratford.*

See also CRUCIFIXION WITH BVM & ST JN BAPTIST, below.

Str-HT pc*, "hongyng afore the awter" of St Jn. Inv of Gild
 of H Cross, Blessed Mary, & St Jn Baptist, 1475. St
 Jn Baptist "wt odur." Anr pc* (altar frontal), at
 Altar of BVM, had Jn Baptist & "ymage of our lady."
 Stratford, Misc. Doc., III, No. 9.

V. THE PASSION

BETRAYAL

Str-HT sc, Balsall tomb, niche at W end. c.1491. Mutilated betrayal scene. 2 figs (Judas, L, & Christ, R) in foreground; soldier at R reaches out toward Christ to arrest him. Other (mutilated) soldiers are also present.

SCOURGING

Str-HT sc, Balsall tomb, 1st niche on S side. c.1491. Fig of Christ is tied to pillar; he is being tortured by 3 torturers, who use scourges (at his R) &, in the case of the torturer at L, fists. Very mutilated.

CHRIST CARRYING CROSS

Str-HT sc, Balsall tomb, 2nd niche on S side. c.1491. Very mutilated scene seems to have represented procession to Calvary with Christ carrying cross. Several very battered figs.

VERNICLE

Str-GCh sc, hood mold of blind arcade, S wall of nave. Late 15c. Vernicle.

SIGNS OF PASSION

Str-HT sc, carved stop, hood mold over N door in chancel. Late 15c. 2 angels hold instruments of Passion (scourges & spear); see RESURRECTION, below.

Str-GCh wp*, over chancel arch. c.1531-45. Angels with instruments of Passion were formerly over fig of Christ in Doom. See LAST JUDGMENT, below.

FIVE WOUNDS

Str-GCh wp*, chancel, S wall. Early 16c. Wounded heart appeared in center, with hands & feet also showing wounds. Inscription: ". . .int in memoria vulnera quinq dei." Il Nichols/Fisher, Pl. XX; Aylesford Collection: Ws Country Seats, II, 636.

CRUCIFIXION

Str-HT sc, tomb of Tho Balsall, 3rd niche on S side. c.1491.
 Very mutilated. Cross of Christ, center, with 2 other
 crosses on R & L. 4 unidentifiable figs in fore-
 ground.

Str-GCh wp*, chancel, S wall, at L of vicar's door. Early
 16c. Crucifix, before which knelt bishop in pontif-
 icals; on his hands (if Fisher's drawing is to be
 trusted) were stigmata. Behind bishop was tonsured
 priest, who was holding crozier for him. Includes
 angel with shield bearing chalice above. Il
 Nichols/Fisher, Pl. XI; Aylesford Collection: Ws Coun-
 try Seats, II, 636.

CRUCIFIXION WITH BVM & ST JOHN THE BAPTIST

Str-HT wdcarv*, high cross, ntd in accounts of Gild of H
 Cross, Blessed Mary, & St Jn Baptist, 1411-7. Cruci-
 fixion with figs of BVM & St Jn Baptist. Painted with
 following pigments: red lead, "Browne de spaygne,"
 white lead, vermillion, gold, chalk, indigo. Strat-
 ford, Proctors' Accounts, No. 26.

Str-GCh wdcarv*. c.1431. Rood, with BVM &, most likely, St
 Jn Baptist, was formerly attached to wall over chancel
 arch. Outlines of these figs are still present on wp
 of LAST JUDGMENT. [Bloom, *Shakespeare's Church*]

Str-HCG im* in mazer. Ntd inv of Gild of H Cross, Blessed
 Mary, & St Jn Baptist, 1475. Mazer had "crucyfix oure
 lady & seynt John Baptiste." Stratford, Misc. Doc.,
 III, No. 9.

 seal of Gild of H Cross, Blessed Mary, & St Jn Bap-
 tist. 15c. Fig on R is Jn Baptist (with staff &
 banner, & Agnus Dei); on L is BVM (holding book) with
 long hair. She is weeping. Tonnochy, No. 887; *Cata-
 logue of Seals*, No. 4473; cf. Bloom, *Shakespeare's
 Church*, il facing p. 138; Aylesford Collection: Ws
 Country Seats, II, 642; Brassington, p. 69.

OUR LADY OF PITY

Str-HT im*, ntd in will of Wm Bell, 1465, who gave candela-
 brum "de laten" to serve before "Marie de Pyte" at
 Altar of St Tho. Stratford, Corporation Mun. Unbound
 Records, XII, No. 190.

BURIAL

Str-HT sc, Balsall tomb, 4th niche on S side. c.1491.
Mutilated. Christ's body, wrapped in shroud, is being
laid on coffer tomb by 5 figs who can no longer be
individually identified. FIG. 25.

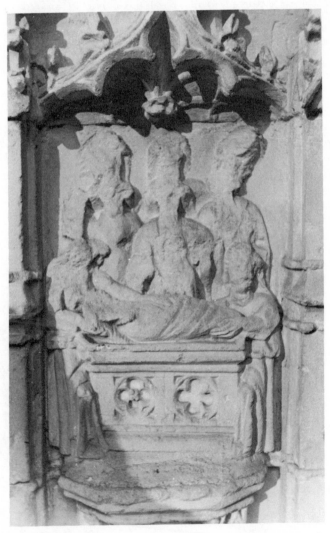

25. Burial of Christ. Very damaged, on Balsall Tomb, Holy
Trinity Church, Stratford-upon-Avon.

VI. THE RISEN CHRIST

RESURRECTION

Str-HT sc, carved stop, hood mold over N door in chancel.
 Late 15c. Resurrection, with 2 angels behind Christ
 holding instruments of Passion (scourges & spear), & 3
 soldiers before tomb (in armor, holding shields); anr
 soldier, behind, holds battle axe. Mutilated, heads
 missing. Christ, rising out of tomb, also has hands
 missing. FIG. 26.

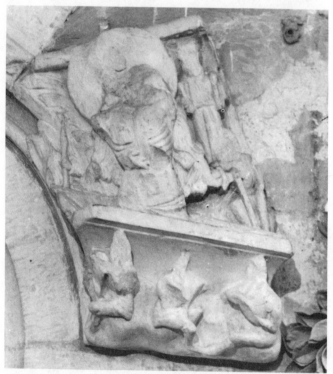

26. Resurrection. Carved stop, hood mold over North Door of
Chancel, Holy Trinity Church, Stratford-upon-Avon.

ANGEL & THREE WOMEN AT TOMB

Str-HT sc, Balsall tomb, 5th niche on S side. c.1491. Very
 mutilated. Angel at W end of coffer tomb (seated)

greets 3 Marys (2 behind tomb & one in front). Coffer
tomb is identical to one in Burial in this series.
FIG. 27.

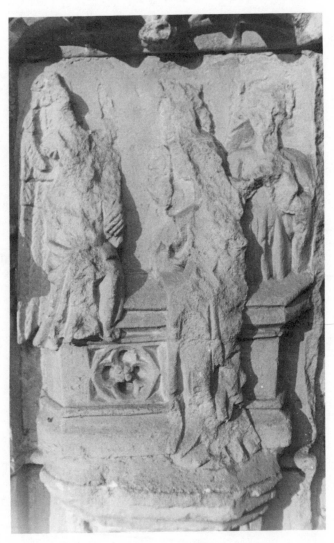

27. Angel and Holy Women at Tomb. Sculpture, very damaged, on
Balsall Tomb, Holy Trinity Church, Stratford-upon-Avon.

68

BVM & HOLY WOMEN

Str-HT pc*, Altar of BVM, ntd inv of Gild of H Cross, Blessed
 Mary, & St Jn Baptist. One pc, which was designed "to
 honge afore the awter," had BVM "wt thre maryes."
 Stratford, Misc. Doc., III, No. 9.

ROAD TO EMMAUS

Str-HT sc, Balsall tomb, niche at E end. c.1491. 3 men
 walking on road. 2 are pilgrims with staffs & purses
 with scallop shells (one broken). Mutilated, but
 identifiable as Christ & 2 apostles on road to Emmaus.

VII. CONCLUSION OF LIFE OF THE VIRGIN

CORONATION OF BVM

Str-HT pc*, Altar of BVM, ntd inv of Gild of H Cross, Blessed
 Mary, & St Jn Baptist, 1475. Coronation of BVM.
 Stratford, Misc. Doc., III, No. 9.

VIII. THE LAST JUDGMENT

JUDGMENT DAY (MATTHEW 25 ACCOUNT)

Str-GCh wp, over chancel arch. c.1531-45. Christ, with R
hand held up in sign of blessing (2 fingers raised) &
wearing mantle (top of fig is covered by modern ceil-
ing), was seated on rainbow (rainbow still visible)
with feet on globe, while at his R was crowned BVM
(with long, flowing hair & nimbus) in blue, ermine-
lined mantle over blue kirtle (with girdle at her
waist) (now very faint). She had hands raised (palms
out). At Christ's L is bearded St Jn ?Baptist, who
has nimbus & wears light-brown gown belted at waist.
He kneels & holds up hands (faint). Formerly, angels
at top held instruments of Passion (nearly obliterated
prior to discovery of wp in 1804). Above, at Christ's
R is heavenly city with heaven's gate attended by St
Peter (with nimbus & wearing green mantle over red
gown, & holding keys). Angel musicians stand on bat-
tlements of city. Musical instruments illustrated
included harp, ?fidel (or ?lute), trumpet. Below at
Christ's L is hell mouth, behind which were hell's

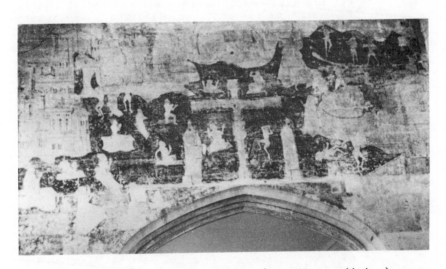

28. The Last Judgment. Wall painting (present condition) over
chancel arch, Gild Chapel, Stratford-upon-Avon. Reproduced by
permission of the Town Council, Stratford-upon-Avon.

flames & tortures. Souls were being forced to join
fellow evil souls in flaming cauldron (now totally
obliterated) which was heated by fire being attended
by devil with bellows. Above, devil stood guard with
flesh hook, & anr holds large raised club; 2 other
devils blow horns. Near hell mouth is group of nude
male & female souls being dragged to damnation with
chain pulled by demon. Anr soul is being dragged
along ground toward hell mouth by devil (holding flesh
hook with L hand), who has taken hold of him by ankle
with his R hand; near top, nude woman with long hair
is led by devil in tunic (he has rope about her
waist). One soul, identified by inscription (now
obliterated) as Pride, is being carried along "pig-
gy-back" by horned devil, while 4 others (2 formerly
identified by inscriptions as Avarice & Wrath) are
present at entrance to hell mouth. Already tortured
inside hell are Gluttony & Envy, the latter hung by
waist & flogged by devil while former is hung by hook
through nose (very faint). One of newly risen evil
souls has her arms raised over her head in despair. At
Christ's R are nude good souls, awaiting entry to
heaven. Below, among those rising from graves, are
bishop with mitre & pope with triple crown as well as
anr high ecclesiastic or official with red ?crown.
Saved include men (at least one with tonsure) & women.
One fig rises up from grave with shroud still over
head & hands raised in supplication. Wp is very
faded, & many details & colors are no longer distin-
guishable. Wall also shows where rood & 2 other figs
(BVM &, most likely, St Jn Baptist) were attached.
FIGS. 28-29. For Fisher's drawing, see
Nichols/Fisher, Pl. XIX; Aylesford Collection: Ws
Country Seats, II, 638.

JUDGMENT (APOCALYPSE ACCOUNT)

Str-GCh wp*, W wall of Nave (N side), under wp of St Geo.
Early 16c. Angel (wearing colored alb & cross diadem)
on each side pointed to nude (possibly her loincloth
is an addition by Fisher) fig of Whore of Babylon (on
her breast was image of head of ass). She stood on
small dragon on pedestal. Around her waist was chain
girdle, which was held below by hairy demon (with claw
feet & hands, horns, bat wings, animal face, & face-
mask over genital area) who also held up to her an
open box containing gold coins. She had her L hand on
lid of box, & with R hand she held cup of abomination
with dragons coming out of it. Anr devil (below, at
L, with horns, pointed ears, long nose, & grotesque

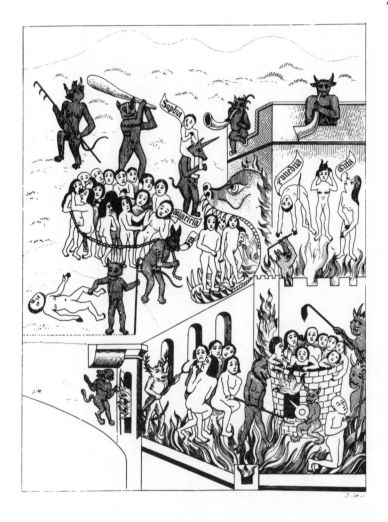

29. Drawing illustrating detail of wall painting of Last Judgment over chancel arch of Gild Chapel, Stratford-upon-Avon, in early nineteenth century. From Thomas Sharp, *A Dissertation on the Pageants or Dramatic Mysteries* (1825), Pl. 6.

animal masks on genital area & both knees) held mallet with sharp point. Below, red flames were rising from earth. Above, in segment of scene designated as heaven, God appeared in center in aureole, & angels appeared with hands in prayer on each side. Il Nich-

ols/Fisher, Pl. XVIII; Aylesford Collection: Ws
Country Seats, II, 632.

ST MICHAEL

Str-GCh wp*, W wall of nave, below representation of Becket's
martyrdom. Early 16c. Feathered angel, identified by
Wheler (*History & Antiquities*, pp. 98-9) as "probably
St. Michael," held scroll with verses "Erthe oute of
erth. . . ." Below, corpse in shroud being eaten by
worms, 3 bones, 2 skulls; older man at L, younger at R
pointed to verses on scroll betw them: "Whoo soo hym
though*t*/ Inwardly and ofte/ How harde it is to flett/
From bede to peyt,/ That neu schall lye certen/ He
wolde not do no syn/ all þe world to wyn." Il Gray,
Pl. 9 (Fisher's drawing); Aylesford Collection: Ws
Country Seats, II, 632.

IX. SAINTS

For explanation of abbreviations, see above, p. 43.

St Christopher

In legend, giant of a man who carried Christ Child across dangerous river. Ubiquitous figure, patron of travellers. Lexikon V.496-508. (Jul 25)

Str-HT sc, carved stop, hood mold on N door of chancel. Late 15c. St Christopher with staff in R hand (water over ankles). Hermit (head missing) appears in front of hermitage on bank. Mutilated; Christ Child, under st's L arm, is mostly broken away. Il Bloom, *Shakespeare's Church*, p. 57.

St Dominic

Founder of Friars Preachers. Lexikon VI.72-9.

Str-HT im*, ntd in will of Wm Bell, 1465, who gave candelabrum "de laten" to serve before im of St Dominic at Altar of St Tho. Stratford, Corporation Mun. Unbound Records, XII, No. 190.

St George

See above, p. 46.

Str-HT wdcarv, misericord S10. 1430-40. St Geo (in contemporary armor, & with head broken away) & dragon. Palm tree on L; virgin with hands joined in prayer at R. Flanked by grotesques. Dragon is on its back as st stands on it & thrusts spear into its mouth. Il White, *Fifteenth Century Misericords*, fig. 17.

Str-GCh wp, W wall (N side) of nave. Early 16c. St Geo (on horseback, swinging sword above head in preparation for striking dragon) wears plate armor. Below him is winged dragon with claw feet & tail of serpent (already wounded at neck, which is pierced by broken lance); it is breaking remains of lance with feet. St rides single-horned horse, whose horn is also piercing dragon. Behind st at R is princess (crowned), who is holding leash attached to lamb. In background are castle (with crowned king & queen looking down), river, anr castle, & ships. Now almost entirely faded

away. Il Nichols/Fisher, Pl. XVIII; Aylesford Col-
lection: Ws Country Seats, II, 632.

St Gregory

Pope, 590-604, & doctor of Church. He sent St Augustine of
Canterbury to England as missionary. Lexikon VI.432-41.
SBr, III, ff. xxxv-xxxvi. (Mar 12)

Str-HT pc*, Altar of St Jn, ntd inv of Gild of H Cross,
 Blessed Mary, & St Jn Baptist, 1475. St Gregory.
 Stratford, Misc. Doc., III, No. 9.

St Helen

Mother of Constantine the Gt & discoverer of true cross.
Lexikon VI.485-90. See SBr, III, ff. lxvii-xlviii. (In-
vention of Cross, May 3)

Str-GCh wp*, N side of chancel. Early 16c. Scenes illus-
 trated legend of finding of cross by St Helen. See
 INVENTION OF CROSS.

St Martin of Tours

Popular st, best known for sharing cloak with beggar. Lex-
ikon VII.572-9. (Nov 11; Jul 4)

Str-GCh pg*, chancel. Ntd accounts of Gild of H Cross,
 Blessed Mary, & St Jn Baptist, 1451-2. Window of St
 Martin. Stratford, Proctors' Accounts, No. 58.

St Mary Magdalene

See above, p. 50.

Str-HT sc, altar tomb of Dean Tho Balsall, E end niche.
 c.1491. Woman with long hair; almost certainly Mary
 Magdalene.

St Modwenna

Legendary st of ??c said to have been beneficiary of a king
of Mercia, who gave land to her for nunnery in Staffs at
Trensall, but other traditions also inform her cult. Oxford
Dictionary of Saints, p. 281.

Str-GCh wp, niche at W end of nave on N side. Early 16c. St
 wears veil & wimple, mantle over kirtle, & rope gir-

dle. Nimbus. She holds open book in R hand, & has crozier resting on L wrist as L hand is placed over breast. Below, cat, biting white mouse, which is lying on its back with legs up & bleeding. Parts are very faint. Il Nichols/Fisher, Pl. XIII; Aylesford Collection: Ws Country Seats, II, 636.

St Thomas of Canterbury

See above, p. 51.

Str-GCh wp, W wall (S side) of nave. Early 16c. Martyrdom of Tho Becket, who is kneeling before altar at R with R hand resting on its edge. On altar are missal, 2 candles, & chalice. He is tonsured & wears chasuble over alb. 4 knights in mixed chain mail & plate armor (2 wear jupons) attack from L (their faces are dark gray with anger). Wm de Tracy & Reginald Fitzurse strike first blows: one sword is piercing Tho's tonsured head & anr is being thrust into his neck. Hugh Morville has sword raised with both hands, & Rich Brito is removing his weapon from scabbard. Behind altar is Edmund Grim, clerk, with hand raised. Now almost entirely faded away. Il Nichols/Fisher, Pl. XIV; Aylesford Collection: Ws Country Seats, II, 632.

St Ursula

St's legend tells how she was executed, along with large number of maidens & Pope Cyriacus who were her followers, by Prince of Huns at Cologne. Lexikon VIII.521-7.

Str-GCh wp, niche at W end of nave (S side). Early 16c. Female st with nimbus, possibly St Ursula though identified in Nichols/Fisher as St Edmund. Ermine trim at bottom of gown noted by Fisher, who also saw 2 smaller faces at st's side. Very damaged & faint; only top portion remains.

76

X. LEGEND OF CROSS

Invention of Cross

Str-GCh wp*, N side of chancel. Early 16c. Series of scenes
(extant in 1804 when discovered under whitewash) began
at W end of chancel with Q of Sheba's recognition of
timber to be used for cross (see SOLOMON & Q OF SHEBA,
above). Illustrated were following scenes: (1) Con-
stantine's vision of cross & victory. In foreground,
Constantine, crowned & mounted on horse, thrust his
lance into body of crowned rival Maxentius (in armor),
who was falling from horse. Constantine's soldiers,
who wore crosses on their breasts, appeared under
standard of tau cross; pagans had red lion rampant on
breasts. Both sides wore plate armor. Behind Con-
stantine, anr soldier on horseback thrust his lance
into a similarly mounted pagan, while one of the Roman
soldiers thrust his sword into breast of anr enemy
soldier. Above L was Constantine's vision of cross,
which winged angel held up for him to see & adore. Il
Nichols/Fisher, Pl. V. (2) Helen's search for cross.
Empress Helen (with nimbus) sets out on horseback (fig
lost prior to 1804) from Byzantium to find cross; at
her L were 2 additional figs mounted on horses; behind
her were 2 standing figs. In front was small dog. 2
trumpeters (one had feather in his hat) stood behind
on hill & blew horns (one horn had red banner with
inscription "ihs" on it); 2 men in hats stood on tower
over city gates at L (one was raising R hand, perhaps
in farewell). Il Nichols/Fisher, Pl. VI. (3) Dis-
covery of cross. St Helen, who was crowned (wearing
veil over hair, wimple, & ermine-lined mantle) & hold-
ing scepter in L hand, raised R hand toward fig at L
with key (jailer) & anr (Judas, wearing tunic) who had
purse at his belt & hands raised (he was stepping
forth from prison). Also present were figs wearing
ermine & fur-lined coats; one held rose in R hand &
bird in L, while other held scroll in R hand & pointed
with his L hand. Child in armor with sword above R arm
& round shield appeared in lower R of scene. Above,
St Helen also appeared at R, holding cross which had
been given to her by man (Judas). Behind, 2 workmen
with pick axes excavated 2 smaller crosses (of tau
design). Inscription: "Here seynte helyn examy' . . .
the J . . . þe holy cros . . . Julius [i.e., Judas]
cyryacus . . . here hete was." Il Nichols/Fisher, Pl.
VI. (4) Verification of the cross. Helen, standing,

held cross with her hands veiled by her gown & touched its top to girl in winding sheet (lower part of body also under coverlet); she responded by raising her hands in adoration as she was brought back to life miraculously. Behind her were her parents: father (wearing hat) pointed with R hand toward st & with other took hold of wrist of his wife (wearing head-dress with cawl). Behind St Helen was fig holding 2 smaller crosses in his hands, & above were 3 additional figs, one standing (man wearing hat with feather) & others (man & woman) looking out of windows. Setting was forest, with tree, deer, & 2 small rustics (one had backpack, while other had lance) with dog. Inscription: "hyt was proued euydently by myrakyl which was þe very cros that owre sauyour suffred. . . . In resynge a made from deth to lyfe." Il Nichols/Fisher, Pl. VII. (5) Cross is taken to church in Constantinople. Angels (in albs, above) played lute, harp, & trumpet as cross was removed to Constantinople. At L, scene was damaged prior to 1804, but cross & St Helen's crown as well as part of her mantle were visible. In lower R corner, small fig beside tree fell to knees & raised hands in adoration, & at R St Helen knelt & adored cross, now transformed into crucifix (nimbed Christ, wearing loincloth, is attached with 3 nails) beside altar with 2 candlesticks. At L of crucifix, bishop in mitre & cope swung thurible, censing it. Behind scroll (inscription obliterated prior to 1804), crowned Emperor Constantine also held hands in prayer (presumably he also was kneeling). Inscription: "Here the hole cros was broughte solemly ynto the . . . þe byschops hands easily and . . .yd ynto the tyme of" Il Nichols/Fisher, Pl. VII; Aylesford Collection: Ws Country Seats, II, 634, 640. Series continued with scenes of EXALTATION OF CROSS; see below.

Exaltation of Cross

Str-GCh wp*, N & S walls (E end) of chancel. Early 16c. Continuing legend of Cross (see also SOLOMON & Q OF SHEBA, & INVENTION OF CROSS), additional scenes illustrated Exaltation of Cross, which was marked by fair kept at Stratford-upon-Avon on 14 Sept. These scenes included: (1) Battle in 629 betw Emperor Heraclius & infidel Persian prince, son of pagan K Chosroës. Heraclius, crowned & wearing plate armor marked with cross, stabbed prince on bridge over Danube. In background, other soldiers looked on. Inscription: "Here eraclyus a crysten prynce fawghte wyth þe sone

of Cosdroy, whyche was gret enyme to þe feythe of
chryst and . . . þe remembrance of þe holy . . . to be
crystende." Il Nichols/Fisher, Pl. VIII; Aylesford
Collection: Ws Country Seats, II, 634. (2) Killing of
infidel K Chosroës (bearded & with long hair),
crowned. At L, Heraclius raised sword over head in
ultimatum to already wounded (at neck, bleeding pro-
fusely) infidel king, who will be decapitated. Por-
tion of cross stolen by Chosroës from Jerusalem in 614
was set in tower under canopy along with im of sun. At
R, countryman in tunic was kneeling & worshipping
(hands more or less in *orans* position) at this false
shrine; with him are 3 sheep. Il Nichols/Fisher, Pl.
IX. (3) Pride of Heraclius. At L, Heraclius (crowned
& holding scepter in L hand) was riding with cross
borne before him & with 3 retainers behind. Their
hands were raised in recognition of greeting of angel
(wearing alb, above in air with wings spread), who
reminded emperor of his excessive pride. Inscription:
"As the nobul kynge eraclyus com rydyng toward þe
cytte of Jerusalem beryng þe crose so grete
pryde. . . ." Central portion of this scene damaged
prior to 1804. Next (at R) Emperor Heraclius, having
removed his crown & other signs of royalty, humbly
carried cross himself through gate of Jerusalem.
Bare-headed attendant held crown; 3 other figs held
hands together in prayer as cross passed. 3 addi-
tional men wearing hats stood in background. From
tower over city gate was flag with crown & inscription
"Ihs." Il Nichols/Fisher, Pl. X; Aylesford Collec-
tion: Ws Country Seats, II, 636.

XI. ALLEGORICAL SUBJECTS

SEVEN DEADLY SINS

Str–HT wdcarv, misericord N10. 1430–40. Possibly Lechery.
Nude woman on stag. She holds branch (with 4 ?roses)
in R hand; L hand points to scroll (inscription not
extant). Il White, *Fifteenth Century Misericords*,
fig. 10.

Str–GCh wp, over chancel arch. c.1531–45. 5 of 7 Deadly Sins
included in wp showing Doom; see LAST JUDGMENT, above.

wp*, N wall of nave, lower tier. Early 16c. Below
representations of Dance of Death were apparently the
Seven Deadly Sins; for location, see Puddephat, p. 34.

XII. MISCELLANEOUS

ANIMALS (INCLUDING FABULOUS)

Str–HT wdcarv, misericords S11–12. 1430–40. In S11, L,
monkey examines jug; R, anr holds jug before him.
Center, Warwick badge (2 bears). S12 shows capture of
unicorn by virgin, L, in horned headdress; her R hand
is touching nose of unicorn, which is laying its head
in her lap, while her L palm is outstretched as if
showing it to hunter on R with spear that he seems to
be plunging into unicorn. Il White, *Fifteenth Century
Misericords*, figs. 15–16.

DANCE OF DEATH

Str–GCh wp*, N wall of nave. Early 16c. Not whitewashed in
1563 & seen by Jn Stow in 1576: "About the body of
this chaple was curiously paynted the Daunce of
Deathe, commonly called the Daunce of Powles, because
the same was sometyme there paynted aboute the
cloysters on the north-west syd of Powles churche,
pulled downe by the Duke of Somarset, *tempore Edward
6.*" (Leland, *Itinerary*, II, 49). Text followed
Lydgate's *Dance* as preserved in Corpus Christi Col-
lege, Oxford, MS. 237, & Bodley MS. 686. 2 tiers of
figs, beginning with Pope, Emperor, Cardinal, Empress,
Patriarch, King, Archbishop, Prince, Bishop, Earl (or
Baron), Abbot, Abbess. At the end, in panel along

with Child, was apparently the King on his tomb eaten by worms; this was followed by a final panel showing Machabree the Doctor with concluding verses. See Puddephat, pp. 34-5, for conjectural scheme of these wall paintings.

SEASONS & ZODIAC

Str-BTMus wdcarv, misericord, formerly in Str-HT, St Tho of Canterbury Ch. 15c. Sower, illustrating March. Il White, *Fifteenth Century Misericords*, fig. 1.

MINSTRELS

Str-HT wdcarv, misericords, S side. 1430-40. Jester grotesque with fool's cap (2 bells, one of which is broken); R hand is raised toward hat (supporter on S10). On S3, fool grotesques appear. On L, fool with lower part of serpent plays pipe; center, reptile with fool's head & cap; R, fig of fool, holding bauble in R hand, issues from mouth of dragon. Il White, *Fifteenth Century Misericords*, figs. 17, 24. Misericord N6 has also been identified as possibly tumbler, but this example is so defaced that certain identification is impossible; on each supporter is mask. See White, *Fifteenth Century Misericords*, fig. 6.

DOMESTIC STRIFE

Str-HT wdcarv, misericords. 1430-40. Domestic quarrels on 2 misericords. On S2, husband birches wife, dog bites legs; wife scratches husband's face while he grabs her hair (supporters on R & L of damaged sphinx & rider, the latter broken off at waist). On S1, couple is fighting, with woman beating man with cooking pan (central fig, with stylized crown of thorns on each side as supporter). Il White, *Fifteenth Century Misericords*, figs. 25-26.

HUMAN & SEMI-HUMAN TYPES

Str-HT wdcarv, misericords. 1430-40. Mermaid (N11), combing her hair & holding (broken) mirror in R hand, & merman, who holds stone. Il White, *Fifteenth Century Misericords*, fig. 11. Additionally, various masks & figures.

Str-BTMus wdcarv, misericord, formerly in Str-HT, St Tho of Canterbury Ch. 15c. Mermaid holds mirror in R hand & comb in L. Il White, *Fifteenth Century Misericords*,

fig. 2.

Green Man

Str-HT wdcarv, Misericord S6. 1430-40. Green man. I1
 White, *Fifteenth Century Misericords*, fig. 21.

I. REPRESENTATIONS OF GOD & ANGELS

GOD THE FATHER

War-BCh rb, in vaulting over E Win. c.1450-60. Father, bearded & with long hair, is surrounded by aureole. He holds orb in L hand; R hand is raised (palm turned inward) with 2 fingers extended. 2 demi-angels L & R. Repainted in gold.

TRINITY, WITH SON ON CROSS (THRONE OF GRACE)

 See *also* CORPUS CHRISTI, *below*.

War-StM seal, from Collegiate Church of Trinity, SS Mary & Geo, Warwick. Late 14c. Central fig is Trinity. On L is St Geo, on R BVM. *Catalogue of Seals*, No. 4268.

 pc*, ntd inv, Harl MS. 7505, f. 5V (17c copy). "Item j. reredos steyned of ymages of saintes hauyng thereto . . . in the middel thereof j. of the trinite and the other of corpus chr*i*sti." Trinity was presumably of Throne of Grace type.

 pl*, paten. Inv, 1463, Harl MS. 7505, f. 8V: "an ymage of the fader al mighti god holding afore him his sone vpon the cros."

 v*, hood of cope. Inv, 1463, Harl MS. 7505, f. 8V. Trinity, possibly of Throne of Grace type.

ANGELS

War-StM sc on alabaster tomb of Tho Beauchamp, Earl of Warwick, & Countess. 1370. Angel holds cushions.

War-BCh rb. c.1450-60. Angel, wearing alb, holds shield with arms chequy or and azure a chevron ermine for Newburgh. Repainted.

 sc, copper, gilded, in niches on Beauchamp tomb. 1452-3. 18 angels with scrolls, containing words "Sit deo laus et gloria defunctis misericordia. . . ." Figs are interspersed among mourners (identified by Chatwin, "Monumental Effigies," Pt. 1, p. 64). Cast by Wm Austen of London, gilded by "Bartholomew Lambe-

springe, Dutchman." Repaired 1682-5 under Dugdale's
direction; work was by Nicholas Paris of Warwick.
Regilt in modern times. Il Stone, Pl. 165.

sc, over W door. c.1450-60. Angel (bust only) holds
shield with arms.

NINE ORDERS OF ANGELS

War-BCh sc, 30 figs. c.1450-60. 9 Orders of Angels, around
God the Father. Complex iconography distinguishes se-
parate orders. Seraphim stand upon sea of fire; radi-
ate flames; clouds with stars around neck; waters at
waist; feathered. Cherubim are crowned, & have col-
lars with beams of light radiating; clouds behind
legs; stand on water. Thrones are feathered &
crowned. One of Dominions has body almost covered by
12-point star (i.e., by Star of Bethlehem); they have
feathered arms & legs. Powers appear in armor, &

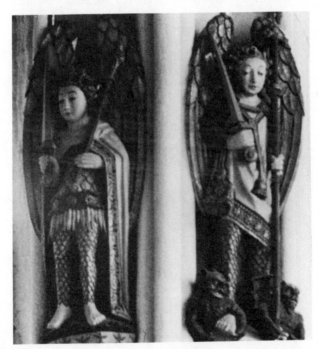

30. Angels. Sculpture, Beauchamp Chapel. By permission of the
Vicar and Churchwardens of the Collegiate Church of St. Mary the
Virgin, Warwick.

84

> trample on devils. Virtues wear dalmatic. Principalities have girdles of clouds & flower-stars. Archangels appear with emblems, spear & lily of Annunciation. Angels wear albs. Repainted. FIG. 30; see also Chatwin, "The Decoration of the Beauchamp Ch" (1928), Pls. LX-LXVIII.

ANGEL MUSICIANS

War-BCh pg, Wins 1, N2-4Tr, & S2-4Tr, by workshop of Jn Prudde of Westminster. c.1447-49. Extensive series of angel musicians, feathered & in albs, who sing & play instruments. Some scrolls are restored with modern notation, but glass in Win N3 has music & text of antiphon *Gaudeamus* (Sarum version) for Feast of Assumption of BVM, while E Win (Win 1) has frags of *Gloria* (song of angels to shepherds at Nativity) & *Ave Regina*. Wins N2 & S2 contain angel musicians with instruments in tracery. Reading from L to R, N2Tr contains: bass shawm, tromba marina, tambourine, pipes

31. Angel Musician playing Clavichord. Painted glass, Beauchamp Chapel, Warwick. Courtesy of Royal Commission on Historical Monuments (England).

32. Angel Musician playing Organ, while another works bellows.
Painted glass, Beauchamp Chapel, Warwick. Courtesy of Royal
Commission on Historical Monuments (England).

86

(duct flutes), clavichord (FIG. 31), bagpipes; above,
clavicembalo (keyed psaltery, or harpsichord), large
portative organ (FIG. 32); continuing below, triangle,
pibcorns, alto shawms, discant shawms, double pibcorn;
S2Tr contains: pipe & tabor, anr tabor & pipe,
rebecs, psaltery; above, positive organ, bells; con-
tinuing below, Irish harps, crwths, lutes, mandoras.
Censing angels are also present. FIGS. 66-69. Also,
instrumentalists il Bentley, Pls. XII-XVII; Montagu,
Pls. 45, 47, 55, 58. Singers & scrolls showing music
il Hardy, Pls. XCVII, C.

II. OLD TESTAMENT

PROPHETS

War-BCh pg* side wins. By workshop of Jn Prudde of Westmin-
ster. c.1447-9. Evidence of inscriptions identifies
orig existence of Hosea (Win N3.1), Joel (N3.2), Amos
(Win N3.3; further, lower part of fig of Amos is ex-
tant in Win 1), Micah (Win N3.5), Habakkuk (Win N3.6),
Haggai (Win N2.2), Zechariah (Win N3.4), Malachi (Win
N2.4), & Ezekiel (Win S2.5). For texts of inscrip-
tions, see Hardy, pp. 602ff.

III. PARENTS OF VIRGIN & HER LIFE (TO NATIVITY)

ST ANNE

War-BCh sc*, reredos, destroyed 1642 by Col Purefoy. Painted
by Christian Colborne. c.1450-64. Fig of St Anne.
[Dugdale]

BIRTH OF THE VIRGIN

War-StM pc*, banner for procession with "the byrthe of oure
lady." Ntd inv, 1454, in Harl MS. 7505, f. 7 (17c
copy).

BLESSED VIRGIN MARY

War-StM seal, from Collegiate Church of Trinity & SS Mary &
Geo, Warwick. Late 14c. At R, BVM (crowned) with
hands lifted in prayer. Central fig is Trinity; on L
is St Geo. *Catalogue of Seals*, No. 4268.

ANNUNCIATION

War-BCh pg Win 1.5B. By workshop of Jn Prudde of Westminster.
c.1447-9. BVM, with hands across breast, probably
from Annuncation scene. Il Chatwin, "Some Notes"
(1928), Pl. IX.

sc*, reredos, destroyed 1642 by Col Purefoy. Painted
by Christian Colborne of London. c.1450-64. Annun-
ciation. [Dugdale]

War-StM tp*, "cloth of arroce," ntd inv, 1463, Harl MS. 7505,
fol 8V. Annunciation to BVM.

VISITATION

War-BCh pg Win 1.3T & 1.5T; formerly in Win N2. By workshop
of Jn Prudde of Westminster. c.1447-9. St Eliz,
wearing veil & wimple, holds up L hand in greeting to
BVM; frags only remain (reconstructed) & bottom of fig
of Eliz is actually part of St Tho. BVM has long
blond hair; she holds up hand in greeting also (pos-
sibly not original). Zacharias also formerly present
in scene. Detail il Chatwin, "Some Notes" (1928), Pl.
XI.

IV. THE INFANCY OF CHRIST

NATIVITY

War-StM im*, listed among items of copper & laton, painted
 table of Nativity. Ntd in inv, 1454, Harl MS. 7505,
 f. 4 (17c copy).

BVM & CHILD

War-StM im*, given by Rich Beauchamp in his will "there to
 remain forever." The im was of "pure gold," & was
 presented in 1435. [Dugdale] Indenture (Harl MS.
 7505, f. 8), 1458, described it as "i faire ymage of
 golde of owre lade goddes moder crouned with gold ber-
 yng hyr sone in the right arme holdyng in his hande a
 braunche made of a ruby & iiij perles. & in the middes
 of thoo iiij perles is pight a litel grene stone."
 From gold base to crown it was 20 inches high.

 pc*, banner for procession, ntd inv, 1454, Harl MS.
 7505, f. 7 (17c copy). BVM with Child.

War-BCh sc, exterior, E end gable niche. c.1450-60, but re-
 stored in 18c. BVM (head missing) & Child (head sus-
 pect), who holds ball; 2 side figs are lost. Il
 Chatwin, "Recent Discoveries" (1931), Pl. IV.

War-StM seal, from Collegiate Church of St Mary, Warwick. BVM,
 seated on throne & crowned, with Child on L knee.
 Below, the Dean in prayer. *Catalogue of Seals*, No.
 4265. Later seal (1528-9) il Wheler, *Collections*, f.
 159.

V. MINISTRY

ST JOHN THE BAPTIST

War-HspS seal, from Hospital of St Sepulchre, Warwick. 1329. Prior's seal shows St Jn Baptist holding Agnus Dei; before him is kneeling prior. *Catalogue of Seals*, No. 4267.

Unknown al. c.1450. Fragment of alabaster fig of Jn Baptist found under floor of War-BCh. Orig size approx 12 inches in height. See Chatwin, "Recent Discoveries" (1931), p. 157.

VI. THE PASSION

PASSION

War-StM v*, orphrey, embroidered with "ymages concernynge the passion of oure lord Jhesu crist." Ntd inv, 1454, Harl MS. 7505, f. 5 (17c copy).

CRUCIFIXION

War-BCh pg Win 1.3B. By workshop of Jn Prudde of Westminster? c.1447-9. Head of Christ with unusual crown of thorns extant (from Crucifixion?) & cross nimbus. Il Chatwin, "Some Notes" (1928), Pl. IX.

CRUCIFIXION WITH MARY & ST JOHN

War-StM pl*, 2 chalices with Crucifixion with BVM & Jn. Inv, 1463, Harl MS. 7505, f. 8V (17c copy).

OUR LADY OF PITY

War-StM im*, small "table gild to stonde afore þe prest on þe auter," ntd inv, 1454, Harl MS. 7505, f. 5.

 im, pilgrim badge. 15c? Our Lady of Pity, seated & with nimbus, holding body of crucified Christ. Il Chatwin, "Recent Discoveries" (1931), Pl. 5.

CORPUS CHRISTI

 See also TRINITY (WITH CHRIST ON CROSS), *above.*

War-StM pc*, ntd inv, 1454, Harl MS. 7505, f. 5V (17c copy). "Item j. reredos steyned of ymages of saintes hauyng thereto . . . in the middel thereof j. of the trinite and the other of corpus christi." Presumably God the Father holding the body of slain son (not on cross).

EASTER SEPULCHRE

War-StNich ESp*. In 1550-1, Edmond Wryght paid 5s for ESp & "6 bannar clothys & other olde peynttyd clothys." ESp was replaced under Q Mary & payments were recorded for watching it. But under Eliz I, we find: "Item to Roger Pygyn ffor deffassing off Images--vj s." [Savage, *Churchwardens' Accounts*]

War-StM ESp, N side of chancel. 15c. Recess of 3 bays.

HOLY SEPULCHRE

War-HspS seal, from Hospital of St Sepulchre, Warwick. Late 12c. H sepulchre, as chest, with lozenge diaper ornamentation. On lid, a patriarchal cross. Il *Catalogue of Seals*, No. 4266.

VII. THE RISEN CHRIST

RESURRECTION

War-StM al*? Large table of Resurrection, painted. Inv, 1454, Harl MS. 7505, f. 4 (17c copy).

VIII. CONCLUSION OF THE LIFE OF THE VIRGIN

DEATH OF BVM

War-StM tp*, "arrace werk wrought vpon silk," ntd inv, 1463,
 Harl MS. 7505, f. 8ᵛ. Scene illustrated "deeth of our
 lady & xi. apostels aboute her."

MARY, QUEEN OF HEAVEN

War-BCh rb (central). c.1450-60. Crowned BVM holding orb in
 R hand & scepter in L; she stands on moon in cloud
 surrounded by aureole. BVM, wearing mantle over kir-
 tle, has long hair flowing over her shoulders. FIG.
 33.

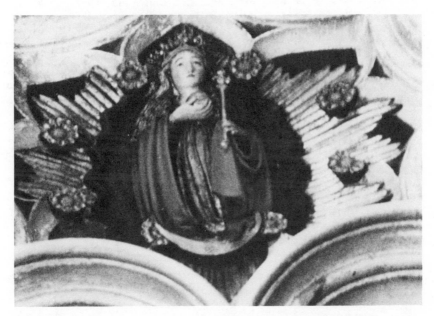

33. Mary as Queen of Heaven. Roof boss, Beauchamp Chapel, War-
wick. By permission of the Vicar and Churchwardens of the Col-
legiate Church of St. Mary, Warwick.

IX. THE LAST JUDGMENT

JUDGMENT DAY (MATTHEW 25 ACCOUNT)

War-BCh wp*, West Wall, by Jn Brentwood, "cityzen and steyner" of London. c.1450-64. Traces remain. Painted following contract with painter, who agreed "to paint fine, and curiously to make at Warwick, on the west wall of the New Chappell there, the Dome of our Lord God Jesus, and all manner of devises and Imagery thereto belonging, of fair and sightly proportion, as the place shall serve for, with the finest colours, and fine gold. . . ." [Dugdale] Repainted by Rich Bird with new design after painting by Michelangelo, 1678. Il Chatwin, "The Decoration of the Beauchamp Ch" (1928), fig. 2.

War-StM v*, im on hood of cope. Ntd inv, 1463, Harl MS. 7505, f. 8V. Fig of Jesus "sittyng on the reyne bowe."

ST MICHAEL

War-StM v*, fig embroidered on vestments, ntd inv, 1454, Harl MS. 7505, f. 5 (17c copy).

X. THE APOSTLES

APOSTLES AS A GROUP

War-BCh pg Win 1.3M (not *in situ*). By workshop of Jn Prudde
 of Westminster. c.1447-9. Now very fragmentary: Tho
 has only bottom of gown, feet, & inscription "homas"
 remaining. Originally 12 apostles & 12 prophets ar-
 ranged in Creed arrangement in side windows.

War-StM pc*, "for the aut*er*." Ntd inv, 1454, Harl MS. 7505,
 f. 6 (17c copy). Apostles.

APOSTLES (INDIVIDUAL FIGURES)

St Thomas

War-BCh pg Win 1.3M. c.1447-9. Fragmentary St Tho. See
 above, APOSTLES AS A GROUP.

XI. SAINTS

For explanation of abbreviations, etc., see above p. 43.

St Alban

 *Protomartyr of Britain whose conversion & death in 3c were
 later reported by Bede. Lexikon V.67-70. SBr, III, ff.
 lvi-lvii. (Jun 22)*

War-BCh pg Win 1.2T. By workshop of Jn Prudde of Westminster.
 c.1447-9. St Alban wears mantle (red with jeweled
 edging & brocade lining) over surcoat (arms on sur-
 coat: azure a saltire or) & plate armor, since prior
 to conversion this st had been soldier. Mantle is
 closed with cord with heavy tassle. R hand holds
 wand, L hand holds wooden cross (on base, with gable
 over it). He wears coronet (fragmentary) with band of
 ermine. Il Chatwin, "Some Notes" (1928), fig. 2.

St Apollonia

 See above, p. 43.

War-StM pc*, banner for procession, ntd inv, 1454, Harl MS.

7505, f. 7 (17c copy). St Apollonia.

St Barbara

> *See above, p. 43.*

War-BCh sc. c.1450-60. St holds 2-story tower in R hand &
 closed book with clasp in L. Under her cloak is gar-
 ment with edge around neck embroidered with flowers.
 She has long hair & oriental style headdress. Re-
 painted.

St Catherine

> *See above, p. 44.*

War-BCh sc. c.1450-60. St holds edge of mantle & long sword
 under R hand (sword extends under cloak; its point
 rests on ground). Top part of her kirtle is very
 ornate. In L hand is open book. Her head has coronet
 (damaged), & she has long hair. Repainted. Il Pevs-
 ner, *Ws*, Pl. 12; Chatwin, "The Decoration of the
 Beauchamp Ch," Pl. LXV.

St George

> *See above, p. 46.*

War-StM seal, from Collegiate Church of Trinity, SS Mary &
 Geo, Warwick. Late 14c. At L, St Geo in armor &
 with shield marked with cross. He is stepping on
 dragon & with L hand is holding lance which is pierc-
 ing head. Central fig is Trinity, & at R is BVM.
 Catalogue of Seals, No. 4268.

War-BCh sc*, reredos, destroyed by Col Purefoy, 1642. c.1450-
 64. Painted by Christian Colborne of London. St Geo.
 [Dugdale]

War-StM banner*? made of "worstede," ntd inv, 1463, Harl MS.
 7505, f. 8^V (17c copy).

St John of Bridlington

> *Following study at Oxford, St Jn of Bridlington became Canon
> Regular (d. 1379).* Lexikon *VII.88-9.*

War-BCh pg Win 1.7T. By workshop of Jn Prudde of Westminster.
 c.1447-9. Tonsured monk appears in habit, fur amice,
 with dark blue cope (brocade with jeweled border). He

is reading book held in R hand, & fingers of L are
betw leaves of book. Left forearm holds crozier a-
gainst his body. Releading; much patch at bottom. Il
Read, Pl. 34.

St Margaret

See above, pp. 49-50.

War-BCh sc. c.1450-60. St has coronet, & holds hands joined
in prayer. She stands on dragon, which is on its
side. She wears mantle over decorated undergarment &
kirtle. Repainted. Il Chatwin, "The Decoration of
the Beauchamp Ch" (1928), Pl. LXV.

St Martin of Tours

See above, p. 74.

War-StM v*, fig embroidered on vestments. Ntd inv, 1454, Harl
MS. 7505, f. 5 (17c copy).

St Mary Magdalene

See above, p. 50.

War-BCh sc. c.1450-60. She holds her emblem, jar of oint-
ment, in her L hand: her R hand is raised (palm turned
in). Her hair, which is long & curly, is partially
covered by veil. Embroidery along bottom of high
waisted kirtle, covered by mantle. Repainted.

St Nicholas

Popular st reputed to have lived in early 4c. Lexikon
VIII.45-58. SBr, III, ff. iv-vii. (Dec 6)

War-StM im*, small "table gild to stonde afore þe prest on þe
auter," ntd inv, 1454, Harl MS. 7505, f. 5 (17c copy).

v*, fig embroidered on vestments. Ntd inv, 1454, Harl
MS. 7505, f. 5 (17c copy).

St Thomas of Canterbury

See above, p. 51.

War-BCh pg Win 1.1T. By workshop of Jn Prudde of Westminster.
c.1447-9. St wears cope, red dalmatic (patched),
white alb, & mitre, & holds crozier in L hand; R hand

is blessing. Il Chatwin, "Some Notes on the Painted
Windows" (1928), Pl. VIII.

St Winifred

*Welsh st of 7c. Her cult was most popular in 15c & survived
Reformation.* Lexikon *VIII.594-5.* SBr, *II, ff. clxvii-
clxix. (Nov 3)*

War-BCh pg Win 1.6T. By workshop of Jn Prudde of Westminster.
c.1447-9. St appears crowned & in black habit;
sleeves are lined with ermine. Her mantle has jeweled
border. Her L hand holds open book, R hand holds
crozier, the staff of which is covered by white veil.
Il Read, Pl. 34.

XII. MISCELLANEOUS

HISTORICAL & LEGENDARY

WarCas tp*, ntd in will of Earl of Warwick, 1398. Probably made in London. Scenes illustrating life of Guy of Warwick. Described in ballad, which lists military action against Saracens; battle with Enkeldered & with K Almain of Tyre; killing of wild boar of Windsor Forest, of the dun cow of Dunsmore Heath, of dragon; battle against Danes (while Guy is dressed as pilgrim); his return to his home; his fight against Danish giant, Colbrand, etc. [Kendrick]

War-StM im*, in choir, altered by Jn Sutton, Carver, in 1396, when old arms of earls of Warwick were placed on it. Fig of Guy of Warwick. [Dugdale]

HUMAN & SEMI-HUMAN TYPES

War seal, Warwick. 13c. On each side of tower, half length watchman blowing horn. *Catalogue of Seals*, No. 5480.

OTHER WARWICKSHIRE LOCATIONS

I. REPRESENTATIONS OF GOD & ANGELS

TRINITY, WITH CHRIST ON CROSS (THRONE OF GRACE)

Whichford pg Win 1Tr. 14c. Christ crucified, with loin cloth,
 yellow stain. His feet are attached with single nail
 to cross. Head of God the Father missing, replaced by
 foliage. Blue with border & possible red mantle for
 Father. Dove missing. FIG. 34.

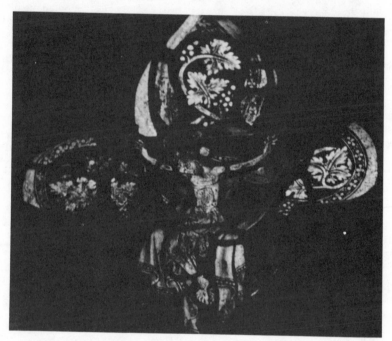

34. Trinity (head of the Father and the Dove are missing).
Painted glass, Whichford.

Withybrook pg Win S5Tr. Late 14c. Frag of Trinity has only R
 hand of Father blessing & L hand holding cross with
 Son, who has cross nimbus & crown of thorns. Body of
 Son is missing from waist down.

Henley sc*, market cross. 15c. Fig of Trinity with seated

Father holding Son on cross, formerly in niche. Il
Gentleman's Magazine, 85 (1815), Pl. facing p. 129.

seal, Gild of H Trinity, St Jn Ev, & St Jn Baptist,
Henley-in-Arden. 15c. Trinity, in niche, with cano-
py, center; L, St Jn Baptist; R, St Jn Evangelist.
Catalogue of Seals, No. 4991.

Astley brass*. c.1500? Monument of ecclesiastic had H
Trinity with Father holding slain Son. [Brown,
"Discoveries"]

Coughton im*, N Aisle at N end of altar. Provided for in will
of Sir Robt Throckmorton, 1518. To be painted & gilt.
[Dugdale, *Ws*]

ANGELS

Halford sc, tympanum, N doorway. Early 12c. Symmetrical
angel, frontal view, with scroll. Painted inscription
is modern. Il Kahn, Pl. XV.

Bir-StMn sc, tomb of knight (possibly Sir Wm de Birmingham).
c.1325. Two angels support cushion, both very dam-
aged.

Cherington sc. c.1340. 2 angels in albs hold pillow under head
of layman (William Lucy?) on tomb. Il Chatwin, "Monu-
mental Effigies," I-II (1924), Pl. XVII.

LCompton sc, effigy of Kenilworth stone. c.1345. Angels at
each side of cushion under head of unidentified lady.

Mancetter pg Win 1.2T. 1333-49. Angel, wearing alb with girdle
& with wing & nimbus. Angel is praying. Incomplete &
patched.

Bourton sc on effigy of sandstone, now in N Ch. c.1350. Ef-
figy of unknown lady has headless angel at each side
of cushion under head. Il Chatwin, "Monumental Ef-
figies," I-II (1924), Pl. VI.

WoottonW pg Win 1.2-6T. 14c. Busts of angels in top of lights
(some are incomplete).

Bir-StMn sc, alabaster tomb of possibly Sir Jn de Birmingham.
c.1400. 2 angels beside head, both much damaged. Il
Chatwin, "Monumental Effigies," I-II (1924), Pl. VII.

Meriden sc, alabaster tomb of Sir Jn Wyard. c.1404. 2 angels

in albs support cushion under head. Il Chatwin, "Monumental Effigies," I-II (1924), Pl. VIII.

Mervl-StM sc, on alabaster tomb chest, possibly of Edmund, Lord Ferrers of Chartley. c.1440. 4 angels in albs & with cross diadems holding shields on tomb chest with alabaster effigies of knight & lady. 2 further angels support cushions under head of female effigy. Il Chatwin, "Monumental Effigies," I-II (1924), Pl. IX. Cf. examples at Aston.

Polesworth sc, on alabaster tomb of Isabel, wife of Jn Cockayne. c.1447. 2 angels in albs (one on L has cross diadem but is armless; angel on R is headless & armless) at sides of pillow under head of lady. Il Chatwin, "Monumental Effigies," I-II (1924), Pl. XVII.

Meriden sc, sandstone effigy of ?Jn Walsh. c.1465. 2 angels in albs with damaged cross diadems support cushions under head. Il Chatwin, "Monumental Effigies," I-II (1924), Pl. XI.

Aston sc, on tomb of woman, possibly Eliz Clodshale. Mid-15c. 2 angels (one at L is headless) in albs beside pillow.

sc, alabaster tomb of Sir Tho Erdington, d.1433. c.1460. Angels on tomb (6 in front & 3 on end) hold shields. Chatwin notes that traces of color suggest angels "with feathers painted in black" ("Monumental Effigies," I-II, 69). Wife (Joan or Anne) has 2 mutilated angels at side of pillow & 2 others (tops broken off) beside her gown. Il Dugdale, *Ws*, 2nd ed., II, 879; Chatwin, "Monumental Effigies," I-II (1924), Pl. XIII.

sc, Harcourt tomb (alabaster). c.1462. 2 angels, seated & holding helmet; also, 10 angels in albs hold shields on side & ends of tomb. Il Chatwin, "Monumental Effigies," I-II (1924), Pls. XIII-XIV.

Astley sc, alabaster tomb effigy of Eliz Grey, d.1483. Angel on each side holds pillow. Mutilated. Il Chatwin, "Monumental Effigies," I-II (1924), Pl. XI.

Aston sc, Arden tomb of c.1490. Sides of tomb palimpsest with backs carved with angels with cross diadems holding shields from 15c turned to face inside of tomb base & plain panels with shields inside cusped squares substituted in 16c. Il Chatwin, "A Palimpsest Tomb-

Chest" (1946), Pl. XI, fig. 2.

Tysoe wdcarv on roof. Late 15c. 2 angels support shield (arms a chevron).

Bir-StMn sc, alabaster tomb of priest in choir habit. c.1500. 2 angels in albs support cushion under head; N very restored, S headless. Tomb chest with 7 angels in niches holding shields; made up from 3 panels, one obviously an end panel originally. Il Chatwin, "Monumental Effigies," IV (1926), Pls. IX-X.

Coughton im*, provided for by will of Sir Robt Throckmorton, 1518. St Raphael, to be placed in S aisle at S end of altar; to be "painted and gilded." [Dugdale, *Ws*]

Aston sc, sandstone tomb of Wm Holte. 1518. Angel in gown holds shield in each of 6 panels in side & W end of tomb chest. 2 small angels (headless) by pillow.

Snitterfld wdcarv, figs on stalls. c.1530. Angels, holding shields. Also, nude cherub with wings.

Bickenhill sc, font. 15c. Angels, with books, wearing cross diadems.

ChestH pg*. 3 angels wearing albs & holding shields. Il Dugdale, *Ws*, 1st ed., p. 379.

Curdworth sc, brought to Curdworth from Water Orton Bridge at Sutton Coldfield, & formerly in Ch of manor house. Angel, headless & lacking R arm. Popularly identified as angel of Annunciation (see Pevsner, *Ws*, p. 285), but such identification is doubtful. Some restoration (with ?plaster). Il Midgely, p. 26 (retouched photograph).

ANGEL MUSICIANS

Austrey pg Win S5.2. 14c? Fragment of angel blowing trumpet (mouthpiece only extant).

Withybrook pg Win S4.3. 14c? Fragment, possibly of angel musician, has R hand holding quill & playing mandora.

Wixford pg Wins S3-5Tr. c.1420-50. Angel musicians play mandora, organ (pipes visible, angel's arm & hands extant), ?fidel (tail piece, possibly from fidel, & portion of angel musician extant), lute, & shawm; also frag of bagpipes in Win S3Tr. 2 angels holding

scrolls which appear to have musical notation. Censing angels are also present. FIGS. 60-61; see also Chatwin, "Wixford Church" (1933), Pls. VIII-IX. Evidence of considerable damage.

Nun-StM tiles*, now indecipherable. Fig of angel with trumpet on upper L on set of 3 tiles. On R, possibly angel playing harp. Il Chatwin, "A Tile Pavement" (1949), fig. 2.

CENSING ANGELS

Mancetter pg Win 1.1T & 1.4-5T; not *in situ*. 1333-49. Angels, wearing albs with girdles & with wings & nimbuses, are censing. Mostly incomplete & patched.

NWhitacre pg Win S2Tr. 14c. Kneeling angel in alb with ornamented hem & cuffs & with green wings swings thurible.

WoottonW pg Win 1.4. 14c. Censing angel in white alb. Incomplete (head missing).

Whichford pg Win 1Tr. Censing angel in white alb, kneeling facing R. Head is replacement. 2nd angel is also largely replacement. In 1830, Tho Ward ntd angel below Crucifixion (i.e., Throne of Grace Trinity) "waving a thurible."

II. OLD TESTAMENT

CREATION, FIFTH DAY: FISH, FOWL, & BEASTS

C-FitzMus msi, McClean MS. 123, f. 30 (initial); from Nuneaton, Priory of BVM. 13c. Fully finished underdrawing for MS. illumination shows Christ, with cross nimbus and book in L hand, with R hand blessing 2 horned goats & 2 birds on R.

TEMPTATION OF ADAM & EVE

Oxhill sc, font. c.1175. Low relief sc in 2 bays illustrates thin figs of Adam & Eve, who are ashamed of their nudity (their hands cover their genitals). Tree, encircled by serpent, in bay which separates them. Serpent's head is turned toward Eve. This font returned to its proper use after being utilized as water trough & "flower vase" (Harris, *Unknown Ws*, p. 19). FIG. 35.

35. Adam and Eve. Sculpture on font, Oxhill.

JACOB & ESAU

Radway pg Win S4.2B (roundel). Late 16c. Esau at L, holding bow, hands bowl of porridge to Jacob who takes it with L hand. Jacob has spoon in R hand. On R, inside building, porridge is being cooked under fireplace. In background at extreme L is small fig of Esau shooting bow.

MOSES & TEN COMMANDMENTS

Mervl-StM pg Win 1.5M. Early 14c, but restored in early 19c, when it was placed in this win. Part of Jesse Tree which, according to tradition, was originally from MervlAb. Moses, standing & holding tables of Law in L hand & scroll (inscription: "moyses profete") in R hand. He has green mantle over tunic, & on his head he has traditional horns. Patched.

PROPHETS

Astley painted stalls, S side. c.1400. Current inscriptions date from 1624 & are in English; previous inscriptions are painted over, & only 3 prophets can be identified even tentatively (Hosea, possibly on S1; Malachi on S6; & Isaiah, Jeremiah, or Joel on S4). These prophets are set off against apostles holding inscriptions with clauses of CREED (see below). Il Houghton, "Astley Church and Its Stall Paintings," Pl. IX.

ISAIAH

Wroxall pg Win N6.2B. Possibly Isaiah, seated (restored fig, currently holding book). Inscription "Isaia Prophet" is old.

SYBILS

Coughton pg Win 1.2-4; formerly in N Ch. c.1530. 3 sybils. Heads are modern (19c replacements). Their garments (mantles over gowns) are exotic & lavish; they wear sandals. Renaissance in style. One (Europa) holds sword; anr (Persica) holds lantern with candle; third (Samia) holds cradle (FIG. 36). Portion of inscription ("SIBILLA PER") identified second sybil.

JESSE TREE

Mervl-StM pg Win 1.1-5T & M. Early 14c, but restored in early 19c, when glass was placed in this win. According to

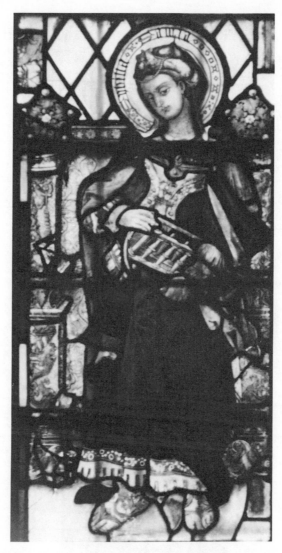

36. Sybil. Samia, with cradle. Painted glass, Coughton.

tradition, pg was originally from MervlAb. Figs in
Jesse Tree include: David (Win 1.2M) playing harp with
R hand & holding scepter with L; he is crowned, &
seated (cross-legged); harp has ornament (head of
monkey) on top (il Rackham, Pl. XIV); K Solomon (Win

1.3M), crowned & holding sword in R hand & scroll with
identifying inscription in L; Zephaniah (Win 1.1T),
standing & holding vine with L & R hands (FIG. 37);
scroll reaches upward from R hand (inscription:
"Sophias profete"); mantle over head looped over arms
(tunic underneath); crowned Ezekiel (Win 1.4M), seated

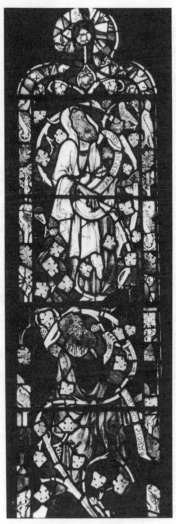

37. Prophets from Jesse Tree: Zephaniah and Malachi. Painted
glass, Merevale.

& holding scepter in L hand & identifying scroll in R;
Malachi (Win 1.1M), standing, looking upward, & taking
hold of vine with R hand (in his L is identifying
scroll) (FIG. 37); K Josiah (Win 1.4T), crowned,
seated, & holding scepter in R hand while pointing
upward with L (index finger extended) & holding
identifying scroll; Isaiah (Win 1.5T), standing &
taking hold of vine with L hand while with veiled R
hand he holds identifying scroll; Moses (Win 1.5M),
identified as prophet (see MOSES & TEN COMMANDMENTS,
above); anr king, unidentified (Win 1.2T), who holds
sword in R hand (feet & L hand missing; tunic patched;
no inscription). Bottom row of figs contains modern
replacements modelled on examples in old glass. All
figs fit frame formed by vine. Figs of Jesse & BVM
are missing.

Mancetter pg Win 1.2-3. Later 14c. Figs from Jesse Tree (3
figs only): David, crowned, seated with crossed legs,
& playing harp (its frame has dragon-swallowing-its-
tail design). In R hand, he is also holding small
cross-head staff. He wears yellowish cloak over
tunic. Fig is somewhat disarranged in lower half.
FIG. 38. Jeconiah is identified by inscription

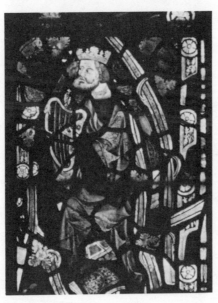

38. David, from Jesse Tree. Painted glass, Mancetter.

"IECONIAS" in Lombardic script on scroll held in L
hand. He has crown & yellowish cloak with patterned
hem over light blue tunic. He wears white gloves, &
has yellow shoes. Il Rackham, Pl. XIV. King ?Abias,
tentatively identified by Newton (III, 897) from frag-
mentary inscription in Lombardic script ("A‡") on
scroll in R hand, holds sword in L hand (point rests
above shoulder). Standing fig is crowned & has cloak
over light blue tunic with patterned hem as well as
white gloves & patterned shoe. Head decayed. Each of
3 figs fits into frame formed by vine. Rackham notes
that this glass is similar to that in Merevale though
it is less good (pp. 92-3). Il Rackham, Pl. XIV.

III. PARENTS OF VIRGIN & HER LIFE (TO NATIVITY)

PARENTS OF THE VIRGIN

WoottonW wp*, S Ch, S wall, discovered 1918. Perhaps included refusal of Joachim's offering (red demon above altar), & Joachim & St Anne at Golden Gate. Now indistinct. [Turpin]

BIRTH OF BVM

WoottonW wp*, S Ch, S wall. Birth of BVM, discovered in 1918 but now faded & indistinct. [Turpin]

ST ANNE TEACHING BVM TO READ

Knowle seal, College of St Anne at Knowle. c.1400. Under canopy, St Anne (standing, with veil & nimbus, at R) teaches BVM (also with nimbus) to read from book. Inscription identifies Ch & chantry founded in time of Rich II. Tonnochy, No. 843. Il ibid., Pl. XXIV.

 seal, Gild of St Jn Baptist, St Lawrence, & St Anne at Knowle. 15c. Center, St Anne (at R) teaching BVM to read; L, St Jn Baptist; R, St Lawrence. Tonnochy, No. 884; *Catalogue of Seals*, No. 4464. Il Tonnochy, Pl. XXV. Later seal (c.1540) il Wheler, *Collections*, f. 90.

Mervl–StM pg Win N4Tr. c.1530. St Anne (seated, under canopy, R) is teaching BVM (standing at L) to read from book. Each has nimbus; St Anne has wimple.

PRESENTATION OF BVM IN TEMPLE

Kinwarton al, found in carpenter shop at Binton. 15c. Dedication of BVM. High priest (wearing hat) with hands raised at R, behind altar. BVM is being presented as child by her parents, Anne (wearing veil) & Joachim: she is ascending 7 steps, which are placed immediately before altar. Bottom trimmed: Joachim's feet missing, as is also bottom of angel who is censing altar. Behind are 5 women in prayer with hands joined; all are wearing veils. Il Chatwin, "Kinwarton Alabaster Table" (1935), Pl. XXXIV.

112

BLESSED VIRGIN MARY

KenilP seal, from Austin Priory (later Abbey) of St Mary,
 Kenilworth. 1299. First seal of Priory shows BVM
 crowned with nimbus & wearing mantle over gown; she
 holds book in R hand, & is seated atop roof of Priory
 Church, where she takes hold of pinnacle of lantern
 tower with R hand. Reverse shows angel. *Catalogue of
 Seals*, No. 3333.

Ufton sc, churchyard cross. 14c; restored 1862. Seated BVM
 (head gone; very poor condition).

Henley im*, Lady Ch, ntd will of Wm Reynolds, 1507. BVM.
 [Cooper, *Records of Beaudesert*]

Unknown j, devotional medals (2) found in grave of Sir Edw
 Saunders & his wife Margery at Weston-under-Wetherley.
 1563-76. Each illustrated BVM in prayer with in-
 scription (complete on one medal only): "S. MARIA
 CONCEPTA FUIT SINE PECCATO ORIGINALI." Il Tho Ward,
 Collections, f. 170.

Coughton pg Win S6.2 (roundel). Head of BVM with cross nimbus.
 Worn.

Knowle wp*, ntd 1793 in *Gentleman's Magazine*, p. 422; in
 1814, wp showed full-length BVM, anr st, & angel.
 [Britton *et al.*; Keyser]

Mervl-StM im* (?sc), in former Ch by monastery gate, was
 venerated by pilgrims. BVM. [Harris, *Some Manors*]

ANNUNCIATION

Withybrook pg Win S2.2. Late 14c? Angel is holding staff in R
 hand; L hand is raised in greeting. Top is missing.
 Possibly from Annunciation.

Wroxall pg Win N6.1B & N6.3B; not *in situ*. 14c? Restored (or
 made-up) Annunciation, with angel at L (R hand raised,
 index finger extended; holding scroll with L hand) &
 BVM with long blond hair, holding book, on R. Dove
 descending by Virgin. She wears blue mantle over
 garment with sleeves, & is seated. Fig of Isaiah
 between these panels in Win N6.2B.

Haseley pg Win W1Tr. c.1410, but restored with much modern
 glass. Gabriel (robe all patch) appears with BVM
 (lower part of robe is modern), who is kneeling before

prayer desk (lily pot is in front of it). Inscription in scroll seems mostly modern. 2 donors, both ecclesiastics, appear below.

Mervl-StM pg Win 1Tr (above Light 3). 15c. 2 panels show BVM & Gabriel; salutation on scrolls: "ave maria *gratia plena*" on angel's scroll, & "ecce ancilla *domi*ni" on Mary's. Both figs are standing. Gabriel (head missing) wears white tunic with design in yellow stain, & holds scroll in L hand. BVM holds scroll in L hand. Her hair is blond (yellow stain), & she has nimbus.

Sheldon sc*, reredos, reset in N wall of aisle. 15c. Reredos has 2 niches formerly holding Annunciation figs. Stone carving at L cut away; silhouette only in niche; carving at R treated likewise. Dove above on R was also perhaps cut away.

Wroxall pg Win 1.1B. 15c. BVM, at R, in blue mantle (ermine underneath), at desk with open prayer book. Gabriel has alb & peacock wings. Heads, etc., are modern, but apparently some old glass.

Coughton im*, in S aisle at N end of altar, provided for in will of Sir Robt Throckmorton, 1518. Separate images of Gabriel & BVM, to be painted & gilt. Gabriel was to have "Roll in his hand of greeting, looking toward our Lady." [Dugdale, *Ws*]

Mervl-StM pg Win N4Tr. c.1530. 2 lights have angel with peacock-feather wings & staff with lion mask, & BVM behind prayer desk with open book on it. Anr book is falling to floor. Behind her are curtains on rod. She wears long cloak which falls to floor. She shows signs of surprise, with hands raised. Though these 2 scenes do not match perfectly in their current state, they probably were intended as a pair to make up an Annunciation.

Whichford pg Win S4Tr. 14c? Seated BVM, facing R, hands clasped, surely from Annunciation since Dove appears above in anr tracery light. She is crowned & has nimbus. (A replica of this fig in restored state is also present.)

WoottonW wp*, S Ch, S wall, discovered 1918, but now faded & indistinct. Annunciation was present. [Turpin]

ST ANNE WITH BVM & CHRIST CHILD

WsMus pg, formerly at Compton Verney. c.1527. Donor panel shows Anne Verney with her 5 daughters; above prayer desk is im of St Anne with BVM & Child. St Anne, seated with veil over head, holds closed book in L hand; at her feet is BVM with gown spread out around her & holding Child on lap. Il Eden, p. 116.

IV. THE INFANCY OF CHRIST

NATIVITY

Henley-StJ wdcarv*? 15c? Rood loft canopy, discovered in "res-
toration" of 1856, contained words "Nativitas Domini
nostri" at L; other scenes were Assumption (center) &
Resurrection (R). [Hannet, *Forest of Arden*]

NATIVITY WITH RECUMBENT BVM

AstonC sc, carving over N doorway in niche (exterior). 14c?
Very battered. Recumbent BVM. Jos is at foot of bed
(head only remains). Child is missing.

BVM ADORING CHRIST CHILD

CoughtonCt al, with some original paint. 15c. Brigittine de-
sign, with BVM kneeling with hands joined in adora-
tion, center, before Child, who is lying on ground on
her mantle which is extended before her. Jos, holding

39. Detail of Nativity. Alabaster, Coughton Court. Reproduced
by permission of Sir Robert Throckmorton and the National Trust.

116

crutch & cap, at R; ox & ass behind Child. At L is a
?midwife. Angel, above with scroll with words "Gloria
in excelsis," has red wings spotted with black. BVM
has gilt hair & crown; inside of her mantle is blue.
Jos has red garment under white coat. Child is partly
broken away, as is angel above & fig behind BVM (?mid-
wife). FIG. 39; see also Chatwin, "Three Alabaster
Tables" (1925), Pl. XXXIV.

Mancetter pg*; extant frag in Win 1.2 rft 4. 15c. Portion of
Jos, holding candle & taking covering from his head;
presumably from original Nativity scene, now lost.

Wroxall pg Win 1.3B. 15c. Fig of Child, below L, seems orig-
inal (in aureole on ground, with one hand raised).
Remainder of scene is patch.

BVM AND CHILD

CombeAb seal, from Combe (Cumbe), Cistercian Abbey of St Mary.
13c. Chapter seal shows BVM, crowned, with Child on L
arm; on R, an abbot (?St Bernard). *Catalogue of
Seals*, No. 2989.

Bir-Mus pl, pewter. Weoley Cruet, from site of Weoley Castle,
Birmingham. c.1300-50. BVM with Child on L arm.

MervlAb seal, from Cistercian Abbey of St Mary, Merevale.
13c. BVM, crowned, seated on throne; Child on L knee.
Catalogue of Seals, No. 3628.

Kinwarton pg Win S2Tr. Early 14c. BVM, standing, with crown &
nimbus (head is modern, painted on old glass, ac-
cording to Newton, III, 889). Child (also modern,
painted on old glass) is on her L arm; rose in R hand.
Her gown is white with border & gold-brown mantle.
Below, green dragon with modern wings & tail. Male
figs (one on L has modern head & nimbus) on each side
hold hands in prayer as they adore Child. Il Pevsner,
Ws, Pl. 9; Chatwin, "Medieval Glass from Kinwarton
Church" (1938), Pl. 1.

Aston sc, frag of churchyard cross, S Ch. 14c. BVM, sit-
ting on bench, is crowned; she holds Child on R knee
(her L arm is around him). Child holds object (?book)
in L hand; R hand is worn away. Virgin's R hand holds
anr object (?bird).

Ansley pg Win N2.3B. 14c? Seated BVM is crowned, wearing
yellow gown, & holding scepter in L hand while she

holds Christ Child, also wearing yellow gown, on her R arm. Child, with nimbus, holds ?fruit in L hand & extends R hand. Il Cossins, *Notes on Ws Churches*, f. 16.

Polesworth seal, from Benedictine Abbey of SS Mary & Edith, Polesworth. 14c. Second seal of abbey shows BVM, crowned & standing with Child on R arm; in L hand is scepter. At L is Jn Evangelist; at R is St Edith. *Catalogue of Seals*, No. 3851. Il Aylesworth Collection: Ws Country Seats, II, 580.

Tysoe sc, font. 14c. Figs of BVM, crowned, & Child, held on her L arm, under crocketed gable. With L hand, she holds ball.

Wixford sc*, churchyard cross. 15c. Now fragmentary & indecipherable. Head of cross had crucifix on one side, BVM & Child on back. Standing BVM in garment looped over upper body held Christ Child on L arm with R arm raised & touching Child's R hand. Child held circular object in L hand. BVM with long hair & circlet; Child in long robe. Lower parts of both figs were damaged. Il Houghton, *Ws Churches*, II, figs. 2870-71.

Caldecote pg Win S7.2. Early 15c? BVM, crowned & with long blond hair, is standing with Child on R arm & with scepter held in L hand. She wears blue gown under red mantle with ermine lining. Child, wearing yellow garment, has cross nimbus & holds unidentified object. Inscription: "maria."

KenilP seal of Abbot of Kenilworth Abbey. 1533. BVM, crowned & seated in niche, with Child on L knee. She holds scepter in R hand. Below, abbot is praying. *Catalogue of Seals*, No. 3339. Il Aylesford Collection: Ws Country Seats, I, 396 (No. 2); second seal of BVM & Child under 16c canopy, I, 396 (No. 1).

CoughtonCt v, embroidered on back of cope, attributed to Q Cath of Aragon. Early 16c. BVM, seated on throne, holds standing Child on her lap. Child, wearing gown, has L hand receiving small gold heart from mother, who has gold mantle with ermine undergarment. Both have nimbus.

Arrow sc, fragment of head of churchyard cross. BVM (bottom only), seated on throne, with Child (top broken away).

118

ADORATION OF MAGI

BurtonD wp, N transept, beside Win 5. 14c? Crowned head of
 king & L hand holding gift, apparently from Magi
 group.

Chesterton sc, now above S porch (not *in situ*). 14c. 3 figs
 beneath niches bearing objects in hands. Fig on R
 kneeling, others standing. All headless. Probably
 from reredos of Adoration of Magi.

NewnhamR wp*, N wall of chancel. c.1630. Dr Thomas in 1730 in
 his edition of Dugdale (p. 102) reported the presence
 of "the offerings of the wise men." Destroyed in
 1745. [Dugdale, *Ws*, 2nd ed.]

PRESENTATION IN THE TEMPLE

Wroxall pg Win 1.4B. 15c. Jos, with crutch, holds basket
 with 2 doves, behind BVM, holding Child. Zacharias
 stands behind altar. Heavily restored panel, but
 lower portion is old. FIG. 40.

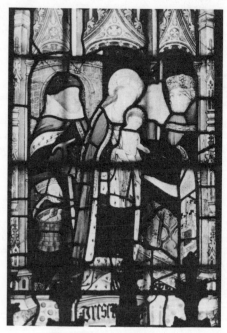

40. Presentation. Heavily restored painted glass, Wroxall.

V. MINISTRY

ST JOHN THE BAPTIST

Mancetter pg Win 1.2 rft3; formerly in Win N5Tr. 1333-49.
Bearded St Jn Baptist holds roundel with Agnus Dei
(incomplete) in R hand; L hand raised. He wears yel-
low camel's hair garment, & has blue nimbus. Standing
in landscape. Il Rackham, Pl. XIV.

Mervl-StM pg Win S5Tr. 14c. Fig of st, with blue nimbus. Poor
condition; lower part incomplete.

Henley seal, Gild of H Trinity, St Jn Ev, & St Jn Baptist,
Henley-in-Arden. 15c. On L, Jn Baptist with Agnus
Dei. Central fig is Trinity. *Catalogue of Seals*, No.
4991.

Knowle seal, Gild of St Jn Baptist, St Lawrence, & St Anne at
Knowle. 15c. St Jn Baptist standing with Agnus Dei
on L; at R is St Lawrence; center, St Anne teaching
BVM to read. Tonnochy, No. 884; *Catalogue of Seals*,
No. 4464. Il Tonnochy, Pl. XXV. Later seal (1540) il
Wheler, *Collections*, f. 90.

ST JOHN THE BAPTIST PREACHING

WoottonW wp*, S Ch, S wall (no longer visible). Jn preaching
to people, who kneeled; also preaching in wilderness.
Outlines of this wp were studied by Turpin in 1919,
but it is now indistinct. See also BAPTISM OF CHRIST,
below.

ST JOHN'S HEAD

US-UNC al, formerly at CoughtonCt. Early 15c? St Peter at L,
St Tho of Canterbury at R on representation of St Jn's
Head. Below, Christ of Pity. FIG. 41.

AGNUS DEI

Curdworth sc, font. c.1050. Lamb over open hell mouth, flaming
(=Satan?), upon which hind feet are placed. Parts of
cross & head of lamb are missing. Il Houghton, "Ws
Fonts," Pl. VIII; Houghton, *Ws Churches*, I, figs.
2515-17.

Whitchurch sc, low relief carving, reset by c.1670 over doorway.

c.1190. Formerly in tympanum. Lamb, facing R & set
in roundel with foliage in spandrels. Cf. sc at Ty-
soe.

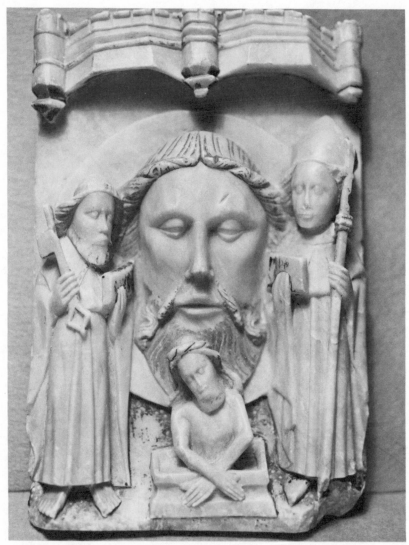

41. St. John's Head, with St. Peter, St. Thomas Becket, and
Christ of Pity. Alabaster, Ackland Art Museum, University of
North Carolina, Chapel Hill. Ackland Fund. Purchased in honor
of John M. Schnorrenberg, Professor of Art (1959-76).

Tysoe sc, reset tablet over S door in arch. Late 12c or early 13c. Lamb & cross, with roundel with foliage in spandrels. Cf. sc at Whitchurch.

Bir-Mus pl, pewter. Weoley Cruet, found at site of Weoley Castle, Birmingham. c.1300-50. Base has Agnus Dei & inscription: *Agnus Dei qui tollit peccata.*

Studley sc, reset over capital of N jamb, chancel arch in 1888. Bird suggests that it is originally from Studley Priory. Early 13c. Agnus Dei with cross nimbus & cross staff.

NewtonR sc, in gray sandstone, on semi-effigy of priest (?Jn de la Worde). c.1330. At foot of monument is possibly representation of Agnus Dei. Il Houghton, *Ws Churches*, I, fig. 2313.

Chadshunt wdcarv, nave roof beam carved with Agnus Dei with cross banner. 15c.

Tysoe rb, over font in nave. Late 15c. Agnus Dei with cross staff & banner.

BAPTISM OF CHRIST

Tysoe sc, font. 14c. Figs under crocketed gable. St Jn Baptist stands at L, with Christ standing with hands clasped in water at R. St is using jug to perform rite of baptism.

WoottonW wp*, S Ch, S wall (no longer visible). Baptism of Christ. Pot was being used in rite. Outlines of this wp were studied by Turpin in 1919 following discovery in previous year.

MINISTRY: CHRIST & APOSTLES

Brailes wp*. Heads only were extant in 19c. Perhaps lost in restoration of church in 1879. Possibly Ministry scene. [Keyser]

VI. THE PASSION

CHRIST BEFORE PILATE

Unknown wdcarv, panel on chest in Snitterfield vicarage until 1920's. 14c. Christ before Pilate on one panel. [Hart]

SCOURGING

ComptonWy wdcarv, carved screen in Ch. 16c. Scourging, with Christ bound to pillar at hands & feet between 2 standing male figs, one on R with scourge.

MOCKING

ComptonWy wdcarv, carved screen in Ch. 16c. Mocking. Central fig of Christ is bound at wrists & is having crown of thorns placed on his head by 2 figs using long poles. Further figs, including demon, beneath.

CHRIST CARRYING CROSS

ComptonWy wdcarv, carved screen in Ch. 16c. Robed fig of Christ is carrying cross with small fig of soldier carrying halbert behind & pointing with L hand. Figs of BVM & St Jn at L & angels above.

Unknown wdcarv, panel on chest in Snitterfield vicarage until 1920's. 14c. Christ is bearing cross on one panel. [Hart]

VERNICLE

CliffChbrs pl, paten. 1494-5. Paten with engraved vernicle.

Wolston pl, paten. 1518. Stylized design. Circle is surrounding cross nimbus which in turn surrounds head of Christ. Circles were carelessly drawn. Jeavens, No. 2. Il ibid., Pl. 1.

PASSION

Wolston sc, capital, chancel arch N. c.1300. Cross, with standing fig on each side. Fig on L has hands bound. Possibly Passion scene.

MaxstokeP pclg*, painted chamber, Prior's lodging, destroyed

mid-19c. Heads of Christ & his enemies--Caiaphas, Herod, Pilate, & Judas--appeared, along with INSTRU- MENTS OF PASSION (see below). [Holloway, "Maxstoke Priory"]

SIGNS OF THE PASSION

Atherstone sc, font. 15c? Possibly recarved. Instruments of Passion on shields: robe & dice; ladder, sponge, & spear; scourges & pillar; cross, hammer, pincers, 3 nails.

MaxstokeP pclg*, painted chamber, Prior's lodging, destroyed mid-19c. Mid-15c. Ceiling was painted with follow- ing: lantern, cresset, ladder, sponge, reed, hammer, spear, cruet, dish, maniple, 3 cylindrical boxes with conical tops, sword, pick, aspergillum, knife, tunic, dice, rods (crossed), cross, crown of thorns, pillar, scourges. Also included were heads of Christ & his enemies; see PASSION, above. [Holloway, "Maxstoke Priory"]

WsMus pg, formerly at Compton Verney. c.1558. Donor panel of Lady Anne Verney (d. 1558) has im of angel holding cross on side of prayer desk. Il Dugdale, *Ws*, 1st ed., p. 439; Kirby, "The Compton Verney Glass," *Coun- try Life*, p. 1133.

Wroxall pg Win 1Tr; probably not *in situ*. 15c. Angels, some with multiple wings, in albs bearing shields with signs of Passion: pillar & cords, moon & sun, spear & sponge, 3 nails, vernicle, crown of thorns, cross, pelican, robe, 3 dice.

FIVE WOUNDS

Nun-StNich rb, S aisle, shield with 5 wounds. 15c?

wdcarv, cartouche-shaped shield with 5 wounds over chancel arch. 16c? Il Herbert, *Parish Church of Nuneaton*, p. 22.

ARMA CHRISTI

Austrey pg Win S5.2T. 14c. Signs of Passion (cross, crown of thorns, spear, 3 nails, 2 scourges) on shield.

Rowington sc* on shields on 4 merlons of parapet of central tower. Passion symbols.

JESUS

C-FitzMus msi, McClean MS. 123, f. 59 (pencil sketch); from Nuneaton, Priory of BVM. 13c. Christ, with book, appears in center, flanked by 2 saints on L, anr on R. Sts on R & far L are both blessing.

Mervl-StM pg Win 1Tr (above Light 3, at top). 14c. Head of Christ, facing 3/4 R, with cross nimbus.

NWhitacre pg Win 2Tr. 14c. Small head of Christ (frontal) with cross nimbus. Very discolored; details obliterated.

Whichford pg Win S4Tr. 14c. Head of Christ, frontal, with cross nimbus. FIG. 42.

42. Head of Jesus. Painted glass, Whichford.

CRUCIFIXION

BM iv, head of tau cross, found in rectory garden at Alcester pre-1903. Early 11c. Christ, wearing loin cloth & with cross nimbus, on cross. Head of fig missing, & cross is broken off at ankles. Reverse has Christ in Triumph trampling beasts. FIG. 43; see also Beckwith, fig. 66; Longhurst, Pl. 18.

Unknown im; ?Limoges enamel; found in churchyard at Kings Norton. 13c. Fig of Christ from crucifix with loin-cloth in blue & white champlevé enamel. R hand missing. Crowned, feet uncrossed & held with 2 nails. Il Holliday, "Church and Grammar School of Kings Norton," Pl. IV.

43. Detail of Crucifixion. Ivory carving, Alcester Cross. Courtesy of the Trustees of the British Museum.

Packwood pg Win N5.2. Early 14c. Christ on cross with arms outstretched. His feet are attached with single nail; he has crown of thorns, & is nude except for loincloth. Inscription "NRI" above head. Harris suggests that this glass is from Cv since Packwood was formerly a chapel of Wasperton, & both were manors owned by Cv monks (*Some Manors*, p. 201).

Ufton sc, churchyard cross. 14c; restored, 1862. Crucifixion. Almost entirely worn away. Il Nelson, "Mediaeval Churchyard & Wayside Crosses," Pl. 15.

Ilmington sc, base of churchyard cross. Late 14c or early 15c. Panel (toward church) has crucifixion (almost worn away). Il Nelson, "Mediaeval Churchyard & Wayside Crosses," Pl. 15.

CliffChbrs pl, chalice. 1494-5. Chalice has Crucifixion & word "Jesus" on foot. Wounded Christ on cross. FIG. 44.

Wixford sc*, churchyard cross. 15c. Fragments; no longer decipherable; head had Crucifixion on front, & BVM & Child on back. Fig of Christ with elongated torso & looped loincloth reaching to knees. Legs crossed below

126

knee & broken off at that point. Arms were missing but
seem to have been raised above head. Clean shaven. Il
Houghton, *Ws Churches*, II, fig. 2872. [Nelson,
"Mediaeval Churchyard & Wayside Crosses"]

Arrow sc, frag of head of churchyard cross. Crucifixion.
Bottom portion of Christ on cross; long loincloth (to
knees) & legs (R foot over L) survive. Feet held with
single nail.

44. Chalice with Crucifixion on foot. Clifford Chambers. Cour-
tesy of Royal Commission on Historical Monuments (England).

Knowle pg* Win 1. Reported by Cossins, *Notes on Ws Churches*,
 II, 44; il (sketch) ibid. 17c drawing in BL Egerton
 MS. 3510, f. 16, shows donor kneeling before Crucifix.

Ratley sc*, churchyard cross. Crucifix. Though cross was
 reported by Miller in 1889 to be in "perfect" condi-
 tion, now deteriorated beyond recognition. Il Nelson,
 "Mediaeval Churchyard & Wayside Crosses," Pl. 15.

Tysoe sc*, churchyard cross. Crucifixion on head of cross
 is now lost, but lower portion is il Nelson, "Medi-
 aeval Churchyard & Wayside Crosses," Pl. 15.

CRUCIFIXION WITH MARY & ST JOHN

Halford sc, relief fig (defaced), in niche at R of chancel
 arch. Early 12c. Discovered 1960. Probably St Jn,
 from Crucifixion, indicating cross with hand. How-
 ever, fig is so defaced that certain identification is
 difficult, & Kahn (pp. 70-1) suggests that it might
 have been BVM from Annunciation group (Gabriel would
 have been in niche on L of chancel & perhaps dove over
 chancel arch). Il Kahn, Pl. XX.

Coleshill sc, font. Mid-12c. Crucifixion, with BVM (one hand
 clasped over other; face worn off) & Jn, who has R
 hand lifted to face. Christ's head tipped to his R;
 ribs visible, but arms are not stretched into V shape.
 Fig of Christ encircled with pierced ring. Sun & moon
 appear above. Il Houghton, "Ws Fonts," Pl. XI.

Bir-Mus pl, pewter. Weoley Cruet, found at site of Weoley
 Castle, Birmingham. c.1300-50. Crucifixion with BVM
 & St Jn. Christ has legs crossed & tucked upward
 awkwardly.

Aston sc, fragments of churchyard cross (square) carved on 4
 sides, S Ch. 14c. Crucifixion, with BVM & St Jn.
 Christ's R foot is over L; he has long loin cloth that
 reaches almost to R knee. BVM holds up hands (joined)
 in prayer. St Jn has R hand lifted to face; he is
 clean-shaven.

Arley pg Win N4.2. Mid-14c. Only St Jn remains (standing &
 facing toward L, with head bowed & R hand raised to
 it). He holds book in L hand. He has orange mantle
 over green tunic, hair of yellow stain, & nimbus. His
 feet are lost (portion of toes of L foot remain).
 Original design presumably included BVM on L & cruci-
 fied Christ in center.

Polesworth sc, head of churchyard cross, now in N aisle. 14c?
Mutilated Crucifixion with BVM (hands clasped across
waist, wearing mantle over dress) on L; R side broken.
Very poor condition. Anr mutilated fig has book &
staff.

BurtonD wp, over chancel arch. Late 14c. On L, BVM, wearing
white veil over head, has mantle over red gown. She
has hands clasped. On R, probably St Jn (very frag-
mentary). Christ formerly on cross, center; dowel
holes reported to indicate presence of wooden cross
with crucified Christ. On each side, censing angel in
alb with wings spread swings thurible. Angel on L has
cross diadem on head. Below are other indecipherable
figs reported to be from earlier wp of Passion. FIG.
45; see also O'Shaughnessy, pp. 5, 15.

45. Virgin Mary, from Crucifixion scene. Wall painting, Burton
Dassett.

CoughtonCt iv, pax. Late 14c. Christ on cross betw BVM on L &
Jn on R. Wearing loincloth only, Christ has feet
attached with single nail.

Henley sc*, market cross. Late 15c. Fig of crucified Christ
 formerly in niche, along with figs of Mary & St Jn
 which were already very worn in early 19c. Il *Gentle-
 man's Magazine*, 85 (1815), Pl. facing p. 129.

Preston pl, chalice; formerly in collection of Js West of
 Alscot, who regilded it & presented it to church in
 1747. On foot, panel (triangular inlay) has Cruci-
 fixion with BVM & St Jn. Jeavons, No. 268. Il ibid.,
 Pl. 2.

ComptonWy pg* Win 1. 1530. Crucifixion, probably with BVM &
 Jn. [Dugdale, *Ws*]

Bir-GHC seal of Gild of H Cross of Birmingham. Crucifixion
 with feet held with 2 nails; fig on each side, pre-
 sumably BVM & St Jn Ev, the latter holding book. Il
 Burgess, *Historic Ws* , p. 219; Brassington, p. 69;
 impression in Birmingham City Museum.

46. Extant head of Christ from Deposition (destroyed) at Newnham
Regis. Wall painting. Reproduced by permission of the Warwick-
shire Museum.

130

BadClint pg* Win 1.3. Early 16c? Glass currently in win is
 much-restored replacement by Edw Ferrers, 1634 (much
 18-19c glass). Scene was reported by Dugdale, who
 noted that Sir Edw Ferrers appeared with scroll con-
 taining inscription "Amor meus Crucifixus est." Also
 shown were Ferrers' wife, Lady Constance, & their
 children as well as her father, Nich Brome. All kneel
 before Crucifixion. Very little early glass would
 appear to have survived in this window. Il Cornforth,
 p. 1805.

DEPOSITION

Unknown wdcarv, panel on chest in Snitterfield vicarage until
 1920's. 14c. Panel on front of chest illustrated
 body of Christ supported by standing male fig on R
 with group of 3 figs on L. Il Hart, p. 80.

WsMus wp, fragments of wp formerly at NewnhamR. c.1630.
 Head of Christ is extant. Pale head of dead Christ
 with drops of blood on forehead, which is supported on
 L by hand (3 fingers only surviving). 2 further frag-
 ments of male heads also in WsMus. Dr Thomas in 1730
 reported (in Dugdale's *Ws*, 2nd ed., p. 102) the scene
 of "the taking down of our Saviour from the Cross."
 Destroyed in 1745. FIG. 46.

IMAGE OF PITY

Astley iv, discovered in excavation of N transept. 14c.
 Image of Pity. Damaged fig of Christ seated on low
 throne with bare torso & drapery around L shoulder &
 over lower parts of body. L hand raised with palm
 outwards. R arm broken at forearm but also raised.
 Torse around forehead. Considerable damage to lower
 part of fig. Probably from head of pastoral staff.
 FIG. 47.

Mervl-StM pg Win 1.3T. 15c. Fragmentary, patched into Jesse
 Tree. Damaged fig; arms & head with cross nimbus
 (frontal view). Arms are raised to show marks of
 scourging & wounds in hands. He is cross-eyed.

US-UNC al, formerly at CoughtonCt. 15c? On alabaster table
 of St Jn's Head, a crucified Christ (half fig) rising
 out of tomb. Crown of thorns, wounds in hands pro-
 minently displayed. FIG. 41.

47. Figure of Christ from Image of Pity. Ivory, discovered at Astley.

BURIAL

CoughtonCt wdcarv, probably of German or Low Countries origin. 15c? Burial of Christ, who is placed on tomb with Jos of Arimathea & Simon at head & feet. Kneeling Mary Magdalene with ointment jar in L hand anoints Christ's R arm which is hanging down (she grasps it with her R hand). BVM has her hands joined in prayer behind body, which is dressed only in loincloth.

HARROWING

L-RCF sc, relief carving which had been reset on W wall of vestry at Billesley (removed). 12c (possibly earlier). Poor condition. Certainly the scene is from Harrowing. Christ, with cross nimbus, holds cross staff in R hand. Anr nimbed head is at his L. Christ is grasping forearm of fig with his L hand. Il Morris, "The Hereford School," Pl. LXXXIb.

WoottonW wp*, S Ch, S wall. Discovered in 1918, but now com-
 pletely faded. Originally included Harrowing. [Tur-
 pin]

EASTER SEPULCHRE

Beaudesert ESp. 14c or earlier.

Cubbington ESp, restored 1855. 14c?

48. Easter Sepulchre, Withybrook.

Arley ESp. 14c. Recess, currently with inserted tomb
 sculpture. Foliage decoration with finial.

Bilton ESp. 14c. Bird thinks it is a combined founder's
 tomb & ESp, "one of the finest in Midlands."

Ladbroke ESp. 14c. Mutilated. Very simple in design, with
 foliage decoration.

LItch ESp, chancel N. 14c. Crocketed.

NewtonR ESp. 14c. Currently niche contains semi-effigy of
 priest (?Jn de la Worde).

Withybrook ESp. c.1450. Formerly this ESp had 2 sleeping sol-
 diers carved on tomb-chest. 2 soldiers (mutilated &
 headless) remain in recess above; one on L wears plate
 armor, & other (on R) wears tunic over plate armor &
 was holding sword. Also extant is mutilated angel
 (frontal). ESp had been plastered over after being
 mutilated with projecting portions crudely cut away;
 uncovered, 1848. Some remains of color extant.
 FIG. 48.

Wolverton ESp. 14c. Molding from ESp extant but raised and
 reset.

Coleshill ESp*, ntd will of Sir Simon Digby, d. 1520. [Chatwin,
 "Monumental Effigies"]

Solihull ESp*, ntd Churchwardens' Accounts, 1534-5: "item re-
 ceived for easter boxe and sepulchre light xx s";
 "item paid to the sexton for watching ye sepulchre
 lyght ii d" (p. 17); item paid for xii lb waxe for
 Sepulchre lyght vii s" (p. 19).

Ansley ESp, N Ch. ESp on N wall has nail head decoration.

VII. THE RISEN CHRIST

THE RESURRECTION

Unknown wdcarv, panel on chest at Snitterfield vicarage until 1920's. 14c. Resurrection on panel on front of chest illustrated Christ in long garment looped over shoulder. Holding staff in L hand & blessing with R, he is stepping out of tomb. 2 seated soldiers in front & 2 further behind tomb. Il Hart, p. 80.

Bramshall, pg, formerly at Compton Verney & now at Bramshall
Staffs (Staffs) Church, SW nave win, inserted c.1772. 18c copy of medieval glass also at Warwickshire Museum. Date of original glass, c.1537. Donor panel of Alice Tame Verney has im of Resurrection with Christ holding vexillum & rising in cloud above tomb; 4 soldiers below, 3 with swords and shields around tomb. Il Dugdale, *Ws*, 1st ed., p. 439; Moss, "A Lost Window," p. 1134.

Weston sc, monument to Sir Edw Saunders & 2nd wife Agnes, 1573. Oblong relief (mutilated) with 7 reclining or seated soldiers with combination of plate armor & classical military garb. 3 hold pike staffs. Christ has R leg in tomb & is stepping out with L leg (damaged); arms & head are also missing. He wears loincloth & flowing cape.

AstonC pg Win N4Tr. Foot & piece of garment above it only extant; blood is flowing from wound in foot.

Henley-StJ wdcarv*? Rood loft canopy, discovered in restoration of 1856, contained words "Resurrectio domini nostri" at R; at L was Nativity, &, center, Assumption. [Hannett, *Forest of Arden*]

ANGEL & THREE WOMEN AT TOMB

WoottonW wp*, S Ch, S wall, discovered 1918 but now completely faded. Perhaps 3 Marys at sepulchre. [Turpin]

APPEARANCE TO MARY MAGDALENE (HORTULANUS)

Unknown wdcarv, panel on chest at Snitterfield vicarage until 1920's. 14c. Hortulanus scene on panel on front of chest. Christ in loose robe with upper torso bare; he is holding staff in L hand with R hand raised. St

Mary Magdalene kneels at his feet. Il Hart, p. 80.

Mervl-StM pg Win N4Tr. c.1530. Risen Christ, whose body is bare under cloak, is hidden in part (by bush in foreground) on R; Mary Magdalene, with long blond hair, kneels at L. Christ has cross-nimbus.

ASCENSION

Weston sc, monument to Sir Edw Saunders & 2nd wife Agnes, 1573. Lunette holds relief of Ascension. Christ's footprints appear on top of mountain. Apostles kneel as Christ disappears into cloud (bottom of gown & feet visible). Some heads are missing.

WoottonW wp*, S Ch, S wall; discovered 1918, but now completely faded. Ascension. [Turpin]

DOVE OF THE HOLY SPIRIT

Solihull pg, St Alphege's Ch, Win W1.2T. Dove of H Spirit.

VIII. CONCLUSION OF LIFE OF VIRGIN

ASSUMPTION OF BVM

Curdworth wp*, in nave. 13c. Tristram reported faint apostles, though it is not certain that these were assocated with Assumption (or with part of series of Death of Virgin?). Assumption, however, was definitely present originally, as the extant inscription "ASSUMPTIO" verifies. Also, very faint angel remains, with word "ANGELUS." [Tristram]

Henley-StJ wdcarv*? Rood loft canopy, discovered in "restoration" of 1856, contained words "Assumptio beatae Mariae," center; other scenes were Nativity (L) & Resurrection (R). [Hannett, *Forest of Arden*]

Mervl-StM pg Win N3.2, fragmentary. c.1530; restored 1933-4. 4 angels in albs (2 on each side) with cross diadems, of which 3 stand on clouds. BVM (lacking head & mostly modern) stands on portion of original aureole.

CoughtonCt v, embroidered on back of cope attrib to Q Cath of Aragon. Early 16c. Crowned BVM with nimbus, wearing mantle over garment, has hands in position of prayer. She is supported by 3 angels.

ComptonWy wdcarv, carved screen in Ch. 16c. Crowned BVM supported by 2 small angels at feet & 2 also at head. 2 standing male figs holding books beneath & 2 further angels with thuribles. Divided from St Hubert scene (see SAINTS: St Hubert, below) by lily in pot.

CORONATION OF BVM

WoottonW wp*, S Ch, E wall; discovered in 1918, but now faded & indistinct. Coronation of BVM. [Turpin]

IX. THE LAST JUDGMENT

SOULS OF THE DEPARTED

NewtonR sc, in gray sandstone, on semi-effigy of priest (?Jn de la Worde). c.1330. Above half-fig of priest are angels taking nude soul up to heaven in napkin; above is dove. Other angels hold thuribles. FIG. 49.

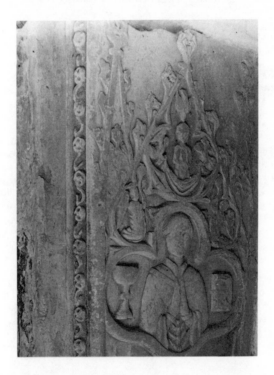

49. Soul of the Departed, on half-effigy of priest. Newton Regis. Reproduced by permission of the Warwickshire Museum.

CHRIST IN MAJESTY

Arley pg Win N4. 14c. Christ in Majesty (frontal view) with R hand raised in blessing (arm missing); L hand rests on orb. Top portion of fig missing; upper part

patched (large female head inserted). Fig of Christ is dressed in white mantle with ivy leaf design over tunic, & is seated on bench.

Tysoe sc, font, fig under crocketed gable. 14c. Christ enthroned, with R hand raised in blessing; L hand rests on orb.

Wroxall pg Win N2.2T. 14c (restored). Blue tunic & hands are modern. Frontal view. Christ, crowned & with cross nimbus. Lower half is not part of this fig.

AstonC pg Win N4Tr. c.1400. Only head (frontal view), neck, & L hand are extant. At neck is jeweled morse. L hand holds portion of orb (misplaced).

Mervl-StM pg Win 1Tr (above Light 3, at top). 15c. Possibly Christ in Majesty. Torso only survives. Christ, facing 3/4 L with R arm raised in benediction, holds open book on knees.

Middleton wp, on W wall in roof space above ceiling of N aisle in nave. Possibly Christ in Majesty. Lower part of throne & fragments of feet only survive, with swathes of drapery apparently over L leg. Fragments of anr fig to R of throne & 3 heads of angels beneath, one angel with nimbus & fragment of stem of unidentified wind instrument in mouth.

TRIUMPHANT CHRIST (TRAMPLING BEASTS)

BM iv, head of tau cross, found in rectory garden at Alcester pre-1903. Early 11c. Worn. Reverse side has Christ in mandorla holding cross in R hand & trampling 2 beasts (lion & dragon); he is nimbused & clad in long robe with band around waist. Il Beckwith, fig. 66; Longhurst, Pl. 18.

JUDGMENT DAY

ComptonWy wdcarv, carved screen in Ch. 16c. Scene illustrates hell mouth & damned souls at Last Judgment. On L at hell mouth is devil, dressed fancifully with grotesque mask (anr serpent mask extending from knee), who is greeting proud & other wicked souls. The damned souls are riding on animals, & are spurred on by 7 small devils who represent 7 Deadly Sins. Il *Compton Wynyates*, p. 19.

Austrey pg Win S5.2T. Fragments of angel with trumpet, from

Last Judgment.

JUDGMENT DAY (MATTHEW 25 ACCOUNT)

Mancetter
pg*. 14c. Fragment of nude woman with arm raised in supplication in Win 1.1T suggests original presence of Doom, now lost.

Wolverton
pg Win 1Tr (not *in situ*). 14c. Frags of Doom, including standing angel in white alb (darkened), blowing trumpet, 3 fragments of nude figs presumably rising from graves (fragment of arm; nude man from waist up, looking downward; & bust of nude man looking up to R).

Coughton
pg formerly in Win 1; fragments in Win N7Tr. c.1520. Bishop, nude & with gold mitre, has head thrown back as he enters hell's flames, presumably from lost hell mouth. Fig of cleric, tonsured & nude, is climbing out of tomb with winding sheet still over his head. Anr fig, with emaciated Death's Head, is covered by winding sheet as he raises his hands in supplication. Yet anr nude fig also in Win S5. This glass was given for E Win by Sir Robt Throckmorton (d. 1518), whose will ordered his executors to provide "story of the Dome." [Dugdale, *Ws*]

Bir-StMn
wp* over chancel arch. Upper portion of wp on beam only extant prior to rebuilding of church in 1873-5. It illustrated head of Christ with cross nimbus & crown of thorns, and with his hands raised palms outward to reveal wounds. Drops of blood appeared on forehead & hands from wounds. Angels on each side. Scrolls with inscriptions "Venite bened*i*cti p*a*tris m*ei*" & "Ite maled*i*cti i*n* ignem et*e*rnam." Il Holliday, "Notes" (1874), Pl. 8.

Brinklow
wp*, nave, S aisle, E beam. Painted with fig of God seated said to be Trinity, with 2 censing angels beside. See *TrBAS*, 2 (1871), 76. However, drawing in Aylesford Collection: Ws Churches, I, 60A, seems more likely to be Last Judgment since seated fig appears to have rainbow under feet & there is no obvious crucifix.

LAST JUDGMENT (APOCALYPSE ACCOUNT)

C-FitzMus msi, McClean MS. 123, ff. 72-105 with ff. 74-77, 79-88, 98-101 missing (drawings in ink over previous pencil sketches); from Nuneaton, Priory of

140

BVM. 13c. St Jn with book; above, a cloud, while at R
ship sinks. Angel blows trumpet (f. 72). FIG. 71.
St Jn; star falls into rivers at R; anr trumpet is
blown (f. 72V). Fire is falling on 2 figs (seated),
while at R sun & moon appear in cloud. Trumpet is
blown (f. 73). St Jn with staff; eagle with scroll
appears in cloud (f. 73V). St Jn appears again with
staff, while 2 figs lie side by side with their feet
toward gate at R. In background is wall; 2 men, one
holding fidel, look on (f. 78). One fig (with staff)
is seen lying dead; anr 2 are rising upward (only feet
are to be seen). St Jn; destroyed city at R (f. 78V).
Angel is speaking from gateway at L; in cloud is fig
with sickle, while below is reaping scene (f. 89).
Angel is speaking from altar at L; anr angel gathers
grapes with sickle. Winepress has devil with horns on
it, while above is angel speaking from building. At
R, 2 heads of horses (f. 89V). St Jn with staff at L,
while angel pours bottle in 5 rivers (f. 91). St Jn
on L, while angel speaks from cloud, above; at R, anr
angel speaks from altar upon which rests chalice (f.
91V). Christ appears within mandorla, center. Angel
& eagle appear on R & L at top. At L is group of
kneeling figs. Above is angel's head (in cloud),
speaking. On R are similar figs & trumpet extending
from cloud (f. 97). St Jn (L). 4 angels, emerging
from clouds, are blowing trumpets (f. 97V). Christ in
mandorla; on L are 3 nude figs, on R 2 additional nude
figs (f. 102). St Jn on L, angel at R proceeds from
building; Christ in mandorla (f. 102V). St Jn writes
at desk (L); at R, Christ in mandorla (f. 103). St Jn
appears on back of angel with long-necked vial; on R
is tree on hill (f. 103V). St Jn, with scroll, kneels
before fig (beardless) seated at R (f. 105)

CORPORAL ACTS OF MERCY

Coughton pg* Win S2. c.1520. This glass given in will of Sir
Robt Throckmorton (d. 1518), who ordered that *"seven
works of mercy"* be placed in "East window of the South
Isle." [Dugdale, *Ws*]

ST MICHAEL

Coughton im*, in N aisle at S end of altar. Provided for in
will of Sir Robt Throckmorton (d. 1518). Im was to be
painted & gilt. [Dugdale, *Ws*]

ST MICHAEL, WITH SWORD OR SCALES

Tysoe sc, font. 14c. Fig with wings, under crocketed gable, holds scales with both hands. Drapery over his alb.

50. St. Michael. Fragmentary painted glass with made-up body of angel, Wolverton.

Wolverton pg Win N4.1. 15c. Fragmentary, including head with
 cross diadem & sword held above it. Hand holding
 sword is misplaced. Possibly torso & portion of
 angel's wings as well as foot also extant. Possibly
 St. Michael. FIG. 50.

ST MICHAEL & DRAGON

MaxstokeP seal, from Maxstoke Priory. 1525. St Michael de-
 feating dragon. *Catalogue of Seals*, No. 3624. Il
 Holloway, "Maxstoke Priory," p. 88.

TORMENTS OF THE DAMNED

Wolston sc, capital, chancel arch. c.1300. Central fig (he
 has R hand thrust into his mouth) is possibly being
 beaten by anr fig, who also holds his L arm. On L is
 3rd fig (above chain), probably a devil. Possibly
 damnation scene.

X. THE CREED

APOSTLES' CREED

Astley painted stalls, N side. c.1400. Current inscriptions are from 1624 & are done in English, but traces of old inscriptions (clauses of Creed) are barely visible beneath. The following apostles appear: St Js Gt (N1), St Tho (N2) (FIG. 51), St Js Less (N3), St Philip (N4), St Matthias (N5), St Matt (N6), St Simon (N7), St ?Jn (N8), & St Peter (N9). Not in original order or location (most likely from S side, set off against PROPHETS on N side; see above, p. 106). For tentative identification of each of apostles with clause of Creed, see Houghton, "Astley Church & Its Stall Paintings," pp. 23-7. Il ibid., Pl. IX.

Coughton pg Wins N3Tr & N4Tr. c.1520. Standing figs of apostles (Matt & Jude missing), with clauses of Creed, beginning in Win N4Tr: (1) St Peter, holding key in R hand & book in L, wears long garment under cloak. Bare feet, nimbus, name in inscription beneath. Scroll: "Credo in deum patrem *om*nipotentem creator*em* celi & terre." (2) St Andrew holding book in L hand & leaning on saltire cross. Bare feet, nimbus, name in inscription beneath. Scroll: "Et in Jesum christ*um* *f*ilium ei*us* un*icum domin*um *nostrum*." (3) St Js Gt, holding book in L hand & staff (with scrip attached) in R, wears long garment & pilgrim's hat with 2 badges of nails in saltire. Nimbus; name in inscription beneath. Scroll: "*Qui conceptus* est de sp*iritu sanc*to n*atus* est ex maria *virgine*." (4) St Jn, holding chalice in L hand, wears long garment. Clean shaven, nimbus, name in inscription beneath. Scroll: "Pas*sus* sub pon*tio* pilato *crucifixus* mortu*us* et sepul*tus*." (5) St Philip, holding knife in L hand & staff in R, is clad in long garment with cloak with decorated border over it. Purse hung from belt. Bare feet, nimbus. Scroll: "*Descendit* ad inferna tertia *die resur*rexit a mor*tuis*." In Win N3 are the following: (1) St Tho, holding spear with pennant in R hand, is clad in tunic. Clean shaven. Scroll: "ascendit ad celos sedit ad dex*teram* dei pat*ris*." (2) Bartholomew, holding knife in R hand against face & in L closed book, is clad in tunic with cloak fastened at shoulder. He is wearing ankle boots. Nimbus, name in inscription beneath. Scroll: "inde venturus est iudicare vivos et mor*tuos*." (3) St Matthias, holding

halbert in R hand & book in L, is clad in long tunic.
Bare feet, nimbus, name in inscription beneath.
Scroll: "Credo in spiritum sanctum." (4) Js Less,
holding large club in L hand & R hand behind body, is
wearing long garment gathered at neck. Bare feet,
nimbus, name in inscription beneath. Scroll: "*Sanctam*

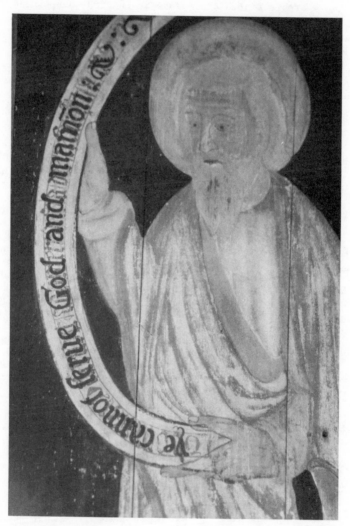

51. St. Thomas, Apostle. Stall painting, Astley. Scrolls over-
painted in 1624.

ecclesiam catholica *sanctorum communionem*." (5) St
Simon, holding book in R hand & saw in L, is clad in
long garment with cloak over it looped over arm. Bare
feet, head missing, name in inscription. Scroll:
"Remis*s*ionem peccatorum." (6) St Jude, fig missing.
Scroll: "Carnis resur*recti*onem." FIG. 52.

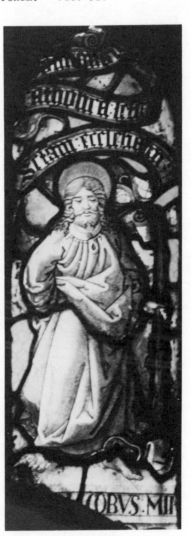

52. St. Peter and St. James the Less, from Creed Series. Painted
glass, Coughton.

146

XI. THE APOSTLES

APOSTLES AS A GROUP

See also CREED, *above.*

Stoneleigh sc, font; probably originally at Maxstoke Priory.
12c. 12 apostles in arcaded niches. Each apostle
identified by name incised (some inscriptions now
impossible to read); only Peter has emblem (key) &
tonsure. 2 hold scrolls, & remainder hold open &
closed books. Il Houghton, "Ws Fonts," Pl. IX.

Mancetter pg, formerly in Win N5. 1333-49. Possibly series of
12 apostles of which only 2 survive. See entries
under ST JS GT & ST BARTHOLOMEW, below. On this
glass, see Newton, III, 901.

Wixford pg Win S3; perhaps originally in Win 1Tr. 1411-8. 12
lights perhaps originally held 12 standing apostles.
Currently, among extant figs, only one can be iden-
tified with certainty--i.e., St Thomas, who stands
with spear in R hand, book in L. He wears white man-
tle over tunic with foliage pattern. Other remaining
figs are one apostle wearing white mantle over tunic &
holding cross staff in R hand & book in L (Chatwin &
Newton suggest that this fig is St Philip), an apostle
(fragmentary) identified by Chatwin as St Js, & por-
tion of anr apostle. Il Chatwin, "Wixford Church"
(1933), Pl. VIII.

Solihull sc*, reredos (figs lost), Ch of St Anthony, S aisle.
15c. 6 niches on each side of original Crucifixion;
possibly apostles were placed here.

APOSTLES (INDIVIDUAL FIGURES)

See also APOSTLES AS A GROUP *and* CREED, *above.*

St Bartholomew

Mancetter pg Win 1.4 rft 3; quatrefoil formerly in Win N5.
1333-49. Bearded St Bartholomew, wearing cloak over
tunic, standing, points with L hand to knife (for his
flaying) held in his R hand. Head is dark, feet are
missing.

Mervl-StM pg Win N3Tr. c.1530. One fig has been identified as

St Bartholomew; see Rackham, p. 102. St holds knife & book in 4th light in tracery of this win.

St James the Great

Mancetter pg Win 1.2 rft 2; quatrefoil light, formerly in Win N5. 1333-49. Bearded St Js Gt appears standing & wearing palmer's garb--i.e., pilgrim's hat with chin strap & decorated with scallop, & in R hand pilgrim's staff with scallop. He wears mantle (yellow) over dark tunic. In L hand is book. Possibly part of series of 12 APOSTLES; see also ST BARTHOLOMEW, above.

pg Win 1.4 rft 4. 14c. Head of Js Gt with hat & scallop shell.

Wroxall pg Win N5.2. 14c? Js as pilgrim, standing & holding staff (with wallet) in L hand; R hand is modern (held up before chest). He has blue hat with scallop shell, & he wears white cloak (hem has pattern). Head is replacement (15c head, possibly of angel).

Mervl-StM pg Win N3Tr. c.1530. Fig has staff in R hand & holds book with L. His hat has scallop shell; anr scallop shell appears on shoulder; his purse is at his side.

St James the Less

Mancetter pg* Win N4.2. 14c. Inscription "Jacobus min" indicates original presence of Js Less.

St John the Evangelist

See also listing for 4 EVANGELISTS, *below.*

Polesworth seal, from Benedictine Abbey of SS Mary & Edith, Polesworth. 14c. At L of BVM & Child on 2nd seal of Abbey is St Jn Ev with nimbus; he holds chalice with serpent in it. *Catalogue of Seals*, No. 3851. Il Aylesford Collection: Ws Country Seats, II, 580.

Wroxall pg Win N5.3. 14c? St Jn, standing with book in L hand; (modern) head resting on R hand. Hands are also modern, as is body beneath mantle & background (grassy bank).

Henley seal, Gild of H Trinity, S Jn Ev, & St Jn Baptist, Henley-in-Arden. 15c. St Jn Ev with book & eagle on R & with palm in L hand. Central fig is Trinity. *Catalogue of Seals*, No. 4991.

Mervl-StM pg Win N3Tr. c.1530. Clean-shaven St Jn with palm in R hand; L hand holds chalice with dragon emerging from it.

St Paul

Mancetter pg Win 1.4 rft 2; quatrefoil from tracery of Win N5. Early 14c. Tonsured st stands with R hand raised to face, & with sword in L hand (point downwards). He has beard & nimbus, & wears yellow mantle over red tunic.

Aston sc, frag of churchyard cross, S Ch. 14c. St Paul carved on one side. He is bearded & with tonsure, & has sword in R hand (held with point down) & book in L hand.

Tysoe sc, font. 14c. Fig of St Paul under crocketed gable holding sword in R hand.

St Peter

Curdworth sc, on font. c.1050. Damaged & headless fig with bound hands (raised, with palms out) may be St Peter, from former dedication of this church to St Peter *ad vincula*. (This identification is, however, far from certain, since what appear to be chains may be only decorated sleeves.) Also 4 additional figs (?apostles) are holding books & have R hands raised in blessing. Il Bond, *Fonts*, p. 134; Houghton, *Ws Churches*, I, figs. 2515-17, 2601-05, 2617.

Bir-Mus pl, pewter. Weoley Cruet, found at site of Weoley Castle, Birmingham. c.1300-50. Fig of St Peter with keys in L hand.

Aston sc, fragments of churchyard cross, S Ch. 14c. St Peter carved on one side. He holds key in R hand & ?book in L. Bearded fig; no tonsure.

Tysoe sc, font. 14c. Tonsured fig, holding 2 keys in R hand & book in L, under crocketed gable. Il Cossins, *Notes*, III, 179 (drawing).

Henley sc*, market cross. 15c. Lost fig of St Peter with key formerly in niche. [*Gentleman's Magazine*, 85 (1815), 129]

US-UNC al, fig at L of St Jn's Head; formerly at CoughtonCt. 15c? Apostle St Peter appears with key in R hand &

book in L. FIG. 41.

Mervl-StM pg Win N3Tr. c.1530. St Peter, with tonsure, holds
 open book in L hand & keys in R hand (over shoulder).
 His cope (fastened with morse at neck) is looped up
 over R arm.

St Philip

Mervl-StM pg Win N3Tr. c.1530. Fig, wearing cope over tunic,
 holds book in R hand & loaves in L hand; identified by
 Rackham as St Philip.

St Thomas

Wroxall pg Win 1Tr. 15c? Fig of Tho, holding square under R
 arm & pointing with L hand.

FOUR EVANGELISTS

Coughton pg Win S4Tr. c.1520. 3 Evangelists only (St Jn is
 missing), all with nimbus & standing. Luke, wearing
 close-fitting skull cap & loose mantle over undergar-
 ment, carries image of BVM & Child (on tablet) in L
 hand; his symbol is missing. Bearded Mark, in flat
 hat & with purse on his belt, holds large closed book
 in both hands; nimbed lion by his R foot. Matt, bare-
 headed & with full beard, holds scroll in L hand &
 points with R; he is looking down at his symbol, a
 small angel with nimbus by his R foot. FIG. 53.

Coleshill sc, font. Mid-12c. Possibly figs of Evangelists. Il
 Houghton, "Ws Fonts," Pl. XII.

NewnhamR wp*, nave. c.1630. Dr Thomas in 1730 (in 2nd ed. of
 Dugdale's Ws, p. 102) reported: "the walls of the
 Church are painted in fresco the four Evangelists in
 full proportion. . . ." Destroyed 1745. [Croft-
 Murray]

SYMBOLS OF THE EVANGELISTS

Rowington pg Win 1B. 15c? Symbols of Evangelists with inscrip-
 tions. All within roundels of twisted stems with
 leaves at corners & names on scrolls.

Atherstone sc, font. 15c? Symbols of Evangelists between In-
 struments of Passion.

ComptonV brass, memorial to Rich Verney & wife Anne. c.1527. 3

symbols of Evangelists extant at corners. Anr extant
symbol located on brass to Anne, daughter of Rich
Verney & wife of Edward Odyngsale. [Stephenson]

53. St. Luke. Painted glass, Coughton.

Aston brass, memorial to Tho Holt, d. 1545. 4 corners of
 edging to brass have roundels with symbols of Evan-
 gelists. Il Aylesford Collection: Ws Churches, I, 21,
 where symbol of St Matt is missing.

Wilmcote sc, pewter processional cross. Recently discovered
 cross from site of previous church has symbols of 4
 Evangelists in roundels at each end of cross arm (from
 top, St Jn, St Luke, St Matt, St Mark). Attached cor-
 pus of Christ is modern.

XII. SAINTS

For explanation of abbreviations, see above, p. 43.

St Anthony of Egypt

 Desert Father (d. 356). Lexikon *V.205-17.*

Wolverton pg Win N4.2. 15c. Very fragmentary. St Anthony, with modern face inserted; his hand holds crutch with bell attached. Fragment of boar's head with bell on collar in same win.

Solihull sc*? reredos, Ch of St Anthony, S aisle. Churchwardens' Accounts for 1534-5 ntd "tabull of se*i*nt Antony" (p. 23).

Henley-GH pg. Fragments of old glass, incl portion of fig of St Anthony. [*VCH*]

St Benedict

 Monastic reformer, responsible for Rule of St Benedict. Lexikon *V.331-63.* SBr, *III, ff. lxxix-lxxx. (Mar 21)*

Wroxall pg Win N4.2. 14c. St (frontal view) in vestments with book in R hand & staff in L. He is wearing red dalmatic, white alb, & yellow (darkened) chasuble. Red nimbus. 19c repairs to this fig; head is replacement (with under-sized head of anr st). Inscription in Lombardic script is mainly original.

St Brendan

 6c Irish monk & missionary whose travels were famous in his lifetime. 9c Navigatio Sancti Brendani Abbatis *records long sea voyage in leather boat & includes incident of landing on whale's back.* Lexikon *V, 442-3.*

C-FitzMus msi, McClean MS. 123, f. 49[v], from Nuneaton, Priory of BVM (pencil sketch). 13c. Whale, with man landing on its back & setting up cooking pot, supported by poles, while anr man remains on ship.

St Catherine

 See above, p. 44.

Bir-Mus pl, pewter. Weoley Cruet, found at site of Weoley
 Castle, Birmingham. c.1300-50. St Cath with wheel by
 L hand, sword (point up) in R.

Bulkington pg*. Early 14c. Ntd Church Notes of Wm Burton (1623)
 in BL Egerton MS. 3510, f. 18. St Cath was crowned &
 standing with her wheel (edge studded with knives) in
 her L hand.

Tysoe sc, font. 14c. Crowned fig holding wheel in L hand &
 sword (point down) in R hand, under crocketed gable.
 Il Cossins, *Notes*, III, 179 (drawing).

Ufton sc, churchyard cross. 14c; restored 1862. St Cath
 holds wheel in R hand. Poor condition. Il Nelson,
 "Mediaeval Churchyard & Wayside Crosses," Pl. 15.

54. St. Catherine. Restored. (mostly modern but with some old
glass) painted glass, Wroxall.

154

Wroxall pg Win N2.3. 14c. Mostly modern, but cloak (below waist) & blue ground are original. FIG. 54.

Caldecote pg Win S7.1. Early 15c? Standing fig of St Cath, crowned & with long blond hair. She holds sword point-down in L hand & book with clasp in R. She wears dark red mantle (fastened with brooch) over orange kirtle (embroidered, with ermine edge). Inscription: "Katerina."

Haseley pg Win W1Tr; formerly in N win. 15c. Restored St Cath holding wheel. Head & L side of robe are modern, wheel is original.

NewtonR pg Win NC4.1. 15c? Crowned fig is seated holding sword point up in L hand. Her wheel is at L.

Solihull im*, ntd in Churchwardens' Accounts, 1534-5, which refer to "lyght yearly before seint Kathryn" (p. 23).

WoottonW wp*, S Ch, S wall. Scenes, discovered in 1918, included trial of St Cath, her martyrdom. She appeared before Maximinus & his fool, & was executed by being beheaded through decrees of same tyrant. Now indistinct. [Turpin]

55. St. Chad. Painted glass, Ladbroke.

St Chad

> *Ceadda, or Chad, was follower of St Aidan. Appointed to see of York, he was shortly judged to have been improperly consecrated; thereafter he became bishop of Mercia at Lichfield. Lexikon V.481-2. SBr, III, ff. xxxiii-xxxiv. (Mar 2)*

Ufton sc*, churchyard cross. 14c; restored 1862. Fig of Chad, now weathered away. [Nelson, "Mediaeval Churchyard & Wayside Crosses"]

Ladbroke pg Win SC2.2. Late 15c. Restored fig incl inserted head, added portion of garment (under chasuble). He wears cope, & crozier is held in L hand. R hand is blessing. Harris suggests that this glass was originally painted at Cv (*Some Manors*, p. 123). FIG. 55.

Chadshunt im*. Tradition says that there was formerly im of St Chad in churchyard; this im is reported to have been very popular. [Sharp, *An Epitome*]

St Christopher

> *See above, p. 73.*

Shotswl wp*. 14c. Fig of St Christopher, described in 1869 as "great painting . . . untouched by time and uninjured by whitewash" ("Archaeology at Banbury & Neighbourhood," p. 669). Other paintings here were said to have been destroyed prior to 1869. [Keyser]

Wyken wp, N wall. c.1500. Placed opposite to main entrance (now blocked). Damaged & fragmentary. Discovered 1956. Child on shoulders is extant, as is landscape with windmill. Christopher wears cloak & has green band (with rosette in middle) about head. His staff is sapling which is budding at top. According to Rouse (p. 79), fish & octopus appeared below in water (now indistinct). Child has red nimbus with orange cross; his gown is fastened at neck with brooch in shape of rosette, & he holds orb with L hand. He is blessing with R hand. Il Rouse, Pl. 2.

WsMus pg, formerly at Compton Verney. c.1527. Donor panel shows Rich Verney (d. 1527) in plate armor & surcoat with his 6 sons kneeling before book with words "Sancte Christophere, ora pro nobis." Above prayer desk is im of St Christopher with Child on R shoulder & holding staff with L hand. Child has cross nimbus.

Il Eden, p. 115.

Berkswell wp*, destroyed 1852. St Christopher. [Cossins, "The Well & Church of St Jn the Baptist, Berkswell"]

Corley wp, N wall. Fig of Child remains from St Christopher scene, but it is very faint.

Stoneleigh wp*, fragmentary fig discovered 1822. Probably St Christopher. [Keyser]

St. Clement

> *Pope, martyred c.100. His relics were recovered c.868, and were thereafter venerated at San Clemente in Rome. Lexikon VII.319-23, SBr, III, ff. clxxxvi-clxxxvii. (Nov 23)*

Solihull im*, ntd in Churchwardens' Accounts, 1534-5, which indicate payment for light before this im (p. 17).

St Cuthbert

> *See above, p. 45.*

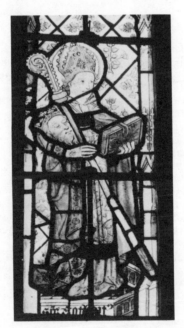

56. St. Cuthbert. Painted glass, Ladbroke.

Ladbroke pg Win SC2.1. Late 15c. St Cuthbert with crowned
 head of St Oswald under R arm; he holds crozier with R
 hand & closed book with L. St wears mitre, blue cope
 with brocade vestment underneath (pink alb is cer-
 tainly a restoration). Nimbus. On his hands are
 gloves (white with motif on back). FIG. 56.

St Dorothy

 See above, p. 46.

Caldecote pg Win N5.2. Early 15c? St Dorothy, who has chaplet
 around forehead & long blond hair, wears ermine gown
 under mantle with patterned gold edge. Standing fig
 is holding basket of flowers in L hand (part of basket
 is missing) & in R hand she is holding chaplet of
 flowers. Piece of blue glass is intruded in center of
 fig. Inscription: "Dorathea."

St Edith

 *Illegitimate daughter of King Edgar. She was devoted to
 poor.* Lexikon *VI.106.* SBr, III, ff. cxl-cxli. *(Sept 16)*

Polesworth seal, from Benedictine Abbey of SS Mary & Edith,
 Polesworth. 14c. At R of BVM on 2nd seal of Abbey is
 St Edith, with nimbus. She holds book in R hand &
 crozier in L. *Catalogue of Seals*, No. 3851. First
 seal of Abbey (ibid., No. 3850) may also have had fig
 of St Edith (or merely an abbess?). Il Bodleian
 Library MS. Digby 12, p. 18.

St Eligius (Eloy)

 Goldsmith who became Bishop of Noyon in 7c. Lexikon
 VI.122-7.

LCompton sc, capital. Head of bishop (possibly St Eloy),
 horse shoe, pincers, hammer. [VCH]

St George

 See above, p. 46.

Coleshill pg*. 14c. St Geo at L was thrusting spear into head
 of dragon coiling about his legs; he wore jupon &
 mixed chain mail & plate armor. K Edw III (in armor,
 crowned, & kneeling on cushion) looked on with hands
 joined in prayer. Destroyed in 17c. Il Burton,
 Church Notes, BL Egerton MS. 3510, f. 14v.

Wroxall pg Win 1Tr. 15c. St Geo in full plate armor, in-
 cluding helmet with visor open. He holds lance & has
 emblem (cross) on breast. Below, dragon under st's
 feet.

BadClint pg* Win 1. Early 16c? Present fig in Win 1.2T is
 replacement. Donors, reported by Dugdale to be Sir
 Edw Ferrers, his wife Lady Constance, 3 sons, & 6
 daughters (all kneeling), appear in 2 panels in L & R
 lights in window (probably entirely modern replace-
 ments). Identification of original presence of St Geo
 in window made possible by scroll reported by Dugdale
 with inscription: "Sancte Georgi, ora pro nobis."
 Current inscription also referring to St Cath seems
 most likely to be entirely a modern insertion.

St Giles (Aegidius)

 Miracle worker who became for a time a hermit; see Golden
 Legend. Lexikon *V.51-4.* SBr, *III, ff. cxxviii-cxxix.*
 (Sept 1)

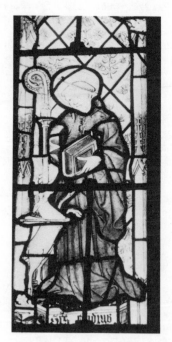

57. St. Giles. Painted glass, Ladbroke.

Ladbroke pg Win SC2.3. Late 15c. St Giles, wearing flowing blue robe & holding crozier in R hand (closed book in L hand), stands with wounded hind at his side (arrow alongside shoulder). St has nimbus. FIG. 57.

St Hubert

Converted following vision of crucified Christ between stag's antlers while hunting on Good Friday, St Hubert (d. 727) eventually became first bishop of Liège. Lexikon *VI.547-51.*

ComptonWy wdcarv, carved screen in Ch. 16c. Vision of St Hubert, who saw Our Lord betw antlers of stag. Kneeling fig of st holding staff in R hand with L resting on sword hilt below large stag rearing on hind legs. Fig of angel between antlers with crucifix & 2 further angels above, one with small naked fig (?soul).

St Lawrence

Deacon at Rome; martyred by being roasted on gridiron. Lexikon *VII.374-80.* SBr, III, f. *cix. (Aug 10)*

Knowle seal, Gild of St Jn Baptist, SS Lawrence & Anne at Knowle. 15c. St Lawrence standing with gridiron & book on R; on L, St Jn Baptist; center, BVM taught to read by St Anne. Tonnochy, No. 884; *Catalogue of Seals*, No. 4464. Il Tonnochy, Pl. XXV. Later seal (1540) il Wheler, *Collections*, f. 90.

Rowington im*, ntd in will of Jn Hill, bailiff, 1499-1500, in Chantry Ch of Blessed Mary. St Lawrence. [Hannett, *Forest of Arden*]

Barton pg*. Fragment of fig of St Lawrence (one piece of gridiron only) remains in Win N2.

St Leonard

Golden Legend *relates how St Leonard was hermit & miracle worker who later founded monastery near Limoges. Patron of prisoners.* Lexikon *VIII.394-8.* SBr, III, ff. *clxix-clxx. (Nov 6)*

Wroxall seal, from Benedictine Priory of St Leonard, Wroxall. 12c. Under arch, 3/4 length St Leonard holds pastoral staff in R hand & book in L. *Catalogue of Seals*, No. 4373.

160

St Margaret

 See above, pp. 49-50.

Bir-Mus pl, pewter. Weoley Cruet, found at site of Weoley
 Castle, Birmingham. c.1300-50. Fig of st, possibly
 St Margaret, with cross staff. No dragon is visible.

HinewoodP seal, from Benedictine Priory of St Margaret, Hine-
 wood, or Henwood. 13c. St Margaret, with nimbus,
 piercing head of dragon with long cross-staff held in
 R hand; she is standing on the dragon. In her L hand
 is book. *Catalogue of Seals*, No. 3283.

Mancetter pg Win 1.3T. 14c. St (full length fig) with book in
 R hand; L hand holds cross-staff piercing dragon's
 head. She has nimbus, & wears cloak over red kirtle.
 Part of dragon & st's legs patched with non-matching
 glass.

Wroxall pg Win N2.1T. 14c? Only dragon's red tail is au-
 thentic; the rest of the fig is 19c.

Caldecote pg Win N5.1. Early 15c? St Margaret, crowned & with
 nimbus, wears white mantle with yellow edge over green
 robe. Her hair is blond. She stands on dragon, &
 holds book in L hand while cross-staff held in R hand
 pierces dragon's mouth. Inscription: "Margare . . ."
 (faint).

Mervl-StM pg Win N4Tr. c.1530. St with nimbus is standing on
 dragon with her cross-staff resting on top of it. Her
 hands are joined in prayer, & her cloak is caught up
 on her R wrist.

St Martin of Tours

 See above, p. 74.

Bir-StMn wp*, E wall of chancel. Late 14c. Scenes from life:
 (1) Martin as bishop; (2) st, mounted on horse,
 dividing his cloak with emaciated beggar (nude, with
 hand raised); (3) 3 figs on L, including 2 workmen
 holding axes (possibly St Martin was at R); (4) shrine
 of st, with hand of God extended above R from cloud;
 below, fig with arms upraised. Additional scenes are
 said to have been lost prior to 1873-5 when the re-
 maining paintings were removed during rebuilding of
 church. Il Holliday, "Notes," Pl. 7.

Mervl-StM pg Win S4Tr; insertion. Early 16c. St, who is
 standing, has cope over plate armor, & holds staff in
 L hand. He wears mitre. R hand holds book with clasp
 & winding sheet. Possibly St Martin of Tours.

St Mary Magdalene

See above, p. 50.

Tysoe sc, font. 14c. Fig with ointment jar under crocketed
 gable. She has long hair over her shoulders.

St Nicholas

See above, p. 97.

Bir-StMn wp*. 14c? Possibly remains of scene showing Charity
 of St Nich; extant until rebuilding of church in
 1873-5. [Holliday, "Notes"]

Maxstoke bell stamp, taken from seal of Gild of Corpus Christi
 & St Nich of Cv (founded 1348). c.1622-40. St Nich
 as bishop in Eucharistic vestments & mitre, standing
 before altar at L; before him on altar is chalice. He
 holds his hands together in prayer; hand of God is
 issuing from above in clouds. Stamp used by Tho Han-
 cox, Jr., of Walsall. Il Tilley & Walters, *Church
 Bells of Ws*, Pl. XIX, fig. 3.

St Thomas of Canterbury

See above, p. 51.

US-UNC al, formerly at CoughtonCt. Early 15c? Fig at R of
 St Jn's Head. He wears mitre & holds archbishop's
 staff. FIG. 41.

Stoneleigh wp*, discovered 1822; no longer extant. Probably
 martyrdom of St Tho of Canterbury. [Keyser]

St Thomas Cantelupe

*Bishop of Hereford, 1275-82. Lexikon VIII.489. SBr, III,
ff. cxlix-cl. (Oct 2)*

Snitterfld pg*, ntd in Dugdale's time as Tho Cantilupe, Bp of
 Hereford. Fig of bishop had alb, tunic, mitre.
 [Dugdale, *Ws*]

162

St William of York

> *Archbishop of York in 12c; opposed by Cistercians. Shrine*
> *at York.* Lexikon *VIII.613-4.*

Austrey pg* Win S5.2. 14c. No fig, but identified by in-
 scription in Lombardic capitals: "S : WILELM : EBOR."

St Winifred

> *See above, p. 98.*

Haseley pg Win WlTr. 15c. St Winifred, holding cross-staff &
 wearing white mantle. Partly modern, including blue
 gown under mantle.

XIII. SEVEN SACRAMENTS

Coughton pg* Win N2. c.1520. This glass given by Sir Robt
 Throckmorton (d. 1518) in his will, which ordered that
 Seven Sacraments be placed in "East Window of the
 North Isle." [Dugdale, *Ws*]

MASS

Ansley pg Win N2.3M. 14c? Priest (head only, with tonsure)
 is saying Mass before open book on stand.

XIV. ALLEGORICAL SUBJECTS

SEVEN DEADLY SINS

ComptonWy wdcarv, carved screen. 16c. Seven Deadly Sins in-
 cluded in scene; see JUDGMENT DAY, above.

WoottonW wp, S Ch, S wall. Described by Turpin in 1919
 ("Devils Blowing Horns or Trumpets," pp. 186-7):
 "Pride is a crowned woman holding a sceptre and trans-
 pierced by a spear; Sloth, a man sitting and playing a
 pipe and a drum [tabor]; Avarice is a burning man--
 perhaps Judas--presented with pieces of money by a red
 devil; Lechery is a monk tempted by a naked woman.
 Above all a big figure of a sort of herald blowing a
 long trumpet with a red pennon hanging from it. His
 face is rather ugly and he may be understood as a
 demon, but I rather suppose it is an unusual represen-
 tation of Supreme Order calling the vices for punish-
 ment." Sloth is currently only recognizable fig
 (faint).

TIME

Nun-StM wp*. Late 16c. Time with scythe; fig stands on
 wheel. Il Bloxam, *Companion*, p. 122 (top portion
 missing).

Stoneleigh wp*, fragments discovered 1822. Probably allegorical
 fig of Time. [Keyser]

FORTUNE

Nun-StM tiles*, set of 9, now worn & indecipherable. Wheel of Fortune, with fig of Fortune in center. 3 figs were present (a 4th seems already to have been worn away when recorded). See drawing in Chatwin, "A Tile Pavement," fig. 1.

XV. MISCELLANEOUS

ANIMALS (INCLUDING FABULOUS)

 Selective listing.

Stoneleigh sc, tympanum, low relief, over N doorway. 12c? 2
 dragons & serpent intertwined.

C-FitzMus msi, McClean MS. 123, from Nuneaton, Priory of BVM
 (pencil sketches). 13c. Pelican in its piety is
 piercing its breast to feed its young (f. 34^V);
 Phoenix in flames (f. 35^V); unicorn, with head in lap
 of virgin, is being killed by hunter (f. 40^V); whale
 (see SAINTS: St Brendan, above) (f. 49^V); additional
 animals in Bestiary described in M. R. James' cata-
 logue of McClean MSS.

Knowle wdcarv, misericords. 15c. On N side (N1), unicorn,
 R, with lion center & hare at L. On S side (S1),
 central fig is ape-physician (in monk's hood) who
 holds urine specimen in L hand (he is pointing to it
 with R); fox holds book on L, while on R is bear.

SalfordPr wdcarv, carved panels from Salford Hall. Late 15c.
 Hunting scenes with wyvern, unicorn, dog chasing bear,
 anr dog chasing hare (also, small dog below); at cen-
 ter is hart. Additionally, wyvern & griffin fighting
 & anr grotesque beast. Il Chatwin, "Carved Woodwork
 from Salford Priors Church" (1943), Pl. XVI.

Ilmington sc, portion of frieze, on display in S transept. 15c
 or 16c. Chained bear is baited by dog. Probably not
 originally from this location; church guide suggests
 origin at "old country house in the neighbourhood."

Astley wdcarv, misericords. Early 14c. 2 boars, lion, lion-
 ess, dog, wyvern, & cockatrice.

BurtonD sc, capitals, S aisle. Various animals. Il O'Shaugh-
 nessy, p. 6.

Brailes sc, portion of shaft. 14c. Sow & piglets. For pos-
 sible connection of this iconography with SS Brynach &
 Brannock, see Anderson, *History and Imagery*, pp. 11-
 12.

DANCE OF DEATH

Stoneleigh wp*, fragments discovered 1822. Probably Death, which
 may have been part of Dance of Death series. [Keyser]

Nun-StM wp*. Late 16c. Skeleton (fig of Death) with head
 missing when seen in last quarter of 19c. Scroll was
 looped over arm. Part of a Dance of Death? Il Blox-
 am, *Companion*, p. 123.

THREE LIVING AND THREE DEAD

Packwood wp, above chancel arch. Early 14c. On L, 3 living
 (head & shoulders of L fig obliterated). 3 dead on R
 are faint & incomplete; fig on L faces kings. Living
 include: (1) fig wearing blue hose & pink robe; (2)
 crowned man with beard & wearing gloves (L hand held
 up with palm out, while R hand holds scepter); & (3)
 anr man in crown & with small beard (one foot lost).
 All 3 stand on scroll (inscription missing). Cleaned
 in 1964. Harris suggests Cv artist since this church
 was formerly ch of Wasperton & both were manors held
 by Cv monks (*Some Manors*, p. 201).

HISTORICAL AND LEGENDARY

Guy of Warwick

GuyCliff sc. In 1830, Tho Ward described it as "mutilated
 statue of the famous Guy" (f. 149v). Guy of Warwick's
 R hand was gone & also hand of shield arm. Missing
 leg had been replaced. Evidence of gilding & paint
 remained, however. In Dugdale's time, it was "well
 preserved." Il Aylesford Collection: Ws Country
 Seats, II, 694; Pevsner, *Ws*, Pl. 11.

TOURNAMENT

ComptonWy wdcarv, screen, Gt Hall. c.1500? Tournament, with
 shield containing arms in center. On L, 2 pairs of
 combatants, with 3 mounted knights in plate armor &
 riderless horse (mutilated, but with head turned back,
 & certainly horse from which one of 3 fallen knights
 at bottom has tumbled). Knight paired with riderless
 horse is removing sword from scabbard. At R is anr
 pair of knights on horses, with 4 knights on ground
 below (fig on L has lost head & legs); at R is stand-
 ing fig (headless) wearing cloak. Il Bolton, "Compton
 Wynyates," p. 619.

SEASONS AND ZODIAC

Bilton pg Win N2.3B. Panel shows December. Above, fig wearing tunic (lower part is modern) with axe swung over head (piece missing in middle); below, pig (modern). Il Winston, *Coloured Drawings*, Pl. Z1.

MINSTRELS AND ENTERTAINERS

C-FtizMus msi, McClean MS. 123, from Nuneaton, Priory of BVM (sketch). 13c. Man playing fidel (f. 78). FIG. 70.

Mervl-StM pg Win S4 (roundels). 14c. 2 nearly identical roundels have organist, wearing hat & gown, playing organ with L hand; R hand is working bellows. Poor condition. Il Cox, *English Church Fittings*, fig. 191.

Halford wdcarv, misericord (not in original stall); possibly formerly in Kenilworth Abbey. 15c. Tumbling trick being performed by man with 3 faces, one bearded & others clean shaven. He is wearing hose & has hold of 2 branches of forked twig. Supporters: 2 smiling heads. FIG. 58.

Tysoe sc, corbel, N aisle. Late 15c. Man playing lute.

58. Tumbling trick. Misericord, Halford.

HUMAN AND SEMI-HUMAN TYPES

Selective listing.

Halford sc, capital, N doorway. Early 12c. Fig of man hold-
 ing ?club in R hand while with L hand he is holding
 head of ?cow. He has pointed & girdled tunic gathered
 in loose folds beneath waist. Il Kahn, Pl. XVII.

Tysoe sc, reset in S aisle. 12c? Knight on horse & with
 shield (pointed & with round top). Top half of knight
 is missing.

C-FitzMus msi, McClean MS. 123, from Nuneaton, Priory of BVM
 (pencil sketch). 13c. Hunting scene: male fig with
 sword in R hand, holding stag with L (f. 32). Hunter
 with hunting horn, 2 dogs & stag & rabbit on R (f.
 45).

Astley wdcarv, misericords. Early 14c. Costume. One has
 head of woman wearing square headdress with pleated
 headband & veiled sides. 2 other misericords have
 busts as supporters, 3 with flat caps. Il Remnant,
 Pl. 40.

Nun-StM rb, nave. 15c? Grotesque mask with large nose &
 teeth.

Ansley sc, N capital, chancel arch. 12c. Man, in center,
 possibly with nimbus, is being eaten by 2 monsters,
 who are swallowing his arms.

Bickenhill sc, on arch over doorway to N chantry ch. Harpy with
 horned headdress.

Green Man

Ilmington sc, capital on chancel arch. 12c. Green man. Il
 Cossins, *Notes*, V, 97.

Oxhill sc, capitals, porch. 12c. Green men. 2 heads on
 capitals with stylized foliage coming from mouths.

Willoughby sc, font. 13c. Green men on underside of font.

AstonC wdcarv, benchend. 14c. Green man with foliage is-
 suing from mouth. He has long ears & possibly crown
 on head.

Nun-StM sc, reset corbel, E end of S aisle. Late 14c? Green

man wearing crown. Il Herbert, *Parish Church of Nun-eaton*, p. 16 (misidentified).

Nun-StM rb, S aisle. 15c? Green man.

Tysoe rb, in nave. Late 15c. Probably green man (damaged).

Kingsbury sc, corbel, N aisle. Green man, with foliage growing out of mouth. Il Cossins, *Notes*, V, 59.

Ladbroke sc, from destroyed church at Radbourne. Green man, with foliage emerging from mouth.

APPENDIX I

RELICS IN COVENTRY AND WARWICK

Inventories of relics are extant for two locations in War-
wickshire, St. Mary's Cathedral and the Collegiate Church of St.
Mary in Warwick. The Coventry relics are listed in British
Library Egerton MS. 2603, fols. 26-27, and have been transcribed
by R. W. Ingram, ed., *Coventry*, Records of Early English Drama
(Toronto: Univ. of Toronto Press, 1981), pp. 487-88. Two lists
of relics have been consulted for St. Mary's in Warwick: (1) the
inventory dated 1455 which Dugdale transcribed in his *Warwick-
shire* (1656), pp. 346-47; and (2) an inventory dated 1454-63
copied by Humphrey Wanley in 1691, now British Library Harley MS.
7505, fol. 7.

COVENTRY, ST. MARY'S CATHEDRAL

Apostles ("A smale shryne of the Appostells"); Confessors
("A barrell of Reliqes of Confessors"); Cross ("A parte of the
hollye Crosse"); St. Andrew; St. Augustine (arm); St. Catherine;
St. Cecilia ("A Relyquie of Saynt Ciscilies foote"); St. George
("An Image of Saynt George *with* a bone of his in his shelde");
St. James ("A Crosse *with* A Relyquie of Saynte Iames"); St.
Jerome (arm); St. Justin (arm); St. Lawrence (rib); St. Mary,
Blessed Virgin ("A pece of Owre ladyes Tombe"; "Owre ladies
mylke"); St. Osburga (at the head of the inventory are listed
"ffirst A shryne of Saynt Osborne of Copper and gylte" and "Saynt
Osbornes hedde Closyd in Copper and gylt"); St. Sylvanus (arm);
St. Thomas Becket; Three Kings of Cologne; and additionally "ij
Bagges of Reliquies."
Ambiguous reference: "A Image of on of the chylderne of
Israell" (a relic of the Holy Innocents?).

WARWICK, COLLEGIATE CHURCH OF ST. MARY

Abraham (piece of his chair); Burial of Christ ("De petra
super quam fuit vinctus post mortem"--Dugdale); burning bush seen
by Moses; Column of Flagellation; Cross ("in qua Crucifixus est
Jesus"--Dugdale); Crown of Thorns ("de Spina quae posita fuit
super capud Jesus"--Dugdale); Holy Innocents (bones); Manger of
Nativity; Mount of Calvary (stone and wood from mount); Nicodemus
("Quaedam pars de manu tergio Nichodemi quando sustinuit corpus
domini super humeros"--Dugdale); oil ("Oleum in quo venit ignis
in vigilia Paschae de coelo"--Dugdale); St. Agnes (clothing); St.
Alkmund; St. Andrew (bone); St. Anne ("De rupe in qua S. Anna
jacet"--Dugdale); St. Blaise; St. Brendan (bones, pan); St.
Catherine (oil, piece of her tomb); St. Cecilia; St. Clara

(pieces of veil and tunic); St. Edmund of Canterbury (comb); St. Edward the Confessor; St. Francis (hair); St. George ("j horn of glory that was sant Gorges"--Harley MS.; also, piece of knee as well as of stone upon which he had shed blood in his martyrdom); St. Giles (bones, stole, etc.); St. Hugh of Lincoln (bones); St. James; St. Lawrence (teeth and bones); St. Martin; St. Margaret; St. Mary, Blessed Virgin (hair, clothing, girdle, milk, piece of tomb); St. Mary Magdalene (hair, clothing); St. Nicholas (oil, etc.); St. Rufin; St. Stephen; St. Swithin; St. Thaddeus; St. Thomas Becket (cloth); St. Wulfhad; Sepulchre of Christ (piece from).

APPENDIX II

MUSICAL ICONOGRAPHY

The prominent placing of angel musicians on the roof of the great hall in St. Mary's Hall in Coventry is indicative of the significance of music in the civic life of Coventry. In civic ritual and drama alike, music and musicians played a most important role. For example, the two extant Coventry plays--the Shearmen and Taylors' Pageant and the Weavers' Pageant which treat the Incarnation, Nativity, and early life of Christ--both require vocal and instrumental music if we are to believe internal and external evidence.

It is to be noted that the first gift of the shepherds in the Pageant of the Shearmen and Taylors is a "pype," presumably one of the shepherds' pipes which figure in the third song appended to this play: ". . . *So mereli the sheppards ther pipes can blow*" (*Two Coventry Corpus Christi Plays*, 2nd ed., ed. Hardin Craig, EETS, e.s. 87 [1957], pp. 11, 32). Such a shepherds' instrument was illustrated in a misericord in St. Michael's, Coventry--a misericord that fortunately was photographed and published prior to the destruction of this building during the air raids of 1940. In the Shearmen and Taylors' Pageant, of course, the shepherds were acting in response to revelation which had taken place through music--the music of the angels singing "*Glorea in exselsis Deo*"--which these humble men described as excellent choral singing ("Hard I neyuer of soo myrre a quere," the Third Shepherd comments [p. 9, 1. 265]). The music of the angels on this occasion is extant in part in the fragmentary scrolls in painted glass dating from the middle of the fifteenth century in the Beauchamp Chapel in Warwick where the Sarum version of the *Gloria* as used in the Mass was set in the traceries of the East Window.

For the Weavers' Pageant, the extant accounts from the first entry in 1525 specify payments to "þe synggers," who continue to appear until the Weavers' play and the others for Corpus Christi "were layd downe" in 1580 (*Coventry*, ed. R. W. Ingram, Records of Early English Drama [Toronto, 1981], pp. 124, 294, and *passim*). These singers were unquestionably needed to sing the "*antem*" required following line 805 of the Weavers' Pageant. In 1541, the singers were joined by a minstrel, who appears again with regularity after 1548. Beginning in 1554, the Weavers' accounts very happily specify the name of the player, James Hewet, and his instrument, the regals. This instrument, appropriate for outdoor performance, would have provided accompaniment for the singers, and it continues in use for the pageant until the last year of the Weavers' participation.

The dramatic records collected for Coventry by Professor

173

Ingram suggest further the presence there of a wide range of
musical instruments and musical activity. The records provide
evidence for the playing of harps, lutes, organs, fidels, flutes,
bagpipes, cornets, curtalls, drums, dulcimers, pipes (including
"small pypis" noted in 1474 in the Coventry Leet Book--instru-
ments perhaps similar to certain of the small pipes in the
Beauchamp Chapel glass), and trumpets in addition to the already-
mentioned regals. Among these, the trumpets were predominant in
the city waits, if we are to believe the order recorded in the
Leet Book in 1439 to the effect "that they Trumpet schall haue
the rule off the whaytes And off hem be Cheffe" (Ingram, p. 12).
This instrument, of course, was needed for the Drapers' Pageant
of the Last Judgment, and in 1561 the "trompeter" was paid the
rather large sum of 3 shillings fourpence for his services
(Ingram, p. 217). To the above list, the play texts of the
Weavers' and the Shearmen and Taylors' pageants add two addi-
tional instruments, viols and bells (see JoAnna Dutka, *Music in
the English Mystery Plays* [Kalamazoo: Medieval Institute Publi-
cations, 1980], pp. 82-86).

The musical forces of sixteenth-century Coventry are sug-
gested very clearly by the participation of musicians in the late
production of *The Destruction of Jerusalem*, presented in 1584 as
a substitute for the prohibited Corpus Christi cycle. For their
contributions to *The Destruction of Jerusalem*, the Drapers rented
a drum and paid a percussionist to play it, hired six additional
musicians, and also paid "ffor the hyre off a trumpet." The
Smiths spent even more on musicians than the Drapers for the same
play, retaining a flutist, a bagpiper, two drummers, and other
musicians (Ingram, pp. 303-04, 307-08).

Yet the extant musical iconography of Coventry is not rich,
and it will quickly be discovered that the angel musicians in St.
Mary's Hall comprise most of the examples in the city. For-
tunately, the painted glass at not-far-away Warwick, to which
reference has been made above, contains one of the most extensive
medieval orchestras to be found anywhere. In this glass we see
genuinely important illustrations of early instruments, though
here every detail can hardly be relied upon to give exact infor-
mation about their design and construction. Quite properly,
Jeremy Montagu features these illustrations of early instruments
in his section on the years 1348-1453 in his popular book, *The
World of Medieval and Renaissance Musical Instruments* (London:
David and Charles, 1976), pp. 53-81. But other locations in
Warwickshire are also valuable additions to the musical icono-
graphy of the area, and the extant examples range from the
painted glass in St. Milburga's, Wixford, a small church with an
important set of angel musicians, to the instruments in the faded
wall painting of the Doom in the Gild Chapel in Stratford-upon-
Avon.

The list which follows includes all extant examples of
musical iconography from Warwickshire as well as items that are

now lost if they are preserved in photographs or antiquarian illustrations. Among the latter are included Thomas Fisher's drawings of the wall paintings in the Gild Chapel at Stratford made after they were first discovered in 1804; of these, the paintings in the chancel, which treated the legend of the Cross and which included some musical instruments, are now totally lost. Fisher's drawings are not entirely reliable, of course, since he was unfamiliar with the forms of the early instruments he was trying to copy. Needless to say, identifications made in the following list must likewise be regarded as less than definite in a few instances, since the examples and illustrations do not always distinguish details with sufficient clarity to allow for certainty.

LIST OF INSTRUMENTS IN EARLY WARWICKSHIRE ART

PERCUSSION

BELLS--*War-BCh* Win S2Tr, pg: angel musician plays set of 8 white (silver?) bells with 2 sticks while anr angel holds music book for him; bells are attached mouth upward on table. c.1447-9. Il Bentley, Pl. XVII (S. 10).

TABOR--*War-BCh* Win S2Tr, pg: tabor is held by angel's L hand & is struck with R, while anr angel plays tabor pipe; in anr opening, angel plays tabor (held by belt over shoulder with its head horizontal rather than vertical) with R hand & pipe with L. c.1447-9. Il Bentley, Pl. XV (S. 2, S. 1).

TAMBOURINE--*War-BCh* Win N2Tr, pg: angel plays tambourine with 3 jingles on each side & with 3 snares inside head (crossing at center of head). c.1447-9. Il Bentley, Pl. XII (N. 2).

TRIANGLE--*War-BCh* Win N2Tr, pg: triangle has loop at top for thumb. c.1447-9. Il Bentley, Pl. XVII (N. 13).

STRING INSTRUMENTS

HARP--*Cv-KHVIII* (formerly in *Cv-WhiteFr*), misericord: David plays harp at L. c.1400. *Cv-StMH* Great Hall, roof, wdcarv: harp, played by angel musician (repainted). c.1390-9. *Cv-StMi*, misericord (destroyed): Jesse Tree with David holding harp. c.1465. Il Harris, "Misericords of Cv," Pl. XXXII (VIII). *Mancetter* Win 1, pg: figure of David from Jesse Tree holds harp with 6 double strings, which he is playing; its frame has dragon-swallowing-its-tail design. Later 14c. FIG. 38. *Mervl-StM* Win 1, pg: Jesse Tree has David playing harp with R hand; instrument has head of monkey ornament on top. Early 14c. Il Rackham, Pl. XIV. *Str-GCh* chancel, wp (lost): angel musician played harp as Cross was removed to Constantinople (Invention of Cross series).

Early 16c. Il Nichols/Fisher, Pl. VII. Also chancel arch, wp: harp held by angel musician on city walls of New Jerusalem in wp of Doom. c.1531-45. Il Nichols/Fisher, Pl. XIX. *War-BCh* Win S2Tr, pg: 2 Irish harps played by angels using both hands; each harp has rose in sounding board, 9-10 strings, no tuning pegs. c.1447-9. Il Bentley, Pl. XVI (S. 5).

LUTE--*Cv-StMH* Great Hall, roof, wdcarv: lute (4 courses of strings?) played by angel musician who plucks it with quill; repainted. c.1390-9. FIG. 62. *Str-GCh* chancel, wp (lost): angel musician played lute as Cross was removed to Constantinople (Invention of Cross series). Early 16c. Il Nichols/Fisher, Pl. VII. *Tysoe*, corbel: minstrel using plectrum to play lute with 5 courses of strings. 14c. *War-BCh* Win S2Tr, pg: angels play 2 lutes (one lost except for tuning pegs; other has at least 5 courses of strings, played with plectrum). c.1447-9. Il Bentley, Pl. XVI (S. 7). *Wixford*, pg: lute with 4 courses of strings, plucked with quill. c.1420-50. FIG. 60.

MANDORA--*War-BCh* Win S2Tr, pg: 2 mandoras, one of which has 3 courses of strings, played with plectrum. c.1447-9. Il Bentley, Pl. XVI (S. 8). *Withybrook* Win S4.3, pg: fragment, possibly of angel musician using plectrum to play mandora with 3 courses of strings. 14c? *Wixford*, pg: angel plays mandora with 3 courses of strings, which are plucked with quill. c.1420-50.

PSALTERY--*Cv-StMH* Great Hall, oriel win, pg: fragment of psaltery with 4 strings. 14-15c. *War-BCh* Win S2Tr, pg: psaltery (boar's head type, resting on table) with at least 20 strings, played with both hands. c.1447-9. FIG. 67.

CRWTH--*War-BCh* Win S2Tr, pg: angels play 2 crwths with curved bows; one has 5 strings while the other has 4. c.1447-9. Il Bentley, Pl. XVI (S. 6).

FIDEL--*C-FtizMus*, McClean MS. 123, f. 78: man holds fidel. 13c. FIG. 70. *Str-GCh* chancel arch, wp: fidel (or lute) held by angel musician on city walls of New Jerusalem in wp of Doom. c.1531-45. Il Nichols/Fisher, Pl. XIX. *Wixford*, pg: tail piece, possibly from fidel, & portion of angel musician are extant. c.1420-50.

REBEC--*Cv-StMH* Great Hall, roof, wdcarv: rebec with 2 strings played by angel musician with curved bow; repainted. c.1390-9. FIG. 63. *War-BCh* Win S2Tr, pg: 3-stringed rebec, played by angel musician with stick that has serrated edge; anr rebec not fully visible. c.1447-9. Il Bentley, Pl. XV (S. 3).

TROMBA MARINA--*War-BCh* Win N2Tr, pg: angel musician plays 4-stringed tromba marina with large curved bow strung with twisted

cord; instrument is held over L shoulder. c.1447-9. FIG. 68; see also Bentley, Pl. XII (N. 1).

KEYBOARD INSTRUMENTS

CLAVICEMBALO--*War-BCh* Win N2Tr, pg: clavicembalo (keyed psaltery, or harpsichord) has approximately 20 keys arranged in 2 rows & 19 strings; soundboard has 3 roses. c.1447-9. FIG. 66.

CLAVICHORD--*War-BCh* Win N2Tr, pg: clavichord, held by angel, is played by anr; 6 strings visible & approximately 26 keys. Under strings is bridge, with felt damping strips on its L. c.1447-9. FIG. 31.

ORGAN--*Mervl-StM* Win S4, pg: 2 roundels have organists playing organs (playing keys with L hand & working bellows with R). 14c. Il Cox, *English Church Fittings*, fig. 191. *War-BCh* Win N2Tr, pg: angel plays large portative organ (bellows worked by anr angel, who also apparently holds instrument) with 24 metal pipes (each pipe has tapered foot, but no mouths are visible). c.1447-9. FIG. 32. Anr organ in Win S2Tr is positive with 26 pipes (mouth of each pipe very clearly defined) & 2 rows of keys (approximately 20 keys) as well as 3 double stops; one angel plays while anr works bellows. c.1447-9. Il Bentley, Pl. XVII (S. 9). *Wixford*, pg: fragment has pipes & only angel musician's arm & hands. c.1420-50.

WIND INSTRUMENTS

BAGPIPES--*Cv-StMH* Great Hall, roof, wdcarv: bagpipe, played by angel musician (no mouthpiece); repainted. c.1390-99. FIG. 65. *War-BCh* Win N2Tr, pg: bagpipe with 2 chaunters (one straight, one curved) & one drone (with tuning slide); blown by mouth of player. c.1447-9. FIG. 69.

HORNS--*C-FitzMus*, McClean MS. 123, f. 45: hunting horn. 13c. *Str-GCh* chancel arch, wp: 2 devils blowing horns in Doom. c.1531-45. FIG. 28; see also Nichols/Fisher, Pl. XIX.

PIBCORN--*War-BCh* Win N2Tr, pg: angels play single & double pibcorns (capped reeds). c.1447-9. Il Bentley, Pl. XIII (N. 5); Montagu, Pl. 58.

PIPES--*Cv-StMH* Great Hall, roof, wdcarv: pipe (presumably recorder) played by angel; repainted. c.1390-9. FIG. 64. *Cv-StMi*, misericord (lost): shepherd was playing pipe. c.1465. Il Harris, "Misericords of Cv," Pl. XXXI (II). *Str-HT*, misericord S3: fool grotesque plays pipe. 1430-40. Il White, fig. 24. *War-BCh* Wins N2Tr & S2Tr, pg: angels play various pipes, including short pipes (possibly with 4 finger holes), duct flutes,

& tabor pipes. c.1447-9. Il Bentley, Pls. XII (N. 3), XIII (N. 3), XIII (N. 8), XV (S. 1, S. 2).

SHAWM--*Wixford*, pg: angel plays shawm (bass?). c.1420-50. Il Chatwin, "Wixford Church," Pl. IX. *War-BCh* Win N2Tr, pg: angels play 2 alto shawms (with many finger holes visible), 2 tenor shawms, 2 discant shawms, & bass shawm (with many finger holes). c.1447-9. Il Bentley, Pls. XIII (N. 6, N. 7, N. 8), XIV (N. 11).

TRUMPETS--*Austrey* Win S5.2, pg: angel blows trumpet (only mouth-piece extant). 14c? *C-FitzMus*, McClean MS. 123, ff. 72, 72v, 97, 97v: angels hold trumpets (Apocalypse series). 13c. FIG. 71. *Cv-StMH* Great Hall, roof, wdcarv: fragmentary trumpet played by angel. 1390-9. *Str-GCh* chancel, wp (lost): 2 trumpets played as Helen sets out to find Cross, & also angel musician played trumpet as Cross was removed to Constantinople (Invention of Cross series). Early 16c. Il Nichols/Fisher, Pls. VI-VII. Also wp of Doom over chancel arch: trumpet held by angel on city walls of New Jerusalem. c.1531-45. Il Nichols/Fisher, Pl. XIX. *Wolverton* Win 1Tr, pg: angel blows trumpet from Doom scene. 14c. *Nun-StM* tiles: angel with trumpet, now indecipherable. Il Chatwin, "A Tile Pavement" (1949), fig. 2.

VOCAL MUSIC

SINGERS--*War-BCh* tracery of windows, pg: in Win N3Tr, angel musicians sing antiphon *Gaudeamus omnes in domino* (Sarum version), which appears on scrolls; in E window (Win 1) angel musicians sing *Gloria in excelsis*, which has fragment of *Ave Regina* (Sarum version) intruded into scrolls. c.1447-9. Il Hardy, Pls. XCVII, C. *Wixford*, pg: angel musician, holding scroll with musical notation. c.1420-50. FIG. 61.

SELECTED BIBLIOGRAPHY

I. *Abbreviations*

AntJ	*Antiquaries Journal*
Arch	*Archaeologia*
ArchJ	*Archaeological Journal*
B&MI	*Birmingham and Midland Institute. Archaeological Section. Transactions.*
BL	British Library
BurlM	*Burlington Magazine*
EDAM	*Early Drama, Art, and Music*
EETS	*Early English Text Society*
JBAA	*Journal of the British Archaeological Association*
TrBAS	*Transactions of the Birmingham Archaeological Society* (subsequently *Birmingham and Warwickshire Archaeological Society*)
VCH	Victoria County Histories

II. *Manuscripts and Archival Material*

Aylesford Collection. Warwickshire Churches, 2 vols. Warwick Country Seats, Castles, etc., 2 vols. Warwickshire Drawings. Birmingham Reference Library. c.1792-1821.

Beauchamp Chapel Glass: Memorials. BL MS. Add. 12,471. 1587.

Bede. Vita S. Cuthberti. Cambridge, Trinity College MS. O.1.64 [1088]. 12c.

Bell, William. Will. Stratford-upon-Avon, Corporation Unbound Records, XII, No. 190. Shakespeare Birthplace Trust Records Office. 1465.

Bodleian Library MS. Top. Warwick C.4.

Boutell, Charles. Illustrated Descriptive Lists of Miseres, with Notes, etc. BL Add. MS. 32,135. 1872.

Brown, H. E. Typescript. Birmingham and Warwickshire Archaeological Society.

Burton, William. Church Notes. BL Egerton MS. 3510. c.1604.

Church Notes. BL Add. MS. 37,180. c.1861.

"Coats of Arms under y^e Benches in Coventry Free-School." BL

Lansdowne MS. 209, fols. 254-255v.

Cossins, Jethro A. Notes on Warwickshire Churches. Birmingham Reference Library.

Coventry, St. Mary's: The Inventorie of all maner of reliques in the Cathedrall Church of Coventrie. BL Egerton MS. 2603, fol. 26.

Coventry - St. Michael's, May 23rd 1913. Typescript. Coventry, Local Studies Centre.

Coventry, Holy Trinity: Churchwardens' Accounts. Warwick Records Office: DR 581/45.

Harris, Mary Dormer. Historic Warwickshire Churches. Clipping book. Coventry, Local Studies Centre. 1931-32.

Houghton Collection. Photographs of Warwickshire Churches. Birmingham Reference Library. 1896-1926. 2 vols.

King, Dennis. Notes on Ancient Windows removed from St. Michael's, Coventry, during World War II. Coventry, Local Studies Centre.

My Church. MS. and clippings. Coventry, Local Studies Centre. c.1937.

Nuneaton Book. Fitzwilliam Museum, McClean MS. 123. 13c.

Oswald, Adrian. Mediaeval Pewter Cruet from Weoley Castle, Birmingham. Typescript. Birmingham City Museums.

Polesworth, St. Edith's Convent: seal. Bodleian Library, Digby MS. 12, p. 18.

Pysford, William. Will. Public Record Office: PROB 11/19, fol. 67. 1518.

Rowe, George. Ornamental Glazing Quarries. Vol. III. BL MS. Add. 39,919.

Solihull, St. Alphege's Church: Solihull Parish Book, 1525-1720. Warwick Records Office: DRB 64/63.

Stratford-upon-Avon Gild Accounts. Proctors' Accounts, Nos. 16, 18-19, 25-26, 38, 40, 42-43, 47, 49, 50, 52-54, 56, 58, 67-68, 70, 74, 76, 78, 80, 82, 84, 86-87, 100-02, 105. Shakespeare Birthplace Trust Records Office: BRT 1/3. 1403-96.

Stratford-upon-Avon, Inventory of Gild Chapels. Miscellaneous Documents, III, No. 9. Shakespeare Birthplace Trust Records Office. 26 July 1475.

Wanley, Humphrey. Transcription by M. D. Harris from Duke of Portland's MSS.: Notes in handwriting of Humphrey Wanley. Coventry, Local Studies Centre.

Ward, Thomas. Notes for Continuation of Dugdale. BL Add. MSS. 29264-65.

Warwick, St. Mary's: Inventories. Copy by Humphrey Wanley, c.1691. BL Harley MS. 7505.

Wheler, R. B. Collections for the History of Warwickshire. BL Add. MS. 28,564.

Winston, Charles. Collections on Glass Painting. BL Add. MSS. 33,846-49. Coloured Drawings of Painted Glass. BL MS. Add. 35,211.

III. *Printed Works*

Anderson, M. D. *The Medieval Carver*. Cambridge: Cambridge Univ. Press, 1935.

_____. *History and Imagery in British Churches*. London: John Murray, 1971.

"Archaeology at Banbury and Neighbourhood," *The Builder*, 8 July 1876, p. 669.

Badger, E. W. *The Monumental Brasses of Warwickshire*. Birmingham, 1895.

Baker, Harold. *The Collegiate Church of Stratford-on-Avon*. London: George Bell, 1902.

Baker, Malcolm. "Medieval Illustrations of Bede's *Life of St. Cuthbert*," *Journal of the Warburg and Courtauld Institutes*, 41 (1978), 16-49.

Barron, Oswald. "St. Mary's Hall, Coventry," *Country Life*, 16 May 1908, pp. 710-12.

Bartlett, Benjamin. *Manduessedum Romanorum: being the History and Antiquities of the Parish of Mancetter*. London, 1791.

Beckwith, John. *Ivory Carvings in Early Medieval England*. London: Harvey Miller and Medcalf, 1972.

Bedford, W. K. R. "The Heraldry of Warwickshire," *B&MI*, 22 (1897), 49-57.

Bentley, William. "Notes on Musical Instruments figured in Windows of the Beauchamp Chapel, Warwick," *TrBAS*, 53 (1931), 167-72.

Beynon, F. W. "The Monumental Brasses of Warwickshire," *The Old Cross*, 1 (1878-79), 254-59, 305-14.

Bigg, Louisa. "St. Mary's Hall, Coventry," *The Old Cross*, 1 (1878-79), 325-34.

Birch, W. de G. *Catalogue of Seals in the Department of Manuscripts in the British Museum*. London, 1872. Vols. I-II.

Bird, W. Hobart. *Old Warwickshire Churches*. London, n.d.

Black's Guide to Warwickshire. Edinburgh, 1874.

Bloom, J. [Harvey]. *Shakespeare's Church*. London: T. Fisher Unwin, 1902.

_____. Topographical Notes, Stratford-on-Avon. [Stratford-upon-Avon, c.1905.] Rpt. from *Stratford-on-Avon Herald*, 1903-05.

_____. *Walks Round Stratford-upon-Avon*. [1908.] Rpt. of articles from *Stratford-on-Avon Herald*, 1907-08.

_____. *Warwickshire*. Cambridge: Cambridge Univ. Press, 1916.

Bloxam, Matthew H. *Companion to the Principles of Gothic Ecclesiastical Architecture*. London: George Bell, 1882.

_____. *A Glimpse of the Sepulchral and Early Monumental Remains of Great Britain*. Oxford: Oxford Univ. Press, 1840-50.

_____. "On Some of the Sepulchral Monuments of Warwickshire," *B&MI*, 5 (1875), 1-20.

_____. *The Ecclesiastical Antiquities of Warwickshire*. Rugby, 1877.

_____. "On Some Rare and Curious Sepulchral Monuments in Warwickshire of the Thirteenth and Fourteenth Centuries." N.p., n.d. [Offprint in BL.]

_____ and W. Staunton. *Notices of the Churches of Warwickshire*. 1837-58. 2 vols.

Bolton, Arthur T. "Compton Wynyates, Warwickshire. A Seat of the Marquess of Northampton," *Country Life*, 30 Oct. 1915, pp. 685-91; 6 Nov. 1915, pp. 616-22.

Bond, Francis. *Fonts and Font Covers*. London: Oxford Univ. Press, 1908.

Borenius, Tancred. "Wall Paintings discovered in Coventry Cathedral," *Country Life*, 2 Oct. 1942, p. 647.

Brassington, W. Salt. "Notes on Ecclesiastical Seals of Warwickshire," *B&MI*, 19 (1894), 59-70.

Britton, John. *The Architectural Antiquities of Great Britain*. London, 1814. Vols. I, IV.

_____, E. W. Bragley, *et al*. *The Beauties of England and Wales*. London, 1814. Vol. XV, Pt. 1.

Brown, Howard E. "Discoveries at Astley Church, Warwickshire, 1944 and 1951," *TrBAS*, 71 (1955), 59-62.

Burgess, J. Tom. *Historic Warwickshire*, 2nd ed., ed. Joseph Hill. Birmingham: Midland Educational, 1893.

Caiger-Smith, A. *English Medieval Mural Paintings*. Oxford: Clarendon Press, 1963.

Carr-Gregg, Ivo. *The History of Astley and Its Parish Church*. N.p., n.d.

Carter, John. *Specimens of the Ancient Sculpture and Painting now remaining in this Kingdom*. London, 1780. Vol. I.

Catalogue of the Books, Manuscripts, Works of Art, Antiquities and Relics at present exhibited in Shakespeare's Birthplace. Stratford-upon-Avon, 1910.

Cave, C. J. P. *Roof Bosses in Medieval Churches*. Cambridge: Cambridge Univ. Press, 1948.

Chatwin, Philip B. "Monumental Effigies in Co. Warwick," *TrBAS*, 47 (1924), 35-88; 48 (1925), 136-68; 49 (1926), 26-53; 57 (1935), 102-74.

_____. "Three Alabaster Tables," *TrBAS*, 48 (1925), 178-80.

_____. "Some Notes on the Painted Windows of the Beauchamp Chapel, Warwick," *TrBAS*, 53 (1931), 158-66.

184

_____. "The Decoration of the Beauchamp Chapel, with Special Reference to the Sculptures," *Arch*, 77 (1928), 313-34.

_____. "Studley Priory," *TrBAS*, 52 (1930), 306-07.

_____. *The Collegiate Church of St. Mary, Warwick.* Warwick, 1929.

_____. "Recent Discoveries in the Beauchamp Chapel, Warwick," *TrBAS*, 53 (1931), 145-47.

_____. "'Finds' in Ufton Churchyard," *TrBAS*, 54 (1932), 70-71.

_____. "Wixford Church, Warwickshire: Its Brass and Painted Glass," *TrBAS*, 55 (1933), 48-56; 56 (1934), iv.

_____. "Kinwarton Alabaster Table," *TrBAS*, 57 (1935), 184-85.

_____. "Recent Finds in Coventry," *TrBAS*, 58 (1937), 56-62.

_____. "Some Notes on Burton Dassett," *TrBAS*, 59 (1938), 147-51.

_____. "Recent Discoveries in Studley Church," *TrBAS*, 59 (1938), 152-56.

_____. "Medieval Glass from Kinwarton Church," *TrBAS*, 59 (1938), 1.

_____. "The Medieval Patterned Tiles of Warwickshire," *TrBAS*, 60 (1940), 1-41.

_____. "Medieval Stone Carvings found at Coventry," *TrBAS*, 61 (1940), 85.

_____. "Carved Woodwork from Salford Priors Church," *TrBAS*, 62 (1943), 44-45.

_____. "Whichford, South Warwickshire," *TrBAS*, 63 (1944), 63-72.

_____. *Some Aspects of Ancient Coventry.* Coventry: Graphic Press, [1945].

_____. "A Palimpsest Tomb-Chest in Aston Church, Birmingham," *TrBAS*, 64 (1946), 114-15.

_____. "Medieval Tiles Discovered as a Result of Air Raids

in Coventry," *TrBAS*, 64 (1946), 116-17.

_____. "A Tile Pavement of the 'Wheel of Fortune' at St. Mary's Priory Church, Nuneaton," *TrBAS*, 65 (1949), 126-27.

_____. "Medieval Stained Glass from the Cathedral, Coventry," *TrBAS*, 66 (1950), 1-5.

_____. *Old Warwick*. London: Compton-Dando, 1951.

Chew, Samuel C. *The Virtues Reconciled*. Toronto: Univ. of Toronto Press, 1947.

Clark, James M. *The Dance of Death in the Middle Ages and the Renaissance*. Glasgow: Jackson, 1950.

Clitheroe, G. W. *Story of the Parish Church of the Holy Trinity, Coventry*. Gloucester, n.d.

Collins, Patrick J. *The N-town Plays and Medieval Picture Cycles*. EDAM, Monograph Ser., 2. Kalamazoo: Medieval Institute Pubications, 1979.

[Colevile, F. L.] *Stoneleigh Abbey from Its Foundation to the Present Time*. Warwick, [1850].

Compton Wynyates, Otherwise Called Compton-in-the-Hole. N.p., n.d.

Cooper, William, ed. *The Records of Beaudesert, Henley-in-Arden, co. Warwick*. Leeds: John Whitehead, 1931.

_____. *Wootton Wawen: Its History and Records*. Leeds: John Whitehead, 1936.

_____. *Henley-in-Arden: An Ancient Market Town and Its Surroundings*. Birmingham: Cornish Brothers, 1946.

Cornforth, John. "Baddesley Clinton, Warwickshire," *Country Life*, 22 June 1978, pp. 1802-05.

Cossins, Jethro A. "The Well and Church of St. John the Baptist, Berkswell," *B&MI*, 10 (1884), 98-119.

_____. "The Excursions," *TrBAS*, 40 (1915), 43-52.

Cox, J. Charles. *English Church Fittings, Furniture and Accessories*. London: B. T. Batsford, 1923.

_____ and P. B. Chatwin. *Warwickshire*. London: Methuen,

1930.

_____ and Alfred Harvey. *English Church Furniture*. London: Methuen, 1907.

Cox, T. *Topographical, Historical, Ecclesiastical and Natural History of Warwickshire*. 1720.

Craig, Hardin, ed. *Two Coventry Corpus Christi Plays*, 2nd ed. EETS, e.s. 87. 1957.

Croft-Murray, Edward. *Decorative Painting in England 1537-1837*. London: Country Life, 1962. Vol. I.

Crossley, Fred H. *English Church Craftsmanship*. London: Batsford, 1941.

D., G. *Clifford Chambers Parish Church*. N.p., n.d.

Davidson, Clifford. "Thomas Sharp and the Stratford Hell Mouth," *EDAM Newsletter*, 1, No. 1 (1978), 6-8.

Dillon, Viscount. "The Warwick Effigy," *ArchJ*, 73 (1916), 207-11.

Drake, Maurice. *A History of English Glass-Painting*. New York: McBride, Nast, 1913.

Dugdale, William. *The Antiquities of Warwickshire*. London, 1656; 2nd ed., London, 1730.

_____. *Monasticon Anglicanum*, ed. John Caley, Henry Ellis, and Bulkeley Bandinel. London, 1821. Vol. III.

Dutka, JoAnna. *Music in the English Mystery Plays*. EDAM, Reference Ser., 2. Kalamazoo: Medieval Institute Publications, 1980.

Eden, F. Sydney. *Ancient Stained and Painted Glass*, 2nd ed. Cambridge: Cambridge Univ. Press, 1933.

Everitt, A. E. "Aston Church," *B&MI* (1873), pp. 1-25.

Exhibition of British Pewterware through the Ages from Romano-British Times to the Present Day. Reading: Reading Museum and Art Gallery, 1969.

F., T. [Letter.] *Gentleman's Magazine*, 85 (1815), 129.

Farmer, David Hugh. *The Oxford Dictionary of Saints*. Oxford:

Clarendon Press, 1978.

Field, William. *An Historical and Descriptive Account of the Town and Castle of Warwick*. Warwick, 1815.

Fine Tapestry, Objects of Art, and Furniture from Various Sources and Early English and German Stained Glass: The Property of the Right Hon. Lord Manton and Removed from the Chapel at Compton Verney, Warwickshire. Christie's Sale Catalogue, 30 July 1931.

Fisher, Thomas. *A Series of antient allegorical, historical, and legendary Paintings, which were discovered on the walls of the Chapel of the Trinity at Stratford-upon-Avon in Warwickshire*. 1807.

Fox, Levi. *The Borough Town of Stratford-upon-Avon*. Stratford, 1953.

Fraser, A. Edward. *The Parish Church of Saint Alphege, Solihull*. Gloucester: British Publishing Co., 1946.

Fretton, W. G. "Coventry and Its Antiquities," *Associated Architectural Societies*, 12 (1873), 122-32.

_____. "Memorials of the Whitefriars, Coventry," *TrBAS*, [3] (1872), 63-78.

_____. "The Benedictine Monastery and Cathedral of Coventry," *TrBAS*, 7 (1876), 19-38.

_____. "The Collegiate Church of St. John the Baptist, Coventry," *B&MI*, 7 (1880), 1-18.

_____. "Memorials of the Franciscans or Grey Friars, Coventry," *TrBAS*, 9 (1880), 34-53.

_____. *Municipal Regalia, Seals, and Coinage*. Coventry, [c.1880].

_____. "Notes on the Guild of Corpus Christi or St. Nicholas, Coventry," *Reliquary*, 21 (1881), 68-71.

_____. *The Staunton Folio: A Series of Illustrations of Coventry, Warwick and Brinklow*. Birmingham, 1883.

_____. "Hospital of St. John the Baptist, Coventry," *TrBAS*, 13 (1887), 32-50.

_____. "Antiquarian Losses in Coventry during a Century and a Half," *JBAA*, 36 (1880), 316-29.

G., R. [Letter.] *The Gentleman's Magazine*, 63 (1793), 813-16.

Gomme, George Laurence. *Topographical History of Warwickshire, Westmoreland, and Wiltshire*. London: Elliot Stock, 1901.

Gooder, Eileen. *Coventry's Town Wall*, revised ed. Coventry and North Warwickshire History Pamphlets, 4. 1971.

Gough, Richard. *Description of the Beauchamp Chapel*. London, 1804.

_____. *Sepulchral Monuments*. London, 1796.

Gray, Douglas. *Themes and Images in the Medieval English Lyric*. London: Routledge and Kegan Paul, 1972.

Greenhill, F. A. *Incised Effigial Slabs*. London: Faber and Faber, 1976.

Halliwell, J. O., ed. *The Will of Sir Hugh Clopton of New Place, Stratford-upon-Avon . . . 1496*. 1865.

Hannett, John. *The Forest of Arden*. London, 1863.

Hardy, Charles F. "The Music in the Painted Glass of the Windows in the Beauchamp Chapel at Warwick," *Arch*, 61 (1909), 583-614.

Harris, Mary Dormer. *Life in an Old English Town*. London, 1898.

_____, ed. *The Coventry Leet Book: or Mayor's Register*. EETS, o.s. 134-35, 138, 146. 1907-13.

_____. *The Story of Coventry*. London: Dent, 1911.

[_____.] "Old Furniture in St. Mary's Hall. The Ancient Chair of State," *Coventry Herald*, 25-26 Feb. 1916, p. 5.

[_____.] "Stories in Stained Glass," *Coventry Herald*, 16-17 Nov., 30 Nov.-1 Dec. 1917, p. 5.

_____. *Unknown Warwickshire*. London: John Lane, 1924.

_____. *The Ancient Records of Coventry*. Dugdale Soc., Occasional Papers, 1. 1924.

_____. "The Misericords of Coventry," *TrBAS*, 52 (1927). 246-66.

_____. *A Romance of Two Hundred Years*. [Coventry, 1930.]

_____, ed. *The Register of the Guild of the Holy Trinity, St. Mary, St. John Baptist, and St. Katherine of Coventry.* Dugdale Soc., 13. London, 1935.

_____. *Some Manors, Churches and Villages of Warwickshire.* Coventry: Coventry City Guild, 1937.

_____. *The History of the Drapers Company of Coventry.* N.p., n.d.

_____. *A Selection from the Pencil Drawings of Dr. Nathaniel Troughton.* London: Batsford, n.d.

Hart, Charles J. "Old Chests," *TrBAS*, 20 (1895), 60-94.

Harvey, John, *et al. English Medieval Architects.* London: Batsford, 1954.

_____. *Gothic England.* London: Batsford, 1947.

Harvey, P. D. A., and Harry Thorpe. *The Printed Maps of Warwickshire, 1576-1900.* Warwick: Warwickshire County Council, 1959.

Hemsley, Rosemary, and John Hemsley. "The Cathedral Church of St. Mary, Coventry." In *Essays in Honour of Philip B. Chatwin.* Oxford: Oxford Univ. Press, 1962. Pp. 10-12.

Herbert, F. S. *The Parish Church of Nuneaton.* Gloucester: British Publishing, n.d.

Hobley, Brian, *et al.* "Excavations at the Cathedral and Benedictine Priory of St. Mary, Coventry," *TrBAS*, 84 (1971), 45-139.

Holliday, J. R. "The Church and Grammar School of Kings Norton," *TrBAS*, 3 (1872), 44-62.

_____. "Notes on St. Martin's Church, and the Discoveries made during its Restoration," *B&MI* (1874), pp. 43-73.

_____. "Maxstoke Priory," *B&MI*, 5 (1878), 56-105.

Hope, W. H. St. John. "On the English Medieval Drinking Bowls called Mazers," *Arch*, 50 (1887), 129-93.

Houghton, F. T. S. "Warwickshire Fonts," *TrBAS*, 43 (1918), 41-61.

_____. "Astley Church and Its Stall Paintings," *TrBAS*, 51 (1928), 19-28.

190

Howard, F. E., and F. H. Crossley. *English Church Woodwork*, 2nd ed. New York: Charles Scribner's Sons, n.d.

Humphreys, J[ohn]. "Sheldon Tapestries," *TrBAS*, 50 (1927), 50-53.

_____. *Elizabethan Sheldon Tapestries*. London: Oxford Univ. Press, 1929.

Husenbeth, F. C. *Emblems of Saints*, 3rd ed., ed. Augustus Jessopp. Norwich: Norfolk and Norwich Archaeological Soc., 1882.

Hutton, William. *An History of Birmingham*, 4th ed. Birmingham, 1809.

Hutton, W. H. *Highways and Byways in Shakespeare's Country*. London: Macmillan, 1914.

Ingram, R. W., ed. *Coventry*. Records of Early English Drama, [4]. Toronto: Univ. of Toronto Press, 1981.

"Inventory of Church Goods, in the County of Warwick, temp. of Edward the Sixth," *Warwickshire Antiquarian Magazine* (1859-77), pp. 156-78, 241-78.

James, M. R. *A Descriptive Catalogue of the McClean Collection of Manuscripts in the Fitzwilliam Museum*. Cambridge: Cambridge Univ. Press, 1912.

_____. *The Western Manuscripts in the Library of Trinity College, Cambridge*. Cambridge: Cambridge Univ. Press, 1902. Vol. III.

Jansen, Virginia. "Christian Colborne, Painter of Germany and London, Died 1486," *JBAA*, 135 (1982), 55-61.

Jeavons, Sidney A. *Church Plate of Warwickshire*. Cheltenham: James Wilson, 1963.

Jenkins, A. *The Story of St. Martin's, Birmingham Parish Church*. Birmingham and Leicester: Midland Educational, 1925.

[Johnson, Robert.] *The Most Famous History of the seuen Champions of Christendome*. London, 1608.

Johnston, P. M. "Mural Paintings in Houses, with special reference to recent discoveries at Stratford-on-Avon and Oxford," *JBAA*, n.s. 37 (1931), 75-100.

Jordan, John. *Original Collections on Shakespeare and Stratford-*

on-Avon, ed. J. O. Halliwell. London, 1864.

Kahn, Deborah. "The Romanesque Sculpture of the Church of St. Mary at Halford, Warwickshire," *JBAA*, 133 (1980), 64-73.

Kendrick, A. F. "The Hatfield Tapestries of the Seasons," *Walpole Society*, 2 (1913), 89-97.

_____. *Catalogue of Tapestries*, 2nd ed. London, 1924.

_____. "The Coventry Tapestry," *BurlM*, 44 (1924), 83-89.

Ker, N. R. *Medieval Libraries of Great Britain*, 2nd ed. London: Royal Historical Soc., 1964.

Keverne, Richard. *Tales of Old Inns*, 2nd ed. London: Collins, 1947.

Keyser, C. E. *A List of Buildings in Great Britain and Ireland Having Mural and Other Decorations Prior to 1550*, 3rd ed. 1883.

Kirby, H. T. "The Lesser Glass in St. Mary's Church, Warwick," *Apollo*, Feb. 1944, pp. 45-48.

_____. "The Compton Verney Glass," *Country Life*, 15 April 1954, pp. 1132-33.

_____. "The Compton Verney Glass," *Apollo*, July 1954, pp. 8-9.

_____. "Some Warwickshire Medallions of 16th Century Stained-Glass," *British Society of Master Glass-Painters Journal*, 12 (1960), 127-30.

Kirschbaum, Engelbert, *et al.*, ed. *Lexikon der christlichen Ikonographie*. Freiburg: Herder, 1968-76. 8 vols.

"Knoll Chapel, Warwickshire," *Gentleman's Magazine*, 63 (1793), 419-22.

Lancaster, Joan C. *Guide to St. Mary's Hall*, 2nd ed. Coventry, 1981.

_____. *Godiva of Coventry*. Coventry, 1967.

Le Couteur, J. D. *English Medieval Painted Glass*. London: SPCK, 1926.

Leland, John. *The Itinerary*, ed. Lucy Toulmin Smith. 1908. Vol. II.

Long, Edward T. "Some Recently Discovered English Wall-Paintings," *BurlM*, 56 (1930), 225-33.

Longhurst, M. H. *English Ivories*. London: G. P. Putnam's Sons, 1926.

Lowe, John. "Stained Glass at Coventry," *British Society of Master Glass Painters Journal*, 13 (1962-63), 585-87.

Macklin, Herbert W. *Monumental Brasses*. London: George Allen, 1913.

Madeley, C. S. "Warwickshire Church Screens," *TrBAS*, 75 (1959), 43-48.

Marks, Richard. "The Glazing of the Collegiate Church of the Holy Trinity, Tattershall (Lincs.): A Study of Late Fifteenth-Century Glass-Painting," *Arch*, 106 (1979), 133-56.

Martin, A. R. *Franciscan Architecture in England*. Manchester: Manchester Univ. Press, 1937.

Mercer, Eric. *English Art, 1553-1625*. Oxford: Clarendon Press, 1962.

Mezey, Nicole. "Creed and Prophets Series in the Visual Arts, with a Note on Examples in York," *EDAM Newsletter*, 2, No. 1 (Nov. 1979), 7-10.

Midgely, W. *A Short History of the Town and Chase of Sutton Coldfield*. Birmingham: Midland Counties Herald, 1904.

Milburn, R. L. P. *Saints and Their Emblems in English Churches*. Oxford: Basil Blackwell, 1957.

Miller, George. *The Parishes of the Diocese of Worcester*. London: Griffith, Farran, Okeden, and Welsh, 1889. Vol. I.

_____. *Rambles Round the Edge Hills and in the Vale of the Red Horse*. Kineton: Roundwood Press, 1967.

Mills, E. M. *Historical Notes on Compton Verney Church*. Long Compton: King's Stone Press, 1932.

Montagu, Jeremy. *The World of Medieval and Renaissance Musical Instruments*. London: David and Charles, 1976.

Morgan, F. C. "Misericords of Malvern, Ripple and Stratford-on-Avon," *Worcestershire Naturalists' Club Transactions*, 7 (1918), 330-34.

Morley, George. *Warwick and Leamington*. London: Blackie and Son, 1913.

Morris, Richard K. "The Hereford School: Recent Discoveries." In *Studies in Medieval Sculpture*, ed. F. H. Thompson. Soc. of Antiquaries Occasional Papers, n.s. 3. London, 1983. Pp. 198-201.

Moss, Michael A. "A Lost Window," *Country Life*, 143 (2 May 1968), 1134.

Nelson, James. "The Mediaeval Churchyard and Wayside Crosses of Warwickshire," *TrBAS*, 68 (1952), 74-88.

Nelson, Philip. *Ancient Painted Glass in England, 1170-1500*. London: Methuen, 1913.

_____. "Some Unpublished Alabaster Tables," *ArchJ*, 82 (1925), 25-38.

Newton, Peter A. "Schools of Glass Painting in the Midlands." Ph.D. thesis, University of London, 1961. 3 vols.

Nichols, J[ohn] G. *Description of the Church of St. Mary, Warwick, and of the Beauchamp Chapel*. N.p., [c.1838].

_____ and Thomas Fisher. *Ancient Allegorical, Historical, and Legendary Paintings, in Fresco, Discovered in the Summer of 1804, on the Walls of the Chapel of the Trinity, belonging to the Gilde of the Holy Cross, at Stratford-upon-Avon, in Warwickshire*. London, 1838.

Norton, R. *Wolston Church*. Rugby, 1952.

O'Shaughnessy, Frances. *The Story of Burton Dassett Church*. Kineton, n.d.

Oswald, A. H. "Interim Report on Excavations at Weoley Castle, 1955-60," *TrBAS*, 78 (1962), 61-85.

Pemberton, Robert. *Solihull and Its Church*. Exeter: William Pollard, 1905.

Pevsner, Nikolaus, and Alexandra Wedgwood. *Warwickshire*. Harmondsworth: Penguin, 1966.

Phythian-Adams, Charles. *Desolation of a City: Coventry and the Urban Crisis of the Late Middle Ages*. Cambridge: Cambridge Univ. Press, 1979.

194

_____. "Ceremony and the Citizen: The Communal Year at Coventry, 1450-1550." In *Crisis and Order in English Towns 1500-1700*, ed. Peter Clark and Paul Slack. Toronto: Univ. of Toronto Press, 1972.

Poole, Benjamin. *The History of Coventry*. Coventry, 1852.

Puddephat, Wilfrid. "The Mural Paintings of the Dance of Death in the Guild Chapel of Stratford-upon-Avon," *TrBAS*, 76 (1960), 29-35.

Rackham, Bernard. "The Glass Paintings of Coventry and Its Neighbourhood," *Walpole Society*, 19 (1931), 89-110.

Read, Charles H. "An English Ivory of the Eleventh Century," *BurlM*, 3 (1903), 99-101.

_____. "On a Morse Ivory Tau Cross Head of English Work of the Eleventh Century," *Arch*, 58 (1903), 407-12.

Read, Herbert. *English Stained Glass*. New York: Putnam's, 1926.

Reader, Francis W. *Tudor Domestic Mural Painting*. [c.1934]. [Rpt. from *London Naturalist*, 1933; copy in Victoria & Albert Museum Library]

_____. "Tudor Domestic Wall-Painting," *ArchJ*, 96 (1936), 220-62.

Reader, W. *New Coventry Guide*. Coventry, [c.1810].

Reeves, W. P. "Stray Verse," *Modern Language Notes*, 9 (1894), 201-06.

Remnant, G. L. *A Catalogue of Misericords in Great Britain*. Oxford: Clarendon Press, 1969.

Robertshaw, Ursula. "Compton Wynyates: An English Idyll," *Illustrated London News*, 2 Aug. 1969, pp. 15-18.

Ronchetti, Barbara. "The Aylesford Collection," *TrBAS*, 71 (1955), 76-79.

Rouse, E. Clive. "A Wall Painting of St. Christopher in St. Mary's Church, Wyken, Coventry," *TrBAS*, 75 (1959), 36-42.

Rushforth, Gordon McN. *Medieval Christian Imagery*. Oxford: Clarendon Press, 1936.

Sabin, John. *A Brief Description of the Collegiate-Church of St.*

Mary, in the Borough of Warwick. Warwick, 1757.

"St. Mary's Hall, Coventry," *The Builder*, 11 Sept. 1931, pp. 418-20.

Savage, Richard, ed. *The Churchwardens' Accounts of the Parish of St. Nicholas, Warwick, 1547-1621.* Warwick, [1890].

_____, ed. *Minutes and Accounts of the Corporation of Stratford-upon-Avon.* Dugdale Soc., 1. Oxford, 1921.

Scharf, George, Jr. "Observations on a Picture in Gloucester Cathedral and Some Other Representations, of the Last Judgment," *Arch*, 36 (1855), 370-91.

_____. "The Old Tapestry in St. Mary's Hall at Coventry," *Arch*, 36 (1855), 438-53.

Sharp, Thomas. "An Account of an Ancient Gold Ring found in Coventry Park in the Year 1802," *Arch*, 18 (1817), 306-08.

_____. *Illustrations of the History and Antiquities of the Holy Trinity Church.* Coventry, 1818.

_____. *Illustrations of the History and Antiquities of St. Michael's Church, Coventry.* Coventry, 1818.

_____. *St. Mary's Hall, Coventry.* Coventry, 1818.

_____. *St. Nicholas's Church, Coventry.* Coventry, 1818.

_____. *Bablake Church, Coventry.* Coventry, 1818.

_____. *St. John's Hospital and Free School, Coventry.* Coventry, 1818.

_____. *A Dissertation on the Pageants or Dramatic Mysteries Anciently Performed at Coventry.* Coventry, 1825. [Annotated copy in BL: MS. Add. 43,645.]

_____. *An Epitome of the County of Warwickshire.* 1835.

_____. *Illustrative Papers on the History and Antiquities of the City of Coventry,* ed. W. G. Fretton. 1871.

[_____?] "Coventry," *Gentleman's Magazine*, 70, No. 2 (1800), 1146-48.

Shelby, J. V. *A Short History of St. James the Great, Snitterfield.* Gloucester: British Publishing, n.d.

Smith, D. J. H. *Coventry through the Ages: Some Descriptions of the City c.1540–1868*. Coventry and North Warwickshire History Pamphlets, 5. Coventry, 1969.

Steinberg, S. H. "Two Portraits of Sir John of Hartshill," *AntJ*, 19 (1939), 438–39.

Stephens, W. B., ed. *A History of the County of Warwick*. VCH. London: Oxford Univ. Press, 1904–69. 8 vols.

Stephenson, Mill. *The Mill Stephenson List of Monumental Brasses in the British Isles*, revised list: *I. The County of Warwickshire*. N.p.: Monumental Brass Soc., 1977.

Stephenson, W. H. *Report on the Manuscripts of Lord Middleton, preserved at Wollaton Hall, Nottinghamshire*. Historical Manuscripts Commission. London: HMSO, 1911.

Stone, Lawrence. *Sculpture in Britain: The Middle Ages*, 2nd ed. Baltimore: Penguin, 1972.

"Stratford-on-Avon Corporation Records: The Gild Accounts," *Stratford-on-Avon Herald*, 1885–86.

Stuart, Donald Clive. "The Stage Setting of Hell and the Iconography of the Middle Ages," *Romanic Review*, 4 (1913), 330–42.

Styles, Dorothy, ed. *Ministers' Accounts of the Collegiate Church of St. Mary, Warwick, 1432–85*. Dugdale Soc., 26. Oxford: Oxford Univ. Press, 1969.

Templeman, Geoffrey. *The Records of the Guild of the Holy Trinity, St. Mary, St. John the Baptist, and St. Katherine of Coventry*. Dugdale Soc., 19. Oxford: Oxford Univ. Press, 1944.

Thorne, James. *Rambles by Rivers: The Avon*. London, 1845.

Tilley, H. T., and H. B. Walters. *The Church Bells of Warwickshire*. Birmingham: Cornish, 1910.

Timmons, Samuel. *A History of Warwickshire*. London, 1899.

Tonnochy, A. B. *Catalogue of British Seal-Dies in the British Museum*. London: British Museum, 1952.

Tourist's Guide to Warwick and Neighbourhood. Warwick, n.d.

Tristram, E. W. "Mediaeval Wall-Paintings," *Illustrated London News*, 27 April 1929, pp. 718–19, 721.

_____. *English Medieval Wall Painting: The Thirteenth Century*. London: Oxford Univ. Press, 1950. 2 vols.

_____. *English Wall Painting in the Fourteenth Century*. London: Routledge and Kegan Paul, 1955.

Turpin, Pierre. "Ancient Glass in England," *BurlM*, 30 (1917), 214-18.

_____. "Ancient Wall Paintings in the Charterhouse, Coventry," *BurlM*, 35 (1919), 246-53.

_____. "Devils Blowing Horns or Trumpets," *Notes and Queries*, 5th ser., 5 (July 1919), 186-87.

"Unpublished Documents belonging to the County of Warwick," *Warwickshire Antiquarian Magazine* (1859-77), pp. 154-78.

Warren, Florence, ed. *The Dance of Death*. EETS, o.s. 181. 1931.

Weever, John. *Ancient Funerall Monuments*. London, 1631.

Wentersdorf, Karl. "Animal Symbolism in Shakespeare's *Hamlet*: The Iconography of Sex Nausea," *Comparative Drama*, 17 (1983-84), 348-82.

West, William. *The History, Topography and Directory of Warwickshire*. Birmingham, 1830.

Westlake, N. H. J. *A History of Design in Painted Glass*. London, 1881-94. Vol. III.

Wheler, Robert B. *History and Antiquities of Stratford-upon-Avon*. Stratford, 1806.

White, Mary Frances. *Fifteenth Century Misericords in the Collegiate Church of Holy Trinity, Stratford-upon-Avon*. Stratford-upon-Avon: Philip Bennett, 1974.

William, Marquess of Northampton. *Compton Wynyates*. London: Arthur Humphreys, 1904.

Williams, Charles. "A Few Notes on Monumental Brasses, with a Catalogue of Those Existing in Warwickshire," *B&MI*, 12 (1887), 16-51.

Winston, Charles. "The Painted Glass in the Beauchamp Chapel at Warwick," *ArchJ*, 21 (1864), 302-18.

_____. *Memoirs Illustrative of the Art of Glass Painting.* London: Murray, 1865.

Woodhouse, F. W. *Churches of Coventry.* London: G. Bell, 1909.

Index

abbess 79
abbot 79, 116-17
Abias, *King* 110
Abraham
 relic of 171
Ackland Art Museum 119, 130, 148, 161, fig. 41
Adam 32, 105, fig. 35
Agnus Dei 25-26, 64, 90, 119-21
alabasters 13, 18, 21, 90, 92, 111, 115, 119, 130, 148, 161
Alcester Tau Cross 4, 124-25, 138, fig. 43
Alexandria 43
Almain, *King of Tyre* 99
altar 52, 75, 77, 91, 95, 97, 103, 111, 113, 118, 140, 161
altar cloths 28, 33
altar frontal 59, 62
Amos 87
Anderson, M. D. 165
angels 1, 5, 13, 15-17, 21-23, 28-29, 31, 35-37, 42, 45, 59-60, 63-64, 66, 69-72, 76-78, 82-86, 101-04, 111-12, 116, 122-23, 128, 133-34, 136, 138, 142, 147, 159, figs. 2, 30
angel musicians 1-2, 17, 69, 84-86, 103-04, 138-40, 173-78, figs. 31-32, 60-69, 71
animals 5, 52, 71, 138-40, 165
Annas 27
Ansley 6
 capital 168
 Easter Sepulchre 133
 painted glass of 116-17, 163
anthem 173
antlers 159
anvil 43
ape 165
Apocalypse *see* Last Judgment
apostles 34-35, 37, 41-42, 68, 93, 95, 135-36, 143-51
 shrine of 41
April, *month of* 54
archangels 84

archbishop 79
Arden tomb 102
ark 18
Arley 6
 Easter Sepulchre 133
 painted glass of 127, 137
arma Christi 123
armor 4, 31, 34, 43, 46-47, 52, 66, 73, 75-77, 83, 95-96, 133-34, 155, 157-58, 161, 166
 helmet 31, 46, 158
Arrow 6
 churchyard cross 117, 126
arrows 46, 50, 159
Arthur, *King* 53
aspergillum 37, 123
ass 70, 116
Astley 4, 6
 brass 101
 ivory carving 130-31, fig. 47
 misericords 165, 168
 painted stalls 106, 143-44, fig. 51
 tomb effigy 102
Aston, Birmingham 6
 brass 151
 churchyard cross 116, 127, 148
 tombs 102-03
Aston Cantlow 6
 benchend 168
 painted glass of 134, 138
 sculpture 115
Atherstone 6
 font 123, 149
attendants 61
August, *month of* 54
Austen, William, *metal sculptor* 82
Austrey 6
 painted glass of 13, 103, 138, 162, 178
Avarice 70, 163
Ave Regina 84, 178
axes 31, 66, 76, 160, 167

199

214

59. Churchyard cross at Ufton showing deterioration of stone sculpture.

60. Angel musician with lute. 61. Angel musician holding
Painted glass, Wixford. scroll with music. Painted
 glass, Wixford.

62. Angel musician playing lute. Roof of St. Mary's Hall,
Coventry. By permission of the Coventry City Council.

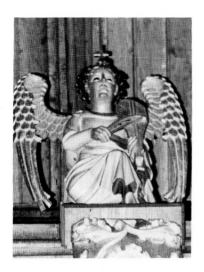

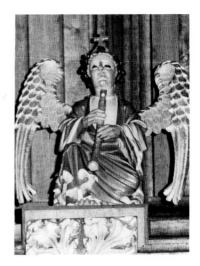

63. Angel musician playing rebec. Roof of St. Mary's Hall, Coventry. By permission of the Coventry City Council.

64. Angel musician playing ?recorder. Roof of St. Mary's Hall, Coventry. By permission of the Coventry City Council.

65. Angel musician playing bagpipes. Roof of St. Mary's Hall, Coventry. By permission of the Coventry City Council.

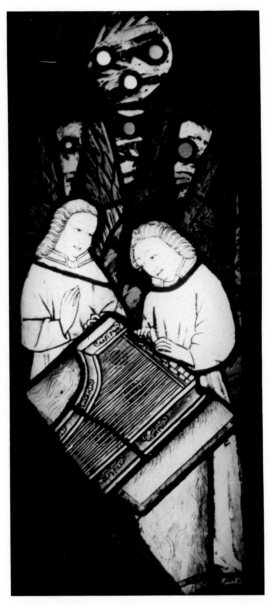

66. Angel musician playing harpsichord. Painted glass,
Beauchamp Chapel, Warwick. Courtesy of the Royal Commission on
Historical Monuments (England).

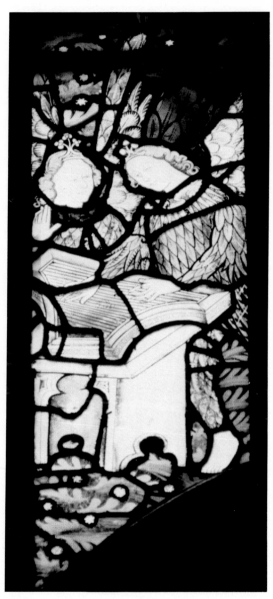

67. Angel musician playing psaltery. Painted glass, Beauchamp
Chapel, Warwick.

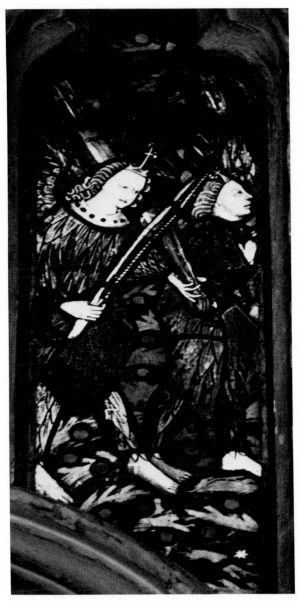

68. Detail of angel playing tromba marine. Painted glass, Beauchamp Chapel, Warwick.

69. Angel musician playing bagpipes. Painted glass, Beauchamp
Chapel, Warwick.

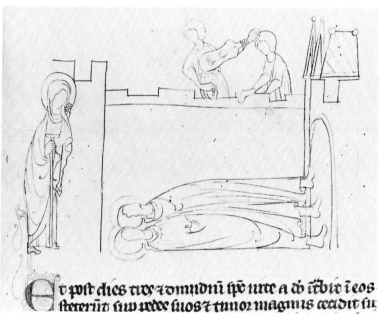

70. Fidel, played by man. Drawing in McClean MS. 123, fol. 78.
By permission of the Syndics of the Fitzwilliam Museum.

Eu secunde angle sa businne sonett,
E une grit muntenne cu fu ardent·
En la mer est ennee la tierce partie,
pur tuer le tierz ki furent en me·
Ensemet le tierz ki sunt de narne·

71. Apocalyptic angel blows trumpet. Drawing in McClean MS. 123, fol. 72. By permission of the Syndics of the Fitzwilliam Museum.